Ado

Photoshop

Elements

JEFF CARLSON

WITHDRAWN

 Peachpit Press

Visual QuickStart Guide
Adobe Photoshop Elements
Jeff Carlson

Peachpit Press
www.peachpit.com

Copyright © 2022 by Pearson Education, Inc. or its affiliates. All Rights Reserved.

San Francisco, CA

Peachpit Press is an imprint of Pearson Education, Inc.

To report errors, please send a note to errata@peachpit.com

Executive Editor: Laura Norman
Development Editor: Victor Gavenda
Senior Production Editor: Tracey Croom
Copy Editor: Linda Laflamme
Proofreader: Kelly Anton
Compositor: Jeff Carlson
Indexer: James Minkin
Cover Design: RHDG / Riezebos Holzbaur Design Group, Peachpit Press
Interior Design: Peachpit Press with Danielle Foster
Logo Design: MINE™ www.minesf.com

Photos: Scott Johnson, pages 82, 88, 92
 Rob Cooper, page 110
 Jeff Carlson, all other pages

ISBN-13: 978-0-13-763701-0
ISBN-10: 0-13-763701-2

1 2022

Dedication:

For Larry, Bob, and Ron

Special Thanks to:

Laura Norman, who first approached me with the idea of revising this title and shepherded the project.

Victor Gavenda for sharp eyes and sharp wit during the editing process.

Tracey Croom for her invaluable production expertise.

Linda Laflamme for even sharper editing eyes.

Kelly Anton for proofing the book (because there can never be too many eyes on a manuscript).

Saurabh Gupta at Adobe for assistance in providing the software and information I needed.

My gratitude also extends to Kimberly Carlson, Agen G.N. Schmitz, Parie Hines, Jeff Tolbert, Makiko Takamatsu, Susan Valencia, Scott Johnson, Lisa Johnson, and Emma Johnson for their permissions to use photos either of them or their adorable kids and pets.

Lastly, I want to extend my love and appreciation to my family for making me a wonderfully fortunate husband and father.

Pearson's Commitment to Diversity, Equity, and Inclusion

Pearson is dedicated to creating bias-free content that reflects the diversity of all learners. We embrace the many dimensions of diversity, including but not limited to race, ethnicity, gender, socioeconomic status, ability, age, sexual orientation, and religious or political beliefs.

Education is a powerful force for equity and change in our world. It has the potential to deliver opportunities that improve lives and enable economic mobility. As we work with authors to create content for every product and service, we acknowledge our responsibility to demonstrate inclusivity and incorporate diverse scholarship so that everyone can achieve their potential through learning. As the world's leading learning company, we have a duty to help drive change and live up to our purpose to help more people create a better life for themselves and to create a better world.

Our ambition is to purposefully contribute to a world where:

- Everyone has an equitable and lifelong opportunity to succeed through learning.
- Our educational products and services are inclusive and represent the rich diversity of learners.
- Our educational content accurately reflects the histories and experiences of the learners we serve.
- Our educational content prompts deeper discussions with learners and motivates them to expand their own learning (and worldview).

While we work hard to present unbiased content, we want to hear from you about any concerns or needs with this Pearson product so that we can investigate and address them.

- Please contact us with concerns about any potential bias at https://www.pearson.com/report-bias.html.

Contents at a Glance

Table of Contents

LIST OF VIDEOS

LIST OF VIDEOS

Introduction

Welcome to Photoshop Elements, the powerful, easy-to-use, image-editing software from Adobe. Photoshop Elements gives hobbyists, photographers, and artists many of the same tools and features found in Adobe Photoshop (long the industry standard), but packaged in a more accessible, intuitive workspace.

Photoshop Elements makes it easy to retouch your digital photos; apply special effects, filters, and styles; create wide-screen panoramas from a series of individual photos; replace bland skies; and more. It also includes several features geared specifically to the beginning user. Of particular note are the Quick and Guided photo-editing controls that make complex image corrections easy to apply.

Here, I'll cover some of the key features of Photoshop Elements and share some thoughts to help you get the most from this book. Then you can be on your way to mastering the simple, fun, and sophisticated image-editing tools in Photoshop Elements.

How to Use This Book

This Visual QuickStart Guide, like others in the series, is a task-based reference. Each chapter focuses on a specific area of the application and presents it in a series of concise, illustrated steps. I encourage you to follow along using your own images.

This book is meant to be a reference work, and although it's not expected that you'll read through it in sequence from front to back, I've made an attempt to order the chapters in a logical fashion.

The first chapter speeds through five steps to import, edit, and share your digital photos. The next chapter takes you on a tour of the work area to make sure we're all on the same page. From there you dive into importing pictures and managing your photo library using the Organizer. Then you explore cropping and straightening, get introduced to Quick and Guided edits, and move on to making selections, working with layers, adjusting lighting and color, working with raw images, fixing and retouching, applying effects, painting and drawing, and adding text. Next, learn a variety of techniques for saving, printing, and sharing images.

This book is suitable for the beginner just starting in digital photography and image creation, as well as hobbyists, photo enthusiasts, intermediate-level photographers, illustrators, and designers.

Sharing Space with Windows and macOS

Photoshop Elements is almost exactly the same on Windows as it is under macOS, which is why this book covers both platforms. In the few places where a feature is found in one environment but not the other, or if the steps are different for each, I make it clear which version is being discussed.

You'll also see that the screenshots are a mix of Windows and macOS—but despite a few cosmetic differences such as title bars and menu bars, everything pretty much tracks the same within the user interface itself.

I also frequently mention keyboard shortcuts, which are faster methods of accessing commands compared to choosing items from menus. Keyboard shortcuts are great time-savers and prevent you from having to constantly refocus your energy and attention as you jump from image window to menu bar and back again.

When this book introduces a command, the keyboard shortcut is frequently also listed, with the Windows version appearing first and the macOS version trailing after a forward-slash. For example, the keyboard shortcut for the Copy command appears as "Ctrl+C/Command+C."

You'll find a complete list of Photoshop Elements keyboard shortcuts in the appendices.

VIDEOS
Sample Video Title

This video icon makes it easy find the video to watch in the Web Edition.

Online Content

Your purchase of this Visual QuickStart Guide includes a free online edition of the book, which contains the videos and is accessed from your Account page on www.peachpit.com.

Web Edition

The Web Edition is an online interactive version of the book, providing an enhanced learning experience. You can access it from any device with a connection to the internet, and it contains the following:

- The complete text of the book
- Hours of instructional video keyed to the text

Accessing the Web Edition

Note: If you encounter problems registering your product or accessing the Web Edition, go to www.peachpit. com/support for assistance.

You must **register** your purchase on peachpit.com in order to access the online content:

1. Go to www.peachpit.com/psevqs2022.
2. Sign in or create a new account.
3. Click Submit.
4. Answer the question as proof of purchase.
5. The **Web Edition** can be accessed from the Digital Purchases tab on your Account page. Click the **Launch** link to access the product.

If you purchased a digital product directly from peachpit.com, your product will already be registered. However, you still need to follow the registration steps and answer the proof-of-purchase question to access the Web Edition.

Editing Photos
in 5 Easy Steps

The paradox of reading a book about editing photos is that you probably want to start working with your images right away! So let's begin with a quick start to this Visual QuickStart guide.

The steps outlined in the next few pages will improve nearly all of your digital photos. When you're ready to fiddle with adjustment sliders and really take advantage of what Photoshop Elements has to offer, continue exploring the rest of the book.

In This Chapter

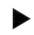

VIDEO 1.1
Photo Editing Workflow in 5 Easy Steps

Step 1. Import and Open Images

Photoshop Elements is really made up of two main programs that work together— the Organizer and the Editor—and as a result, you can open a photo for editing in two ways. The Organizer stores your entire photo library and lets you apply metadata, such as keyword tags. When you want to make adjustments to an image, you send it to the Editor. If you want to edit a photo independently of the Organizer, you can open the file directly from within the Editor.

To import photos into the Organizer, make sure your camera is connected to your computer or the camera's memory card is plugged into a card reader.

To import into the Organizer:

1. Open Photoshop Elements and, in the Home screen, click the Organizer button to open the Organizer.

2. Click the Import button at the top left of the window and choose From Camera Or Card Reader (or press Ctrl+G/Command+G). The Photo Downloader companion application launches.

3. Choose your camera or memory card from the Get Photos From menu (if it's not already selected) (**FIGURE 1.1**).

4. Click the Get Media button to download the images to your computer.

5. To edit one of the imported images, select it and click the Editor button in the taskbar; or, right-click it and choose Edit With Photoshop Elements Editor (**FIGURE 1.2**).

> **TIP** If you open the Organizer for the first time and an introductory window appears, click Skip to dismiss it.

Photos' source

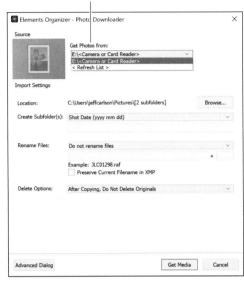

FIGURE 1.1 Use the Photo Downloader to import pictures into the Elements Organizer.

FIGURE 1.2 Open the image in the Editor using the taskbar (top) or the context menu (bottom).

> **TIP** See Chapter 3 for details on importing photos into the Organizer.

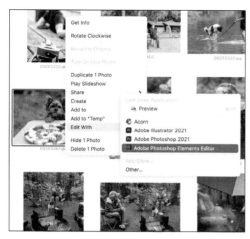

FIGURE 1.3 Choose to edit in Elements instead of within Apple's Photos app in macOS.

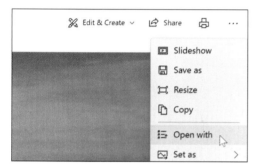

FIGURE 1.4 Pick an alternate editor in Microsoft's Photos app in Windows.

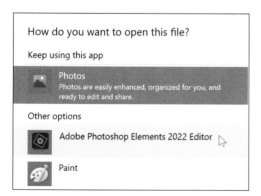

FIGURE 1.5 Send the image to the Photoshop Elements Editor in Windows.

To open a photo directly in the Editor:

1. Open Photoshop Elements and, in the Welcome screen, click the Photo Editor button to open the Editor.

2. Choose File > Open.

3. In the Open dialog, navigate to the image file you want to edit and select it.

4. Click the Open button to open the file.

To edit an image from Apple Photos (macOS):

1. If you use Photos on the Mac to organize your photo library, launch the Photos app.

2. Select a photo to edit and choose Image > Edit With > Adobe Photoshop Elements Editor, or right-click the image and choose the same item from the context menu that appears (**FIGURE 1.3**).

To edit an image from Photos (Windows 10):

1. If you use the Photos app in Windows to organize your photo library, open that app.

2. Select a photo to edit, click the See More (...) button, and choose Open With (**FIGURE 1.4**).

3. Choose Adobe Photoshop Elements 2022 Editor in the dialog that appears (**FIGURE 1.5**). Click OK.

> **TIP** The Organizer automatically monitors some folders for new images. If the Watch Folders window appears unexpectedly after a few minutes, click Cancel. (I'll cover watched folders in Chapter 3.)

> **TIP** Photos shot in raw format first open in Adobe Camera Raw before reaching the Editor. See Chapter 9 to learn more about working with raw photos.

Step 2. Crop and Rotate

The composition of a photo is often just as important as what appears within the frame. If you're not happy with the image's original framing or you want to excise distracting elements like tree branches from the edges, recompose the shot using the Crop tool.

Another common correction is to adjust a photo's rotation. Unless you set up the shot on a sturdy tripod, it's not uncommon to get shots that are slightly tilted. Don't worry, the Editor offers easy fixes.

To crop a photo:

1. With the image open in the Editor, select the Crop tool (or press the C key) (**FIGURE 1.6**). Selecting it automatically makes a crop suggestion based on the content of your photo.

2. Do one of the following:
 - ▸ Drag one of the corner handles to define a selection representing the boundaries of the visible area (**FIGURE 1.7**). Don't worry about being precise at first.
 - ▸ Instead of drawing a freeform rectangle, you can constrain the selection to match preset aspect ratios, such as common photo sizes or the photo's original dimensions. Choose an option from the Crop Preset menu in the Tool Options bar (**FIGURE 1.8**).

3. Click the Commit button or press Enter or Return to apply the crop (**FIGURE 1.9**).

TIP You can also enter specific sizes for the width and height of the crop, as well as the image's pixel resolution. See Chapter 4 to learn more.

FIGURE 1.6 The Crop tool

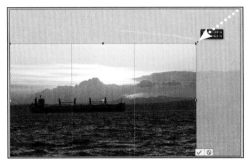

FIGURE 1.7 Drag to define the image's new dimensions after cropping.

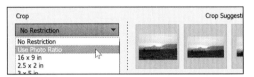

FIGURE 1.8 Set a crop ratio using the controls in the Tool Options bar.

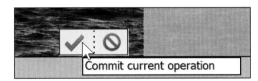

Commit current operation

FIGURE 1.9 The Commit button appears at the bottom of the crop area.

FIGURE 1.10 The Rotate buttons

FIGURE 1.11 The Straighten tool

FIGURE 1.12 Drag to define a "horizon line," which is especially easy when there's a clear horizon.

To rotate a photo:

If you shot a photo in portrait (tall) orientation but the image file was imported with a landscape (wide) orientation, you can shift it easily. Click the Rotate button on the taskbar to turn the entire image left (counter-clockwise) in 90-degree increments. Click the small triangle to the right of the button to reveal a Rotate Right (clockwise) button (**FIGURE 1.10**).

Or, choose Image > Rotate to turn the entire image 90° Left, 90° Right, or 180°.

To straighten a photo:

There are a few ways to nudge the rotation and straighten an image, but the easiest way is to use the Straighten tool:

1. Select the Straighten tool from the toolbox (**FIGURE 1.11**).
2. Drag a line along an object or feature that should be perfectly horizontal, such as a well-defined horizon line (**FIGURE 1.12**). The image straightens.

TIP The Straighten tool also works when you drag vertically to define a line that should be straight up and down.

TIP If you're cropping the image, save time and straighten it before you apply the crop. Drag just outside a corner of the selection to rotate the image, and then commit the change.

TIP The Straighten And Crop Image and Straighten Image commands in the Image > Rotate menu direct the Editor to do the straightening for you. My experience with this command is mixed, so I prefer to do the straightening myself.

Step 3. Adjust Lighting and Color

Almost every photo needs a little lighting and color adjustment, whether it's brightening shadows or punching up the saturation slightly to make colors pop. The Editor is awash in color and lighting adjustment choices, but this is where I start.

Quick Fixes

One of the appeals of Photoshop Elements is its Quick mode adjustments. You don't need to be a digital imaging expert—you may just want to correct a few shots with the least amount of fuss. See Chapter 5 for more information.

To apply Quick mode edits:

1. Open a photo in the Editor.

2. Click the Quick heading to reveal the Quick edit options (if it's not already selected) (**FIGURE 1.13**).

3. Click an attribute (such as Smart Fix) and drag the slider to make the adjustment. Or, click a preset from the grid; positioning your pointer over a thumbnail previews the change, and clicking it applies the adjustment (**FIGURE 1.14**).

4. If you don't like the effect, click the reset icon to return the image to its original state.

FIGURE 1.13 The Quick mode edits handle many common corrections.

Reset to original

FIGURE 1.14 Reveal a grid of settings presets and see how they affect the image.

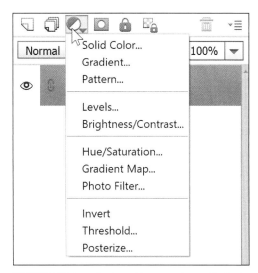

FIGURE 1.15 An adjustment layer makes edits that don't interfere with the image's original pixels.

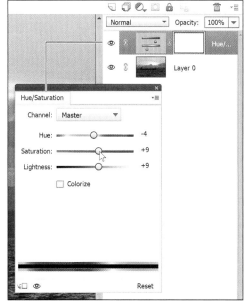

FIGURE 1.16 The Adjustments panel includes settings specific to the adjustment layer you're on.

Manual Adjustments

If you'd rather handle the details yourself, turn to manual corrections. I prefer to use adjustment layers in the Expert mode, which let you apply corrections without changing any of the original pixels in your image. Other controls, such as those found in the Enhance menu, are less flexible.

To apply an adjustment layer:

1. Click the Expert button to switch to that mode.

2. Click the Layers button in the taskbar to open the Layers panel.

3. In the Layers panel, click the Create New Fill Or Adjustment Layer button and choose one of the options (**FIGURE 1.15**). A new adjustment layer (which allows you to make edits to the photo without changing the pixels on the base image layer) is created, and a panel containing its controls appears.

4. Manipulate the controls in the panel to alter the look of the image (**FIGURE 1.16**).

 For example, to increase the saturation of a flat image, add a Hue/Saturation adjustment layer and, in the Hue/Saturation panel, increase the value of the Saturation slider.

TIP Chapter 8 contains much more information about adjusting lighting and color.

Step 4. Apply Corrections

In many cases, you'll probably be finished editing a photo after the previous step. Sometimes, though, you'll want to perform a little correction to remove dust spots, crumbs, or other distracting blemishes. The Spot Healing Brush smartly fixes areas like that without any fuss.

Of course, the Editor includes an arsenal of correcting tools, enabling you to not only repair small areas but to also take the best parts of several photos and merge them together, or even remove people or objects from a scene entirely. Chapter 10 covers all of those options.

To repair areas using the Spot Healing Brush:

1. In either Quick or Expert mode, select the Spot Healing Brush from the tool-box, or press J.

2. In the Tool Options bar, specify a brush size that roughly matches the size of the area you want to repair (**FIGURE 1.17**).

3. Click the area once to apply the brush's healing properties (**FIGURE 1.18**).

4. If the area wasn't repaired to your satisfaction, try clicking it one more time. The tool examines nearby pixels to determine how best to fill the area you're fixing, and sometimes the first pass may not be exactly what you're looking for.

TIP For finer detail work and more control, you may want to break out the Clone Stamp tool for making repairs. See Chapter 10.

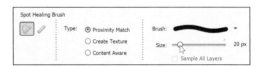

FIGURE 1.17 Adjust the Size slider of the Spot Healing Brush to define how large an area to correct.

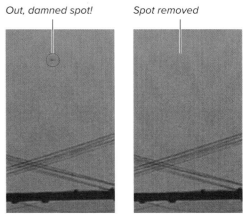

FIGURE 1.18 The Spot Healing Brush really does fix blemishes with one click.

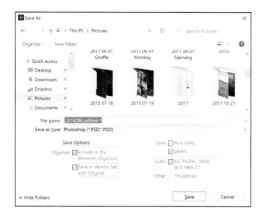

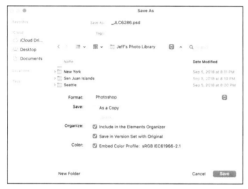

FIGURE 1.19 Save the file so you can edit it later (Windows top, macOS bottom).

Step 5. Save the Photo

Now the photo looks more like what you had in mind when you were shooting it. When you're finished making adjustments, save the image back to the Organizer or to a location on your hard disk.

To save the photo:

1. Choose File > Save or press Ctrl+S/Command+S. Or, choose File > Save As (Ctrl+Shift+S/Command+Shift+S) to save a new copy of the file.

2. In the Save As dialog that appears, select a location on your hard disk (if you want to move it to a new location) (**FIGURE 1.19**).

3. Type a name for the file in the File Name field (or the Save As field, in the macOS version).

4. Choose a file format from the Format menu; use the native Photoshop format (PSD) to retain any layers you applied.

5. Select Include In The Elements Organizer to make the edited file appear in the Organizer.

 To group the edited version with the original, select Save In Version Set With Original.

6. Click Save.

TIP See Chapter 14 for more details on saving files, including other file formats.

TIP To share the photo to an online photo service or as a slideshow, see Chapter 15.

2

The Basics

Before you start really working in Photoshop Elements, it's good to take a look around to familiarize yourself with the program's tools and menus.

If you're new to the software, this chapter will orient you to the work area, which includes the document window, where you'll view your images, along with many of the tools, menus, and panels you'll use as you get better acquainted with the program.

In This Chapter

Understand the User Interface

The Photoshop Elements interface is designed like a well-organized workbench, making it easy to find and use menus, panels, and tools.

The Home screen

When you first start Photoshop Elements, the Home screen automatically appears. Click Organizer to open the Adobe Elements Organizer application, or click Photo Editor to open the Adobe Photoshop Elements Editor application (**FIGURE 2.1**). (You can bypass the Home screen by opening either of those apps by themselves.)

The Organizer and the Editor

Photoshop Elements is made up of two separate components: the Organizer and the Editor, which can be (and often are) open simultaneously. The conventions in this chapter primarily apply to the Editor; the Organizer's unique interface items are covered in Chapter 3.

Menus, panels, and tools

The **menu bar** offers menus for performing common tasks, editing images, and organizing your work area. Each menu is organized by topic (**FIGURE 2.2**).

The **Tool Options bar**, running below the image area and above the taskbar when it's visible, provides unique settings and options for each tool in the toolbox. For instance, when you're using the Marquee selection tool, you can choose to add to or subtract from the current selection (**FIGURE 2.3**).

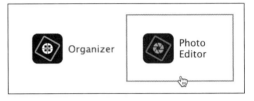

FIGURE 2.1 Launch components from the Welcome screen.

FIGURE 2.2 The menu bar offers myriad menus with commands you choose to help perform tasks.

FIGURE 2.3 The Tool Options bar changes its display depending on the tool you select in the toolbox.

The Editor and the Mac App Store

If you purchase the Photoshop Elements Editor application from Apple's Mac App Store, the Organizer is not included in the download. Adobe has made only the Editor available. If you want to use the Organizer, you'll need to buy Photoshop Elements as a disc or as a download from Adobe.

FIGURE 2.4 The Photo Bin is a holding area where you can access all of your open images.

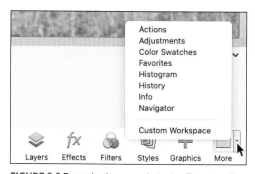

FIGURE 2.5 The Panel Bin holds controls for the Quick (shown here) and Guided edit modes, and items such as layers and effects in the Expert mode.

FIGURE 2.6 Reveal other panels in the Expert edit mode by clicking the menu portion on the More button.

The **Photo Bin**, which occupies the same space as the Tool Options bar when visible, serves as a convenient holding area for all of your open images (**FIGURE 2.4**). In addition to providing a visual reference for any open image files, the Photo Bin allows you to perform several basic editing functions. Click to select any photo thumbnail, and right-click to display a context menu. From the thumbnail menu you can get file information, minimize or close the file, duplicate it, and rotate it in 90-degree increments.

The **Panel Bin** groups common tasks and controls into the right edge of the window (**FIGURE 2.5**). To temporarily hide this area and make more room for working, choose Window > Panel Bin.

When you're in the Expert mode, the Panel Bin contains the Layers, Effects, Filters, Styles, and Graphics panels. The More button reveals a host of other panels that float outside the Panel Bin (**FIGURE 2.6**).

TIP The Panel Bin's default arrangement is known as the Basic workspace, but you can customize it. From the More menu, choose Custom Workspace. Instead of buttons, the main panels are arranged as tabs, which you can manipulate in several ways.

▶ **VIDEO 2.1**
Work with Panels

Open and Close Files

You can open a photo for editing via several methods, depending on whether you're working in the Organizer or the Editor. (To import images into the Organizer's photo library, see Chapter 3.)

To edit a file from the Organizer:

- Select a thumbnail and choose Edit > Edit With Photoshop Elements Editor; the image opens in the Editor. You can also right-click an image and choose the same item from the context menu, or press Ctrl+I/Command+I.

- With an image's thumbnail selected, click the Editor button in the taskbar at the bottom of the screen.

To open a file in the Editor:

1. To find and open a file, choose File > Open, click the Open button above the toolbox, or press Ctrl+O/Command+O. The Open dialog appears (**FIGURE 2.7**).

2. Browse to the folder that contains your images.

3. To open the file you want, do one of the following:

 ▸ Double-click the file.

 ▸ Select the file and click the Open button.

 The image opens in its own document window.

To close a file in the Editor:

- Click the Close button on the title bar for the active window.

- Choose File > Close, or press Ctrl+W/Command+W.

Windows

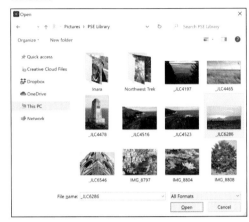

macOS

FIGURE 2.7 The Open dialog displays all files that match formats Photoshop Elements understands.

TIP If several files are open, you can close them all at once by choosing Close All from the File menu or by pressing Ctrl+Alt+W/Command+Option+W.

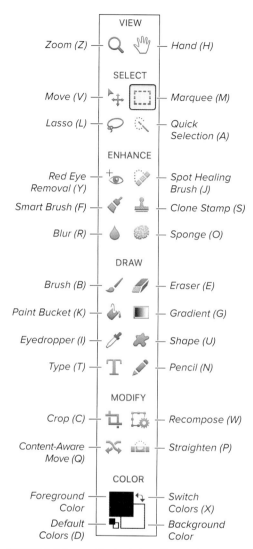

VIEW
Zoom (Z) — Hand (H)

SELECT
Move (V) — Marquee (M)
Lasso (L) — Quick Selection (A)

ENHANCE
Red Eye Removal (Y) — Spot Healing Brush (J)
Smart Brush (F) — Clone Stamp (S)
Blur (R) — Sponge (O)

DRAW
Brush (B) — Eraser (E)
Paint Bucket (K) — Gradient (G)
Eyedropper (I) — Shape (U)
Type (T) — Pencil (N)

MODIFY
Crop (C) — Recompose (W)
Content-Aware Move (Q) — Straighten (P)

COLOR
Foreground Color — Switch Colors (X)
Default Colors (D) — Background Color

FIGURE 2.8 Access the tools to edit your images.

Other tools available

Lasso
New
Anti-aliasing
Feather: 0 px
Refine Edge...

FIGURE 2.9 When you see a triangle in the corner of a tool's icon as you move the pointer over it, other related tools are available in the Tool Options bar.

Select Tools

The **toolbox** in the Expert mode contains all the tools you need for editing and creating your images; an abbreviated version appears in the Quick mode. You can use the tools to make selections, paint, draw, and perform sophisticated photo retouching operations. To view information about a tool, rest the pointer over it until a tool tip appears showing the name and keyboard shortcut (if any) for that tool.

To use a tool, first select it from the toolbox (**FIGURE 2.8**). Some tools hide additional tools, as indicated by a small triangle that displays in the corner of the tol icon when you hover the pointer over it.

To select a hidden tool:

- Hold Alt/Option and click any tool that displays a small triangle in the corner of the tool icon. The next tool is enabled.

- With a tool selected, go to the Tool Options bar and click an alternate (**FIGURE 2.9**).

TIP For easier access to tools, just use keyboard shortcuts. You'll find them in tool tips and in the online help. For example, press T to activate the Type tool. (Note that when you press a letter to select a tool with a hidden tool group, the Editor selects the tool from the group that was used most recently.)

TIP To cycle through hidden tools, repeatedly press the tool's shortcut key.

Use the Zoom Tool

You'll never want to view your images at just one magnification level. Editing out dust, for example, requires a close-up view. The Zoom tool magnifies and reduces your view.

You can see the current level of magnification in the lower-left corner of the document window, and, when the Zoom tool is selected, in the Tool Options bar. Adjust the magnification either with the Zoom slider or by entering a value in the Zoom field (**FIGURE 2.10**).

To zoom in:

1. In the toolbox, select the Zoom tool, or press Z on the keyboard. The pointer changes to a magnifying glass when it's in the document window.

2. Be sure that a plus sign appears in the center of the magnifying glass (**FIGURE 2.11**). If you see a minus sign (–), click the Zoom In button in the Tool Options bar (**FIGURE 2.12**).

3. Click the area of the image you want to magnify.

 With a starting magnification of 100 percent, each click with the Zoom In tool increases the magnification in 100 percent increments up to 800 percent. From there, the magnification levels jump to 1200 percent, then 1600 percent, and finally to 3200 percent!

TIP If you turned on the **Allow Floating Documents In Expert Mode** setting in the Elements preferences, you can automatically resize the document window to fit the image when zooming in or out (see "Arrange Windows," later in the chapter). With the Zoom tool selected, select **Resize Windows To Fit** in the Tool Options bar. To maintain a constant window size, deselect the option.

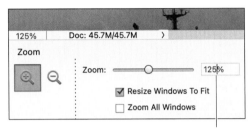

Zoom text field

FIGURE 2.10 With the Zoom tool selected, adjust the magnification level using the Tool Options bar.

Magnifying glass pointer

FIGURE 2.11 Click the area you want to zoom in on.

Zoom In button

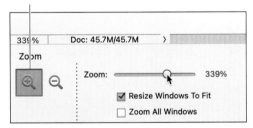

FIGURE 2.12 To zoom in on an image, check that the Zoom In button is selected in the Tool Options bar.

FIGURE 2.13 Drag with the Zoom tool to zoom in on a specific area of an image.

FIGURE 2.14 After zooming in, the work area is filled with the portion you defined when dragging.

To zoom out:

1. In the toolbox, select the Zoom tool, or press the Z key.

2. Click the Zoom Out button in the Tool Options bar, and then click in the area of the image that you want to zoom out from.

 With a starting magnification of 100 percent, each click with the Zoom Out tool reduces the magnification as follows: 66.7 percent, 50 percent, 33.3 percent, 25 percent, 16.7 percent, and so on, down to 1 percent.

To zoom in on a specific area:

1. In the toolbox, select the Zoom tool; if necessary, click the Zoom In button in the Tool Options bar to display the Zoom tool with a plus sign.

2. Drag over the area of the image that you want to zoom in on.

 A selection marquee appears around the selected area (**FIGURE 2.13**). When you stop dragging, the selected area is magnified and centered in the document window (**FIGURE 2.14**).

3. To move the view to a different area of the image, hold the spacebar until the hand pointer appears. Then drag to reveal the area you want to see. For more information on navigating through the document window, see "Move Around in an Image" two pages ahead.

TIP You can also change the magnification level by entering a percentage in the Zoom field in the lower-left corner of the document window. Double-click the field to select the zoom value, and then type in the new value.

To display an image at 100 percent:

To display an image at 100 percent (also referred to as displaying actual pixels, or 1:1 magnification), do one of the following:

- From the toolbox, double-click the Zoom tool.

- From the toolbox, select either the Zoom or Hand tool, and then click the 1:1 button in the Tool Options bar (**FIGURE 2.15**).

- From the View menu, choose Actual Pixels, or press Ctrl+1/Command+1. I use this method more than any other zoom technique.

- Enter **100** in the Zoom field in the Tool Options bar, and then press Enter/Return.

- Enter **100** in the status bar at the bottom of the document window, and then press Enter (**FIGURE 2.16**).

TIP A quick way to change the magnification is to press Ctrl/Command along with the plus sign (zoom in) or the minus sign (zoom out).

TIP Toggle the Zoom tool between zoom in and zoom out by holding down the Alt/Option key before you click.

TIP You can automatically resize the document window to fit the image (as much as possible) when zooming in or out. With the Zoom tool selected, in the Tool Options bar select Resize Windows To Fit. To maintain a constant window size, deselect the option.

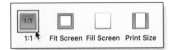

FIGURE 2.15 Clicking the 1:1 button in the Tool Options bar sets the image view to 100 percent.

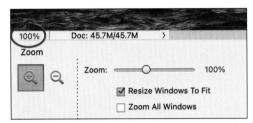

FIGURE 2.16 Entering 100 in the status bar also changes the image view to 100 percent.

Drag with the Hand tool...

...to move the image.

FIGURE 2.17 To view a different area of the same image, drag with the Hand tool.

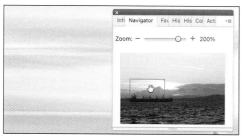

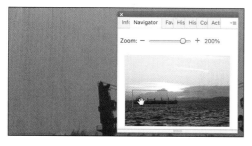

FIGURE 2.18 You can also use the Navigator panel to view a different area of the same image.

Move Around in an Image

When working in the Editor, you'll often want to move your image to make a different area visible in the document window. This can happen when you're zoomed in on one part of an image or when an image is just too large to be completely visible within the document window.

To view a different area of an image:

- From the toolbox, select the Hand tool and drag to move the image around in the document window (**FIGURE 2.17**).

- Use the scroll arrows at the bottom and right side of the document window to scroll to the left or right and up or down. You can also drag the scroll bars to adjust the view.

To change the view using the Navigator panel:

1. Choose Window > Navigator to open the Navigator panel.

2. Drag the view box in the image thumbnail (**FIGURE 2.18**).

 The view in the document window changes accordingly.

TIP With any other tool selected in the toolbox, press the spacebar to give you temporary access to the Hand tool.

TIP Drag the slider in the Navigator panel to adjust the magnification level in the document window.

Arrange Windows

The Editor takes a different approach to arranging open file windows than many applications. Instead of windows floating on top of each other, they occupy the entire work area, with tabs that indicate open files (**FIGURE 2.19**).

If you prefer overlapping windows, a preference enables them to float like traditional windows in Expert mode.

To arrange multiple windows:

1. Click the Layout button in the taskbar.
2. From the menu that appears, click a preset layout icon (**FIGURE 2.20**).

To enable floating windows:

In Windows, choose Edit > Preferences > General and select Allow Floating Documents In Expert Mode. In macOS, access the Preferences menu from the Adobe Photoshop Elements 2022 Editor menu.

With that preference active, you can drag a window by its title bar to make it appear as a free-floating window.

The options in the next section assume you've enabled floating windows; otherwise, many of the options described are not available.

Document tab

FIGURE 2.19 Open documents occupy the main workspace and are visible only one at a time. Click a tab to bring a document to the front.

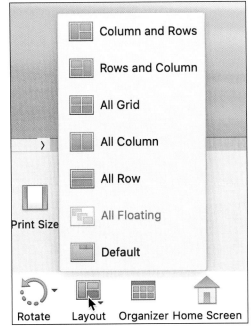

FIGURE 2.20 Click the Layout button to set how multiple files appear in the Editor.

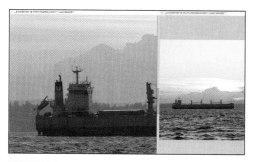

FIGURE 2.21 Multiple image views let you work on a detailed area (left) while at the same time allowing you to see how the changes affect the overall image (right).

Arrange Multiple Views

You can open multiple windows with different images, or, if you prefer, you can open multiple views of the same image. This is a handy way to work on a detailed area of your image while viewing the full-size version of the image at the same time. It's especially useful when you're doing touch-up work, such as correcting red eye or erasing a blemish in a photo.

To open multiple views of an image:

Choose View > New Window For *[filename]*. The window appears as a new tab or, if you enabled the Allow Floating Documents In Expert Mode preference, as a new floating window. You can also look in the Photo Bin to see the new view.

To arrange multiple views:

- To create cascading, overlapping windows, choose Window > Images > Float All In Windows.

- If the windows are floating, position them by dragging their title bars, or use the commands under Window > Images to tile or cascade them (**FIGURE 2.21**).

To close multiple view windows:

- To close a single window, click the Close button on that window's title bar.

- To close all document windows, Choose File > Close All or press Ctrl+Alt+W/Command+Option+W.

▶ **VIDEO 2.2**
Arrange Multiple Views

TIP To quickly switch from one open window to another, press Ctrl+~/Command+~ (tilde).

TIP You can set different levels of magnification for each window to see both details and the big picture at the same time.

TIP When you're working on a zoomed-in image, it's easy to get lost. Choose Window > Images > Match Zoom to set all open windows to the same zoom level. Or, choose Match Location to make the same visible pixels appear in all windows. That's a quicker option than scrolling around looking for a match or using the Navigator panel.

Use Rulers

Customizable rulers along the top and left sides of the document window can help you scale and position graphics and selections. The rulers are helpful if you are combining photos with text (in a greeting card, for example) and want to be precise in placing and aligning the various elements. Interactive tick marks in both rulers provide constant feedback, displaying the position of any tool or pointer as you move it through the window. You can change the ruler origin, also known as the *zero point*, to measure different parts of your image.

FIGURE 2.22 Drag the zero point to a new location anywhere in the document window.

To show or hide the rulers:

From the View menu, choose Rulers to turn the rulers on and off, or press Ctrl+Shift+R/Command+Shift+R.

To change the zero point:

1. Place the pointer over the zero point crosshairs in the upper-left corner of the document window (**FIGURE 2.22**).

2. Drag the zero point to a new position in the document window.

 As you drag, a set of crosshairs appears, indicating the new position of the zero point (**FIGURE 2.23**).

3. Release the drag to set the new zero point.

FIGURE 2.23 The new rulers' adjusted zero point establishes the new origin of the rulers.

To change the units of measure:

Right-click either ruler. A context menu appears, from which you can choose a new measurement unit.

TIP To reset the zero point to its original location, double-click the crosshairs in the upper-left corner of the document window.

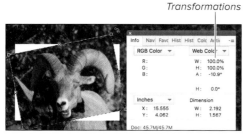

Color information

FIGURE 2.24 Any two sets of color information (RGB, HSB, Web Color, or Grayscale) can be viewed at once in the Info panel.

FIGURE 2.25 You can change color modes (and other settings) from menus in the Info panel.

X and Y coordinates

FIGURE 2.26 The X and Y coordinates of the pointer are shown in the Info panel.

Transformations

FIGURE 2.27 Any change in the scale or transformation of a selection or layer is visible in the Info panel.

Get Information About an Image

The Info panel displays measurement and color information as you move a tool over an image. In addition, you can customize the status bar at the bottom of the Info panel to display different file and image information.

To use the Info panel:

1. Choose Window > Info to open the Info panel.

2. Select a tool and then move the pointer over the image. Depending on the tool you are using, the following information appears:

 ▸ The numeric values for the color beneath the pointer. You can view any two color modes at the same time (**FIGURE 2.24**). Choose which modes to display from the menus above the color values (**FIGURE 2.25**).

 ▸ The X and Y coordinates of the pointer, and the starting X and Y coordinates of a selection or layer (**FIGURE 2.26**).

 ▸ The width and height of a selection or shape and the values relating to transformations, such as the percentage of scale, angle of rotation, and skew (which distorts a selection along the horizontal or vertical axis) (**FIGURE 2.27**).

TIP It's usually quicker to change units of measure using the Info panel or the rulers rather than by going into the Editor preferences.

Use the History Panel

The History panel lets you move backward and forward through a work session, allowing you to make multiple undos to any editing changes you've made to your image. The Editor records every change and then lists each as a separate entry, or *state*, on the panel. With one click, you can navigate to any state and then choose to work forward from there, return to the previous state, or select a different state from which to work forward.

To navigate through the History panel:

1. Choose Window > History to open the History panel.

2. To move to a different state in the History panel, click the name of any state (**FIGURE 2.28**).

TIP The default number of states that the History panel saves is 50. After 50, the first state is cleared from the list, and the panel continues to list only the 50 most recent states. The good news is you can bump the number of saved states up to 1000, provided that your computer has enough memory. In the Editor's preferences, select Performance. In the History & Cache section enter a larger number in the History States field.

TIP The History panel doesn't track every micro adjustment you make. For instance, if you add a Hue/Saturation adjustment layer and make several changes (such as increasing the saturation on multiple channels), the History panel records only that you added the adjustment layer. Switching to the previous state removes the entire adjustment layer instead of stepping through the settings you made to it.

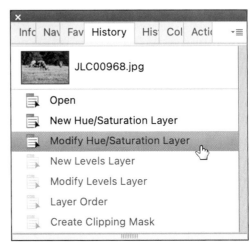

FIGURE 2.28 Move to virtually any point in time in the creation of your project using the History panel.

FIGURE 2.29 Delete any state by selecting it and choosing Delete from the panel menu.

FIGURE 2.30 If system memory is a concern, you can periodically clear the panel of all states.

To delete a state:

Click the name of any state, then choose Delete from the panel menu (**FIGURE 2.29**).

The selected state *and all states following it* are deleted. This action cannot be undone.

To clear the History panel:

From the panel menu, choose Clear History (**FIGURE 2.30**). You can also right-click a state and choose Clear History. This action can't be undone.

TIP Sometimes—when you're working on an especially complex piece, for instance—the History panel may become filled with states that you no longer need to manage or return to, or that begin to take their toll on your system's memory. At any time, you can clear the panel's list of states without changing the image by clearing the history.

Use Multitouch Gestures

If your device accepts touch input—such as a laptop's trackpad or a touch-sensitive screen—Photoshop Elements supports multitouch gestures that let you work in a more hands-on manner.

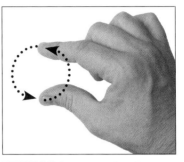

FIGURE 2.31 Rotate your hand to turn an image 90 degrees.

To rotate an image:

1. Place two fingers on the multitouch surface.

2. Turn your fingers clockwise or counter-clockwise, like you're turning a physical knob, to rotate the image 90 degrees in that direction (**FIGURE 2.31**).

To zoom:

1. Place two fingers on the surface.

2. Drag outward to enlarge the image (zoom in), or pinch inward to reduce the image (zoom out) (**FIGURE 2.32**).

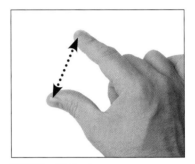

FIGURE 2.32 Pinch out to zoom.

To scroll in an image:

1. Place two fingers on the surface.

2. Drag in the direction you want to move the visible portion of the image (**FIGURE 2.33**).

TIP Adobe calls the scrolling gesture a *flick*, because the image continues to move after you've lifted your fingers, depending on how you made the gesture. The movement approximates physics and quickly comes to a smooth stop.

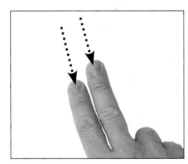

FIGURE 2.33 Drag two fingers to scroll.

Managing Photos in the Organizer

Digital photography can be a double-edged sword. Ironically, its greatest advantage to the amateur photographer—the ability to quickly and easily capture a large number of images, and then instantly download them to a computer—can also be its greatest source of frustration. Once hundreds of images have been downloaded, photographers find themselves faced with the daunting task of sorting through myriad files, with incomprehensible filenames, to find those dozen or so "keepers" to assemble into an album or post online for friends.

The Organizer workspace comes to the rescue with a set of tools and functions to help you locate, identify, and organize your photos.

Because we need some source material to work with, this chapter jumps right into importing photos from a digital camera and opening images already on your hard disk.

Import Images

Often, digital cameras come with their own software to help you browse and manage photos—but don't bother. Access your camera from within Photoshop Elements and then import your images from the camera, or copy photos first to your hard drive and then open them in the Organizer.

To import images from a digital camera (Standard dialog):

1. Connect your digital camera to your computer using the instructions provided by the camera manufacturer, or connect a card reader containing the camera's memory card.

 If the Photo Downloader launches automatically, skip to step 3. If you don't see the Photo Downloader, continue to step 2.

2. If you're in the Home screen or in the Editor, click the Organizer button to launch the Organizer.

 If you're in the Organizer already, click Import and choose From Camera Or Card Reader **(FIGURE 3.1)**. You can also choose File > Get Photos And Videos, or press Ctrl+G/Command+G.

 The Photo Downloader dialog opens in its Standard mode **(FIGURE 3.2)**. For more importing options, see "To import images from a digital camera (Advanced dialog)," just ahead in this chapter.

3. Your camera or card will likely be selected in the Get Photos From menu, but if not, choose it.

 Listed below the menu are the number of pictures, and their combined size.

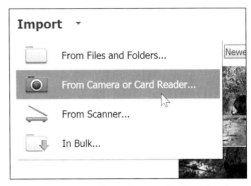

FIGURE 3.1 Choose From Camera Or Card Reader to download photos from your digital camera.

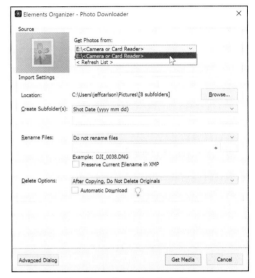

FIGURE 3.2 The Photo Downloader's Standard dialog makes it easy to import all photos in one fell swoop.

FIGURE 3.3 To make it easier to find images on disk later, specify a custom name for subfolders.

FIGURE 3.4 Choose a date format for naming subfolders with the images' capture dates.

Where the Image Files Exist

To keep track of the images in your library, the Organizer creates a *catalog*, typically located in the Pictures folder on your computer. When you import photos into your library, the image files are saved in the same location as the catalog. See "Work with Catalogs," later in this chapter, for more information.

4. By default, the Photo Downloader saves images to your Pictures folder; hold your pointer over the path listed next to Location to view the full destination if it's truncated.

 If you want to save the files to a different location, click the Browse (Windows)/Choose (macOS) button and select a folder or create a new one. Then click OK.

5. By default, the Photo Downloader creates new subfolders to store each batch of imported images, named according to the shot dates. From the Create Subfolder(s) menu, you can customize this behavior by choosing one of the following options:

 ▸ **None** saves the files in the folder specified by Location, normally your My Pictures folder.

 ▸ **Custom Name** creates a folder with a name that you enter **(FIGURE 3.3)**.

 ▸ **Today's Date** automatically creates a folder named with the current date.

 ▸ **Shot Date** creates folders with the date the images were captured; choose your preferred date format from one of the options **(FIGURE 3.4)**.

6. Choose an option from the Rename Files menu to automatically name the imported files something more descriptive than what your camera assigns.

 For example, your camera's default naming scheme is probably something like IMG_1031.JPG. With a Rename Files option selected, you can name and number a set of photos "Vacation," for instance. Then your photos will be saved and named Vacation001.jpg, Vacation002.jpg, and so on.

 continues on next page

7. In the Delete Options area, choose what happens to the files on the memory card. Just to be safe, I recommend leaving the option set to After Copying, Do Not Delete Originals, and then erase the card in-camera later.

In the Windows version of the Organizer, the Automatic Download option is useful if you want to offload pictures onto the computer without going through the Photo Downloader. Images download automatically when a camera or other device is attached. You can turn it off later in the Organizer's preferences.

8. Click Get Media to download the selected images to your computer.

Your photos first appear in their own Organizer window. Click the Back button (which sometimes reads All Media, depending on context) to return to the main Organizer window **(FIGURE 3.5)**.

To import images from a digital camera (Advanced dialog):

1. Follow steps 1 through 8 in the previous sequence, but in step 2 click the Advanced Dialog button to view the Advanced options **(FIGURE 3.6)**.

2. Click to deselect the box under any photos you do not want to import. By default, the Organizer assumes you want to download every image.

3. In the Advanced Options area, choose to enable or disable the following **(FIGURE 3.7)**:

▸ **Automatically Fix Red Eyes** attempts to find and correct red eye problems in your photos as they're downloaded.

▸ **Automatically Suggest Photo Stacks** groups similar photos together for easy organization and review later

To view your entire photo library, click the Back button.

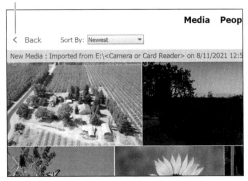

FIGURE 3.5 Photos downloaded from the camera or memory card appear in the Organizer.

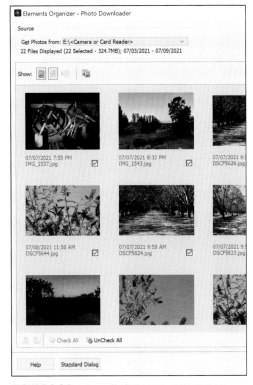

FIGURE 3.6 Preview all photos on your camera before importing them in the Advanced dialog (the left side of the window is shown here).

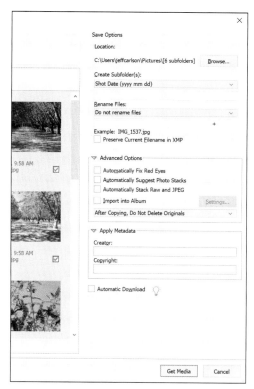

FIGURE 3.7 Further customize the importing process in the Advanced dialog (right side of window here).

Rotate buttons

FIGURE 3.8 Rotate images during import so you won't have to do it later.

(see "Use Stacks to Organize Similar Photos," later in this chapter).

▸ **Automatically Stack Raw And JPEG** pairs both image files captured when your camera is set to Raw+JPEG.

▸ **Import into Album** assigns the photos to a photo album you've previously set up (see "Use Albums to Arrange and Group Photos," later in this chapter).

4. Type your name (or the name of whoever took the photos) and a copyright notice in the Apply Metadata fields. This text is embedded in the image files (but not visible in the image itself).

5. To rotate an image as it's imported, select it and click the Rotate Left or Rotate Right button at the lower-left corner (**FIGURE 3.8**).

TIP For a fast way to select just a few photos for import, first click the UnCheck All button, and then click the photos you want—don't worry about clicking their individual boxes. Then, with the images selected, click just one box to enable the boxes of your selections.

TIP The Organizer can import photos stored in cameras' Raw formats, which are the unprocessed versions of the captured images. Raw enables more adjustment possibilities than JPEG (which is processed and compressed in the camera). When you edit the photo in the Editor, it first opens in the Camera Raw dialog to set initial edits before continuing in the Editor. For more information, see Chapter 9.

TIP The contents of the Creator and Copyright metadata fields are applied to all photos imported in that batch. If you want different authors, for example, either import them in several batches or edit the metadata after they've been added to the catalog.

To import images from files or folders:

1. In the Organizer, click Import and choose From Files And Folders.

 In Windows, if you insert media that contains photos, you may be asked what action you'd like to take (if you haven't specified it already). Click the icon labeled Organize And Edit Adobe Elements 2022 Organizer, which opens a dialog to locate files.

2. Select the files you want to import **(FIGURE 3.9)**; Shift-click to select a consecutive range of files, or Ctrl-click/Command-click to select nonconsecutive files.

3. If the images are stored on removable media and you want to import only low-resolution versions, disable the Copy Files On Import option and enable the Generate Previews option (see the sidebar for more information).

4. As in the Advanced dialog mentioned on the previous pages, select from the processing options below the preview.

5. Click the Get Media button to import the photos. If the photos already include keyword tags, you have the option to import them.

> **TIP** Now that we've gotten those import steps out of the way and you understand what's going on, here's a much quicker method: Simply drag image files from a folder on your hard disk to the Organizer's window. Elements imports them without fuss.

> **TIP** If you know some photos exist on your hard disk but can't find them, let the Organizer hunt for them instead. Click the Search button in the upper-right corner and enter criteria about them.

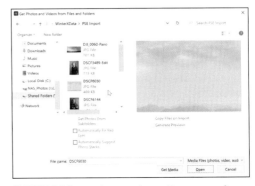

FIGURE 3.9 Import images from other areas of your hard disk or from removable media.

Working with Offline Images

With removable media, you have the option of importing just a low-resolution file to the hard disk. This feature can save hard disk space, especially if lots of files are stored on a shared network drive or on several CDs or DVDs. Importing them as offline images allows you to view and track your entire media catalog.

Offline images are designated with an icon in the upper-left corner of the image in the Organizer **(FIGURE 3.10)**. You can apply tags, build collections, and perform other tasks. However, if you want to edit the image, the Organizer asks you to connect the original media. If it's not available, you can still edit the low-resolution proxy, but the results won't look good. Once you make the original available again, Elements copies the source image to your catalog as an online image.

Offline icon

FIGURE 3.10 Offline images are denoted by a corner icon.

FIGURE 3.11 The Organizer can keep an eye on one or more folders and automatically import photos when they're added.

Remove or Stop Watched Folders

Watched folders can be helpful, but they're enabled by default. As a result, the Watch Folders dialog always interrupts what I'm doing. You can remove a folder from the list of watched items, or turn off the feature entirely.

To remove a folder, choose File > Watch Folders, select the item in the list, and click Remove.

To turn off the feature, deselect Watch Folders And Their Sub-Folders for New Files.

VIDEO 3.1
Work with HEIC/HEIF Images in Windows

To import images using Watch Folders:

1. You can specify one or more folders that the Organizer watches in the background for new files. Choose File > Watch Folders.

2. Click Add and navigate to the folder you wish to watch (**FIGURE 3.11**). Repeat for as many folders as you'd like.

3. Select an action under When New Files Are Found In Watched Folders; the Organizer can notify you when files are found or add them to the library automatically.

4. Click OK when you're done.

5. When you add photos to your watched folder, you're asked if you want to import them (if you opted to be notified in step 3). Click Yes to add the photos, which are moved from the watched folder to the directory where the Organizer stores your catalog.

To scan an image into the Organizer (Windows only):

1. Connect a scanner to your computer using the instructions provided by the scanner manufacturer.

2. In the Organizer, click the Import button and choose From Scanner. Or, you can choose File > Get Photos And Videos > From Scanner (or press Ctrl+U).

3. Choose your scanner software from the Scanner menu.

4. Select an image format and quality level.

5. Click OK. The Organizer hands off the actual scanning duties to the scanner's software for you to complete the scan.

6. When you complete the scan and exit the scanner's software, the image is imported into your catalog.

Understand the Organizer Work Area

The Organizer is dominated by the Media Browser, which is used to find and view thumbnail representations of your photos. It's flanked by two panels that you use to group and organize your image files (**FIGURE 3.12**); the panels can be hidden to make room for more photos.

The Media Browser

Every digital photo or video downloaded into the Organizer is automatically added to the Media Browser. Resizable thumbnails in the Media Browser window make it easy to scan through even a large number of images.

Media is usually organized by the dates the photos or videos were captured, but you can also view images grouped by the people in them, by places where they've occurred (using geotagging information embedded in the files or locations you've specified on a map), or by time-based events. I cover each mode in this chapter.

The Folders panel

The panel at left includes multiple ways to display an overview of your image collection. Clicking Albums shows the albums you've created (discussed later in this chapter), and clicking Folders reveals where the files are stored on disk (**FIGURE 3.13**). Click a folder name to view its contents.

You can also click the button at the top-right corner of the Folders panel to expose your disk's structure as a list or in a Tree view that reveals the folder hierarchy (**FIGURE 3.14**). In this view, for example, you can move images between disks (which ensures that the Organizer properly keeps track of them).

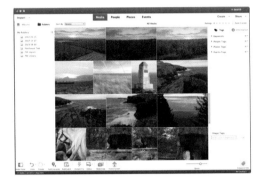

FIGURE 3.12 The Organizer workspace makes it easy to browse your entire photo collection.

FIGURE 3.13 The My Folders list reveals directories where your imported photos are located.

FIGURE 3.14 The Tree view shows folders in their hierarchies on disk.

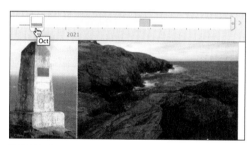

FIGURE 3.15 Move photos or folders using the Folder Hierarchy List.

FIGURE 3.16 Click a month marker in the timeline to view that month's photos on the Media Browser.

To move folders in the Tree view:

1. Choose View As Tree from the button at the top right of the Folders panel.

2. Drag a folder to a new location **(FIGURE 3.15)**.

 Or

 Select images in the Media Browser and drag them to a folder.

The folders and their files are moved in the Explorer (Windows) or Finder (macOS), not just in the Organizer.

The timeline

An optional, but helpful, way to quickly navigate your photos by date is the timeline, located just above the Media Browser. Choose View > Timeline or press Ctrl+L/Command+L. The timeline uses date and time information embedded in each image to construct bars (month markers) to represent sets of photos taken within specific months and years. When a month marker is selected in the timeline, that month's photos are displayed at the top of the Media Browser **(FIGURE 3.16)**.

Work in the Media Browser

Throughout this chapter I'll cover a variety of ways to work in the Media Browser to label, identify, and organize your photos. But first it's important to know how best to select, sort, and display the image thumbnails.

To select photo thumbnails:

Do one of the following:

- Click to select a thumbnail in the Media Browser. The frame around it becomes light blue and gains a checkmark, indicating the thumbnail is selected **(FIGURE 3.17)**.

- Ctrl-click/Command-click to select nonconsecutive thumbnails at once **(FIGURE 3.18)**.

- Shift-click to select a group of consecutive thumbnails **(FIGURE 3.19)**.

- Choose Edit > Select All, or press Ctrl+A/Command+A to select every thumbnail in the Media Browser.

To deselect photo thumbnails:

Do one of the following:

- Ctrl-click/Command-click to deselect a single thumbnail.

- Choose Edit > Deselect, or press Ctrl+Shift+A/Command+Shift+A to deselect every thumbnail in the Media Browser.

> **TIP** You can tweak the appearance of the Media Browser. Choose View > Details to reveal information such as grid lines, filenames, ratings, and timestamps **(FIGURE 3.20)**.

FIGURE 3.17 A selected thumbnail appears with a light blue frame around it and a box.

FIGURE 3.18 Ctrl-click/Command-click to select thumbnails that are not consecutive.

FIGURE 3.19 Shift-click to select thumbnails that are consecutive.

FIGURE 3.20 When you choose to view details, the Media Browser gives each photo more space and displays additional information.

FIGURE 3.21 Select an option to sort thumbnails in the Media Browser.

FIGURE 3.22 When you select the Import Batch option, the Media Browser displays thumbnails in grouped batch sets.

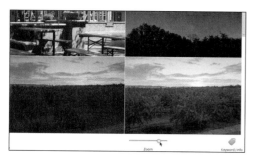

FIGURE 3.23 When you drag the Zoom slider to the right, the thumbnails grow larger (top). When you drag the slider to the left, they become smaller (bottom).

To sort photo thumbnails:

- From the Sort By menu above the Media Browser, choose a sorting option (**FIGURE 3.21**):

 ▸ **Newest** displays the most recent photos at the top, based on the images' creation dates.

 ▸ **Oldest** displays photos chronologically, with the oldest at the top.

 ▸ **Name** sorts images in ascending alphabetical order based on their filenames. To make the names visible, choose View > Details, and then choose View > File Names.

 ▸ **Import Batch** groups photos into the batches they were imported in (**FIGURE 3.22**).

To resize photo thumbnails:

- Below the Media Browser, drag the Zoom slider to the right to increase the size of the thumbnails, or to the left to make them smaller (**FIGURE 3.23**).

- Click the far left of the Zoom slider to display the thumbnails at their smallest possible size.

- Click the far right of the Zoom slider to display just one large photo thumbnail at a time (also known as Single Photo view).

TIP Double-click any thumbnail to change to Single Photo view. Double-click the image again to return to the Grid view.

VIDEO 3.2
Essential Organizer Techniques

Rate Photos

The number one method I use to organize my photos is rating them. By applying star ratings, I determine the shots that are worth keeping, the ones I want to edit later, and the ones I'm ready to share with others. Pairing ratings with other metadata, such as events for example, I can immediately view the best photos captured during a particular vacation or holiday.

To rate a photo:

- In the Media Browser, with View > Details enabled, click the gray stars that appear below a photo to set a rating from 1 to 5 **(FIGURE 3.24)**.

- Select one or more images and click the stars under one of the photos to apply the same rating to them all.

- Select one or more images and press a number key between 1 and 5 corresponding to the rating you want to apply.

TIP Star ratings are arbitrary—assign any value you like—but in general a 5-star rating indicates an excellent photo, while 1 star suggests one that is barely passable. The scale that I personally use works like this: A 1-star rating means the image is fine—often not exciting, but not out of focus or immediately worth deleting. A 2-star rating is for photos that show promise during my initial review; usually I'll revisit these photos during editing. A 3-star rating is for images that have been edited to my satisfaction. A 4-star or 5-star rating is reserved for photos that I think stand out above others.

TIP I know it's tempting to jump straight to editing, but I recommend taking a few minutes to do a quick rating pass on your photos after you've imported them. Doing so makes it easier to pick out which ones to work on first.

FIGURE 3.24 Apply a rating to identify your higher-quality photos.

Mark Photos as Hidden

If some photos seem to be cluttering up the Media Browser, use the Hidden attribute to keep them out of sight until you need them. Select a photo and choose Edit > Visibility > Mark As Hidden (or press Alt+F2/Option+F2) to make the image disappear from view.

To view hidden photos, choose Edit > Visibility and choose either Show All Files or Show Only Hidden Files. An eye icon with a strikethrough mark appears on the face of each hidden photo's thumbnail. Hide them again by choosing Edit > Visibility > Hide Hidden Files.

To make a hidden file permanently visible again, choose Edit > Visibility > Mark As Visible, which removes the attribute.

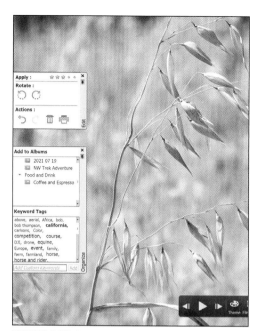

FIGURE 3.25 The full-screen review includes panels that automatically hide when you're not using them.

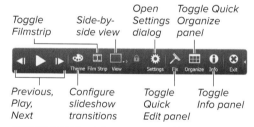

Toggle Filmstrip · Side-by-side view · Open Settings dialog · Toggle Quick Organize panel

Previous, Play, Next · Configure slideshow transitions · Toggle Quick Edit panel · Toggle Info panel

FIGURE 3.26 The full-screen control bar

Full-Screen Slideshows

The full-screen review feature is good even if you're not reviewing. Use it to play quick slideshows, including background music and transitions. Click the Play button in the control bar (or press the spacebar) to start; adjust the settings by clicking the Settings button, and choose a transition by clicking Theme.

Review Photos Full Screen

When you're looking over a set of photos, you want to see the photos, not everything else around them. The full-screen reviewing option lets you see just your images, with a minimal set of controls for ranking and sorting, and even for applying basic edits.

To review photos full screen:

1. Choose View > Full Screen, or press Ctrl+F11/Command+F11. If you have a photo selected, it fills the screen; if not, the first item in your library appears **(FIGURE 3.25)**.

2. Use the navigation controls at the bottom of the screen to switch between files, play a slideshow, or hide or show the Quick Organize and Quick Edit panels **(FIGURE 3.26)**.

3. Use the Quick Organize panel to apply keyword tags and create new tags: click tag names in the Keyword Tags field to apply them.

 You can also use the Quick Edit panel to make basic adjustments if you're in a hurry.

4. Press Esc or click the Exit button to leave full-screen mode when you're finished reviewing.

TIP Click the tiny pushpin icon on a panel to toggle between the panel remaining visible and automatically retracting to the edge of the screen.

TIP If you apply Quick Edit adjustments to a Raw image, you're asked to save the edited version in a different file format, such as JPEG.

Use Stacks to Organize Similar Photos

You've spent a day at Yosemite shooting picture after picture, and when you return home in the evening and download all of those photos to your Media Browser, you realize you have about a dozen shots of the same waterfall—some lit a little differently than others, some with different zoom settings, but all similar.

Stacks serve as a convenient way to group those related photos together. They not only save valuable space in the Media Browser, they also make assigning tags much faster, because tagging a stack automatically tags every photo in the stack. When you're ready to take a careful look at all of those waterfalls and weed out the greats from the not-so-greats, you simply expand the stack to view all of the stacked photos at once.

To create a stack:

1. In the Media Browser, select the photos you want to include in a stack **(FIGURE 3.27)**.

2. Choose Edit > Stack > Stack Selected Photos, or press Ctrl+Alt+S/ Command+Option+S.

 The photos are stacked together, indicated by a Stack icon in the upper-right corner of the top photo in the stack **(FIGURE 3.28)**.

To automatically suggest stacks:

1. Select a group of images.

2. Choose Edit > Stack > Automatically Suggest Photo Stacks.

3. Click Stack to combine a row of photos into a new photo stack **(FIGURE 3.29)**.

FIGURE 3.27 Select similar photos to organize them into a stack.

Stack icon

FIGURE 3.28 When stacked, the photos occupy just one thumbnail and gain the Stack icon.

Stacked

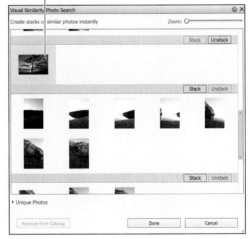

FIGURE 3.29 Let the Organizer automatically suggest stacks.

FIGURE 3.30 When Details is active, the stack's expansion arrow is visible.

FIGURE 3.31 An expanded stack reveals the photos that have been grouped together.

FIGURE 3.32 A warning reminds you that you are about to delete all but the top photo in your stack.

To view all photos in a stack:

1. Choose View > Details to show the photos with details visible, if they aren't already. A stack can only be expanded when Details is active.

2. Click the arrow icon at the right of the stack (**FIGURE 3.30**). Or, choose Edit > Stack > Expand Photos In Stack (press Ctrl+Alt+R/Command+Option+R). The photos in the stack appear (**FIGURE 3.31**).

To unstack photos in a stack:

Choose Edit > Stack > Unstack Photos.

The stacked photos return to their original locations in the Media Browser.

To flatten a stack:

1. If you're certain you don't want any photo in a stack except for the top one, you can "flatten" the stack and delete the others. Choose Edit > Stack > Flatten Stack.

2. In the dialog that appears, click OK to delete all of the photos except for the top photo in the stack (**FIGURE 3.32**).

 You can also choose to delete the associated image files from the disk.

TIP While you're viewing the expanded stack, you can also remove specific photos from a stack or designate a new photo to be the top photo (the photo that appears at the top of the stack in the Media Browser). Right-click any stacked photo and then, from the context menu, select an option from the Stack submenu, such as Set As Top Photo.

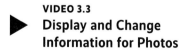

VIDEO 3.3
Display and Change Information for Photos

Create Keyword Tags

The humble little tag serves as the foundation for the Organizer's sorting and filing system. And yet, I get it: Most people don't take the time to tag their photos. You can locate photos using other means, but give tags a chance. They make it much easier to work with your library. (Technically, keyword tags are just one type of tag, but it's common to use "tag" or "keyword" to mean the same thing. I talk about the other types of tags later in this chapter.)

Click the Keyword/Info button at the right of the taskbar to reveal the panel, and then click the Tags tab. Expand the Keywords heading to reveal the keyword tags **(FIGURE 3.33)**.

Keyword tags are hierarchical and full-featured: They can exist in multiple sub-categories, be color coded, and include notes and thumbnail images. I'll go into all that, but first I want to highlight the simplest, most friction-free approach I usually take: the Add Custom Keywords field. You can also add keyword tags when importing images.

To create keyword tags using the Image Tags field:

1. Select one or more images.

2. Type a keyword in the Add Custom Keywords field. Better yet, type *several* keywords, separated by commas, to create and apply them together **(FIGURE 3.34)**. As you type, suggestions based on existing keywords appear; if you want to add one, click it immediately.

3. Press Enter/Return or click Add. The Organizer creates the new tags and applies them to the selected image(s). In the Keywords list, they appear under the Other category **(FIGURE 3.35)**.

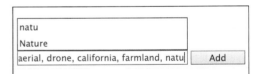

FIGURE 3.33 Keyword tags, along with other tags, appear in the Tags panel.

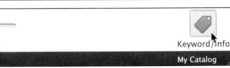

FIGURE 3.34 Type one or more words into the Add Custom Keywords field to create new tags.

FIGURE 3.35 New keywords you create show up in the Other category.

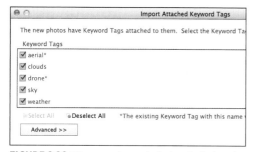

FIGURE 3.36 When you import photos that already contain keyword tags, you can opt to add them to the list in the Tags panel.

FIGURE 3.37 Click the New (+) button at the top of the Tags panel to create a new tag.

FIGURE 3.38 All tags reside in categories. Define a category for your new tag in the Create Keyword Tag dialog.

To import tags with images:

1. Using the steps outlined earlier, import photos from your hard disk that may already contain keywords (for example, if someone sent you the images or you used another program to assign tags).

2. In the Import Attached Keyword Tags dialog, select which tags you want to add to your list (**FIGURE 3.36**). Click OK. The tags can then be applied to any other photos in your library.

TIP Click Advanced to access more options such as renaming the tags before they're imported.

To create a new keyword tag (the long way):

1. Click the New (+) button in the upper-right corner of the Keywords section of the Tags panel (**FIGURE 3.37**) to open the Create Keyword Tag dialog.

2. From the Category menu, choose the category or sub-category in which you want to place your new tag (**FIGURE 3.38**). (I go into more depth about categories a few pages ahead.)

3. In the Name field, enter a name for your tag.

4. In the Note field, optionally enter information relevant to the photos that will have the tag applied.

5. Click OK to close the dialog.

 Your new tag appears in the Tags panel within the category you chose.

TIP The first photo to which you attach a new tag automatically becomes the icon for that tag. This is an easy and convenient way to assign tag icons, so I'll ignore the Edit Icon button for now.

To change a tag's properties:

1. In the Tags panel, select the name of the tag you want to edit (not its box; more on that shortly).

2. Do one of the following:
 - ► Click the menu attached to the New (+) button and choose Edit **(FIGURE 3.39)**.
 - ► In the Tags panel, right-click the tag whose properties you want to change and choose Edit from the menu.

3. In the Edit Keyword Tag dialog, make the desired changes and click OK.

To delete a tag:

1. In the Tags panel, right-click the tag you want to delete.

2. From the context menu, choose Delete **(FIGURE 3.40)**.

3. In the Confirm Keyword Tag Deletion dialog, click OK.

 The Organizer removes the tag from the Tags panel, from any photos tagged in the Media Browser, and from any saved searches that use it.

To merge tags:

1. Select tags with similar terms (or other criteria you want to simplify).

2. Right-click the tags and choose Merge Keyword Tags.

3. In the dialog that appears, select one tag to keep **(FIGURE 3.41)**; the others are deleted and the photos with the old keywords gain the selected tag.

FIGURE 3.39 Edit a tag's properties.

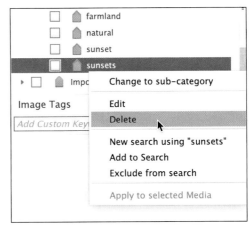

FIGURE 3.40 Delete a keyword tag you don't want.

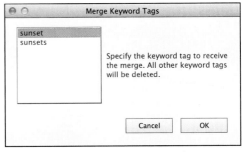

FIGURE 3.41 Merge tags to remove duplicate terms.

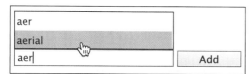

FIGURE 3.42 Existing tags appear as you type into the Image Keywords field.

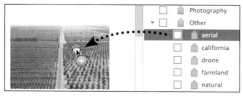

FIGURE 3.43 To attach a tag to a photo, drag it from the Tags panel to a thumbnail image in the Media Browser.

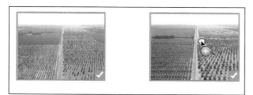

FIGURE 3.44 Select multiple photos, and then tag them all by dragging a tag icon over just one.

Keyword tag applied Tag icon set

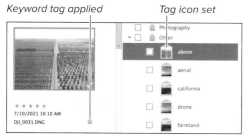

FIGURE 3.45 When you use a tag for the first time, the photo you attach it to is used for the tag's icon.

Use Keyword Tags to Sort and Identify Photos

Tags operate independent of where photos are located on your computer, which means you can attach a tag to photos in different folders—even on different disks—and then use that tag to quickly find and view those photos all at once.

To attach a tag to a single photo:

- Select a photo and type a term into the Add Custom Keywords field; if the tag already exists, choose it from the menu that appears **(FIGURE 3.42)**.

- Drag a tag from the Tags panel onto any photo in the Media Browser **(FIGURE 3.43)**.

A keyword tag icon appears below the photo to indicate that it has been tagged.

To attach a tag to multiple photos:

1. Select any number of photos.

2. From the Tags panel, drag a tag onto any one of the selected photos **(FIGURE 3.44)**. Or, type keywords into the Add Custom Keywords field.

 A category icon appears below all of the selected photos in the Browser window to indicate that they have been tagged.

> **TIP** You can also drag a photo to a tag in the Tags panel to attach it.

> **TIP** Hover the pointer over a photo's tag icon to view which tags are applied.

> **TIP** Tags normally appear with a generic blue icon, but they can also display a photo thumbnail for its tag icon **(FIGURE 3.45)**. With a tag selected, click the menu on the New (+) button, and choose Show Large Icon.

To view a set of tagged photos:

In the Tags panel, click the box to the left of the desired keyword. It will display a small binoculars icon when selected (**FIGURE 3.46**).

That performs a basic search on that keyword, displaying only photos with that tag (**FIGURE 3.47**).

To view all photos again, click the box to deselect it or click the All Media button.

To remove a tag from a photo:

Select a photo thumbnail in the Media Browser, and then do one of the following:

- Right-click a photo thumbnail; then, from the menu, choose Remove Keyword Tag > *[name of tag]*.

- Right-click the category icon below the photo thumbnail and choose Remove *[name of tag]* Keyword Tag from the menu (**FIGURE 3.48**).

TIP If you're viewing photos by import batch (choose **Import Batch** from the **Sort By** menu), click the batch's heading to select all of its photos, then apply tags to them all at once.

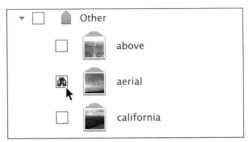

FIGURE 3.46 When the binoculars icon is visible next to a tag in the Tags panel, only that tag's photos appear in the Media Browser.

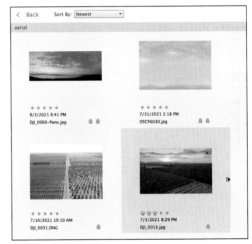

FIGURE 3.47 When a tag is selected in the Tags panel, only photos with that keyword appear.

FIGURE 3.48 Remove a tag from a photo by right-clicking the category icon below the thumbnail in the Media Browser.

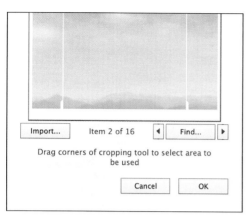

Import... Item 2 of 16 ◀ Find... ▶

Drag corners of cropping tool to select area to be used

Cancel OK

FIGURE 3.49 Use the arrow buttons to preview tagged images one at a time.

FIGURE 3.50 Select a new image for the icon.

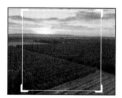

FIGURE 3.51 Resize the selection rectangle to choose the visible area of the icon.

FIGURE 3.52 Drag the selection rectangle to choose a different area of a photo to use.

To change a tag's icon:

1. In the Tags panel, right-click the tag you would like to change.

2. From the menu, choose Edit.

3. In the Edit Keyword Tag dialog, click the Edit Icon button.

4. Click the arrow buttons to select from any of the photos to which the tag has been applied **(FIGURE 3.49)**.

4. To select a different tagged photo, click the Find button.

5. In the Select Icon For *[name of tag]* Keyword Tag dialog, click to select a photo thumbnail and click OK **(FIGURE 3.50)**.

 The new image appears in the preview window of the Edit Keyword Tag Icon dialog.

6. To crop the area of the photo that will appear on the tag icon, drag any of the four cropping handles in the image preview **(FIGURE 3.51)**.

7. To select a different cropped area of the photo to appear on the tag icon, move the pointer inside the crop box and drag it in the preview window **(FIGURE 3.52)**.

8. When you're satisfied with the look of your icon, click OK to close the Edit Keyword Tag Icon dialog, and then click OK again to close the Edit Keyword Tag dialog. The new icon appears on the tag in the Tags panel.

TIP If you don't want to use any of your tagged photos for a particular keyword icon, click the Import button in the Edit Keyword Tag Icon dialog to browse your computer and select a different image.

Organize Tagged Photos Using Categories

All tags must reside in either a category or sub-category. The Organizer starts you off with a few ready-made categories, but you can create as many new categories and sub-categories as you want. Tags can be easily moved from one category to another or converted to sub-categories that contain their own sets of tags.

To create a new category:

1. Click the menu on the New (+) button at the top of the Tags panel (**FIGURE 3.53**).

2. Choose New Category to open the Create Category dialog.

3. In the Create Category dialog, enter a name in the Category Name field.

4. Optionally, in the Category Icon area of the dialog, click a category icon that appears when icons are visible (**FIGURE 3.54**).

5. Also optional, if you'd like to color-code your categories, click the Choose Color button to open the Color Picker. Colors are applied to sub-category and tag icons within the category.

6. Click to select the color and then click OK (**FIGURE 3.55**).

7. When you're satisfied with your other category settings, click OK to close the dialog. Your new category appears in the panel.

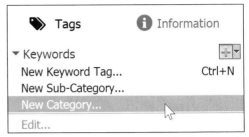

FIGURE 3.53 Use the New menu in the Tags panel to open the Create Category dialog.

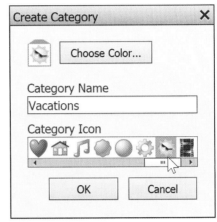

FIGURE 3.54 The Create Category dialog includes a variety of icons you can use to represent your new category.

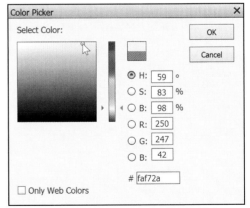

FIGURE 3.55 The color you choose in the Color Picker appears on the icons for tags in your new category.

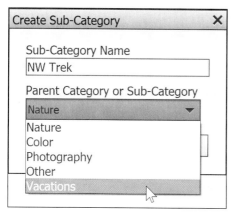

FIGURE 3.56 Sub-categories can be nested within categories or other sub-categories.

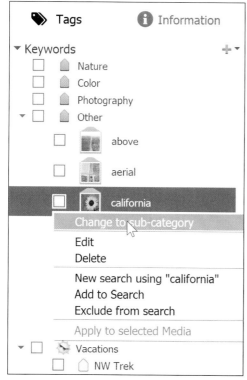

FIGURE 3.57 Convert a tag to a sub-category from the tag context menu in the Tags panel.

To create a new sub-category:

1. From the New (+) button's menu, choose New Sub-Category to open the Create Sub-Category dialog.

2. In the Create Sub-Category dialog, enter a name in the Sub-Category Name text field.

3. From the Parent Category or Sub-Category menu, choose a location in which to place your new sub-category **(FIGURE 3.56)**.

4. Click OK to close the dialog.

 Your new sub-category appears in the Tags panel, under the category or sub-category you selected.

To convert a tag to a sub-category:

1. In the Tags panel, right-click the tag you want to convert.

2. From the menu, choose Change To Sub-Category **(FIGURE 3.57)**. The tag icon changes to one for a sub-category.

TIP If you decide you'd like to convert a sub-category (that was formerly a tag) back to a tag, right-click the sub-category and choose Change Sub-Category To A Tag. All the tag's properties, including its icon, are retained.

To assign a tag to a new category or sub-category:

1. In the Tags panel, right-click the tag you want to assign and choose Edit.

2. From the Category menu in the Edit Keyword Tag dialog, choose the category or sub-category in which you want to place the tag (**FIGURE 3.58**).

3. Click OK to close the Edit Keyword Tag dialog. In the Tags panel, the tag appears within the category and sub-category you defined (**FIGURE 3.59**).

 If you've already applied the tag to a photo or photos in the Media Browser, the category icons below the photo thumbnails automatically update to display the icon of the new category.

TIP You can also move tags into new categories or sub-categories right in the Tags panel. With both the tag and the category or sub-category visible, drag a tag onto a category or sub-category icon. The tag will nest beneath the category or sub-category you choose. The disadvantage of this method (as compared to the one outlined in the steps above) is that you must be able to see the tag and category or sub-category in the Tags panel. Because the Tags panel can get filled with categories quickly, it may require that you do quite a bit of scrolling and searching, whereas the Category menu in the Edit Keyword Tag dialog gives you a list of every category and sub-category in one convenient place.

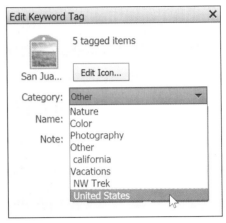

FIGURE 3.58 Easily move a tag from one category to another using the Edit Keyword Tag dialog.

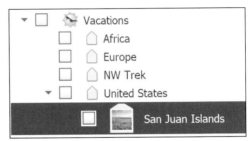

FIGURE 3.59 Changes you make to a tag's placement in the Edit Keyword Tag dialog appear instantly in the Tags panel.

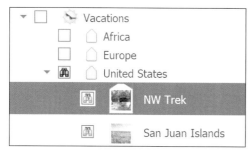

FIGURE 3.60 View all images tagged with keywords in a category or sub-category.

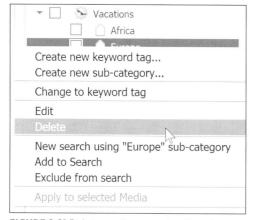

FIGURE 3.61 Delete a category or tag from the Tags panel.

To view photos belonging to a category or sub-category:

In the Tags panel, click the box to the left of the sub-category name. A small binoculars icon appears on the category, and a gray binoculars icon shows up on the affected tags (FIGURE 3.60). All photos with tags belonging to that category appear.

To view all photos again, click All Media or deselect the box.

To delete a category or sub-category:

In the Tags panel, click a category or sub-category, and then right-click and select Delete (FIGURE 3.61).

However, before you delete a category or sub-category, bear in mind that you will also delete all related sub-categories and tags and will remove those tags from all tagged photos. In some circumstances, a better alternative may be to change a category or sub-category's properties to better match the content or theme of related tagged photos.

TIP Deleting a category does not delete the photos that belong to the category.

Identify People

The Organizer automatically detects faces in your images, which enables tools to sort, identify, and tag photos based on the people in them. This can be done in individual shots, or in the People view, which can process many images at once and organizes photos of people into stacks.

Name and group people

At first, the software doesn't know who appears. With your help assigning names, it will be able to determine who those people are in other photos. Make sure View > People Recognition is selected.

To identify people in one photo:

1. Double-click a photo containing a person to view it full-size.

2. Hover the pointer over a face. If the Organizer displays an Add Name field, do one of the following:

 ▸ Type a name **(FIGURE 3.62)**. If it's a new person, a new People tag is created and applied to the photo. If the person already exists as a People tag, but their face wasn't identified, click the name that appears below the field as you type.

 ▸ The Organizer will start to make suggestions as the database of faces grows **(FIGURE 3.63)**. Click the checkmark button if the suggestion is correct; if it's not, click the X button and enter a different name.

 ▸ If the Organizer suggests an area that isn't a face, click the X button to dismiss it **(FIGURE 3.64)**.

3. If a person is in the picture but wasn't identified, click Mark Face in the taskbar, drag the box that appears to their face, and then enter their name.

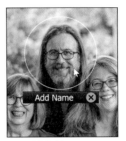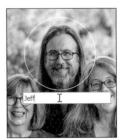

FIGURE 3.62 Click the Add Name field to identify the detected person.

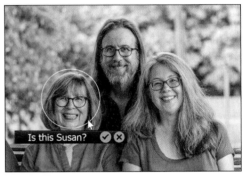

FIGURE 3.63 As the database of recognized faces builds, the Organizer attempts matches.

FIGURE 3.64 Well, no one ever said computers were perfect.

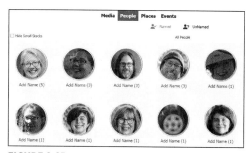

FIGURE 3.65 The Organizer finds faces but needs your help identifying them.

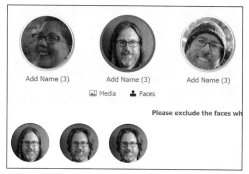

FIGURE 3.66 Make sure the images in the stack are all the same person.

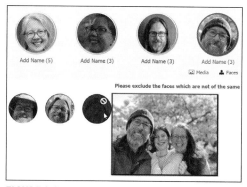

FIGURE 3.67 Pause over a thumbnail to view its full photo for context.

To identify people in multiple photos:

1. Click the People button at the top of the screen (**FIGURE 3.65**).

 The people are divided into two categories: Named, the folks you've already identified, and UnNamed. If you see only a few people appear in the UnNamed category, deselect the Hide Small Stacks option. Don't be surprised if people you've already identified show up here; you're training the database.

2. Click the icon of a person you want to identify. Thumbnails of the photos in which they appear show up below the icon (**FIGURE 3.66**).

3. If a thumbnail is of a different person, select it and click the Not This Person button at the bottom of the screen. Or, click the small white Not This Person button that appears when the pointer is over the thumbnail.

4. Click Add Name and type the person's name; if they're already known, choose the name from the suggestions that appear as you type. Then click the checkmark button.

 With the person identified, the photos in the stack are moved to the Named screen.

TIP Move the pointer over a person's icon to quickly preview the photos in the stack.

TIP By default, the thumbnails show only the person's face, but sometimes you need more context. Click the Media button under the person's icon to view thumbnails of the full photos. Better yet, hover the pointer over a thumbnail in its Faces mode to pop up a preview of the image (**FIGURE 3.67**).

TIP If the Organizer picks a person you don't know (such as a tourist in the background, or an item that isn't a person), right-click the icon and choose Don't Show Again.

To merge multiple people:

1. Select two or more icons that contain the same person.

2. Click the Merge People button. Type a name in the dialog that appears and click OK **(FIGURE 3.68)**.

3. If the person's name already exists, confirm that you want to continue in the next dialog.

To identify more photos containing named people:

1. In the Named view, select a person whose name includes an attention icon **(FIGURE 3.69)**. It indicates the Organizer has found new potential matches for that person.

2. Select the thumbnails under "Is this [*name*]?" that match the person and then click the Confirm button.

 Or, position the pointer over a thumbnail and click the white Confirm (checkmark) button that appears **(FIGURE 3.70)**.

 If the photo is not a match, click the Not This Person button (the white circle with a slash through it).

To assign people to groups:

1. In the People view, click the Groups button in the bottom-right corner of the window to reveal the Groups panel if it's not already visible.

2. Three suggested groups already exist, but if you want to create your own, click the New (+) button. In the Add Group dialog, enter a name for the group and click OK.

3. Drag one or more people to a group name **(FIGURE 3.71)**.

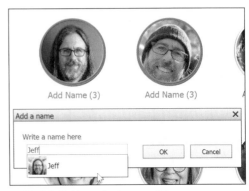

FIGURE 3.68 Merge instances of the same person if the Organizer doesn't recognize them.

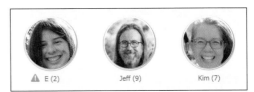

FIGURE 3.69 An attention icon indicates that more photos of that person have been found and are ready to be reviewed.

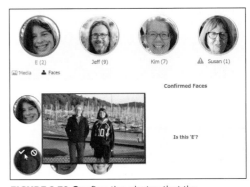

FIGURE 3.70 Confirm the photos that the Organizer thinks are matches to the person.

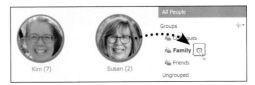

FIGURE 3.71 Drag people to include them in groups.

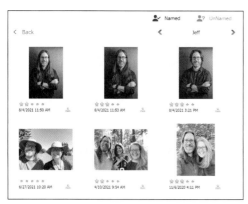

FIGURE 3.72 Double-click a person's icon to view all photos in the stack.

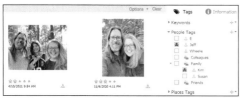

FIGURE 3.73 Only photos containing both Jeff and Kim appear when spotlighting those People tags.

FIGURE 3.74 Yes, I named a false identification "Wheelie" in order to demonstrate how to remove it from the People view. I couldn't help myself.

To view photos containing people:

- Double-click a person's stack to view the photos tagged with their name **(FIGURE 3.72)**.

- In the Media Browser, open the Tags panel, expand the People Tags section, and click the box next to a person or group.

- If you want to quickly view photos that contain two or more people together, click their respective boxes **(FIGURE 3.73)**.

To remove people:

You can remove names from the People database without deleting the photos themselves.

1. In the People view, select a person you want to remove.

2. Right-click the person's icon and choose one of the following from the context menu **(FIGURE 3.74)**:

 ▸ **Not This Person:** If the person is named, choosing this option moves the stack to the UnNamed panel.

 ▸ **Don't Show Again:** This option removes the person from the facial-recognition database (but, again, the photos remain in the library).

3. If you chose Don't Show Again, confirm that you want to remove the person by clicking Yes in the dialog that appears.

> **TIP** Is it time to show off photos of kids or friends? Select one or more names in the People view, click the Slideshow button, sit back, and enjoy.

> **TIP** The Organizer regularly scans your library in the background, so it's worth checking the Named view occasionally to see if there are new potential matches. Also check after you've imported a new batch of photos that contain people.

Use Albums to Arrange and Group Photos

Although photos have gone digital, we don't have to discard our analog thinking. Just as you can store Polaroids and prints in a photo album, you can collect your digital photos in albums in the Organizer.

An album can be composed of photos associated with several different tags or categories. Plus, the photos within albums can be sorted and reordered, independent of their date or folder structure.

To create a new album:

1. Click the Albums tab in the left panel.

2. Click the New (+) button at the top of the My Albums list.

3. From the New menu, choose New Album (**FIGURE 3.75**). The New Album panel appears along the right side of the Media Browser.

4. Leave the Category menu set to None (Top Level). You'll learn more about album categories later in this section.

5. In the Name field, enter a name for your album.

6. Drag the photos you want to add to the album to the media bin (**FIGURE 3.76**).

7. Click OK to close the panel. Your new album appears in the Albums panel at the left side of the Media Browser. By default, albums are sorted in alphabetical order.

To create an album from a folder:

1. Right-click a folder in the Folders panel.

2. Choose Create An Instant Album (**FIGURE 3.77**). The album is created with the name of the folder.

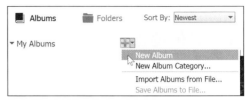

FIGURE 3.75 Use the New menu in the Albums list to open the Create Album dialog.

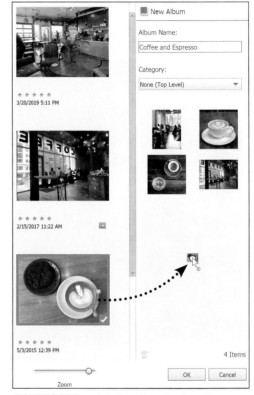

FIGURE 3.76 Populate the album by dragging photos to it.

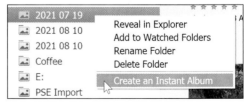

FIGURE 3.77 A quick way to create an album is to base it on an existing folder.

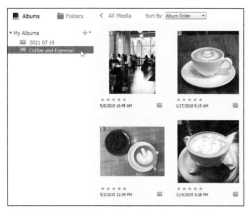

FIGURE 3.78 Select an album to view only the photos assigned to it.

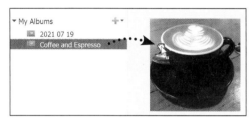

FIGURE 3.79 Another way to add photos to an album is to drag the album icon from the Albums list onto one or more photos.

To view a photo album:

Click an album name in the My Albums list. The Media Browser displays only the photos in that album **(FIGURE 3.78)**.

To view your entire catalog, click the All Media button.

To add more photos to an album:

Do one of the following:

- From the Media Browser, drag one or more photos onto an album in the Albums list.

- This seems counterintuitive, but from the Albums list, drag an album onto a photo thumbnail in the Media Browser **(FIGURE 3.79)**.

Or

1. In the Albums panel, right-click an album and choose Edit from the menu.

 The Edit Album panel opens.

2. Drag photos to the media bin area of the panel.

3. Click OK.

To rename an album:

1. In the Albums list, right-click an album and choose Rename from the context menu.

2. Enter a new name in the dialog that appears and click OK.

Or

1. In the Albums list, right-click an album and choose Edit from the context menu.

2. Change the text in the Album Name field and click OK.

To arrange photos within an album:

1. In the My Albums list, click an album name.

2. In the Media Browser, click to select a photo, and then drag it to a new location (**FIGURE 3.80**).

Or

1. In the My Albums list, right-click an album and choose Edit.

2. Drag to rearrange the photos in the Edit Album panel and click OK.

To remove photos from an album:

With an album displayed in the Media Browser, select a photo thumbnail and then do one of the following:

- Right-click the album icon below the thumbnail and select Remove From *[name of album]* Album (**FIGURE 3.81**).

- Right-click inside a photo thumbnail, and then choose Remove From Album > *[name of album]*.

Or

1. In the My Albums list, right-click an album and choose Edit.

2. In the Edit Album panel, select one or more photos and click the Remove button (the trash can icon) (**FIGURE 3.82**).

3. Click OK.

To create an album category:

1. Click the New (+) button at the top of the My Albums list and choose New Album Category.

2. Enter a name in the Album Category Name field. Leave the Parent Album Category option set to None (Top Level).

3. Click OK to close the dialog. The category appears at the bottom of the list.

FIGURE 3.80 To reorder photos within an album, drag a thumbnail to a new location in the Media Browser. The numbers on the thumbnails indicate their order.

FIGURE 3.81 Right-click a photo's album icon to remove it from the album.

FIGURE 3.82 Remove a photo from an album in the Edit Album panel.

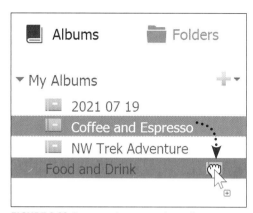

FIGURE 3.83 Once you've created an album category, you can add albums to it from the My Albums list.

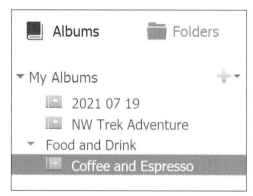

FIGURE 3.84 Expand the category name to see which albums belong to it.

To add an album to a category:

In the My Albums list, drag an album icon onto the name of the album category **(FIGURE 3.83)**.

Or

1. In the Albums list, right-click the album you want to include.

2. From the album context menu, choose Edit.

3. In the Edit Album panel, choose an existing category from the Category menu.

4. Click OK.

Click the triangle to the left of the category name to reveal its albums **(FIGURE 3.84)**.

To delete an album:

1. In the My Albums list, right-click the album you want to delete.

2. From the context menu, choose Delete.

3. In the Confirm Album Deletion dialog box, click OK. The album is removed from the Albums list, but the images within the album remain untouched.

> **TIP** It's possible to group one album category within another when creating a category. If you've already created an album category, its name appears in the Parent Album Category menu of the Create Album Category dialog. You then have the option of nesting your new album category within the existing one.

> **TIP** You can't drag an album out of an album category to take it back to the top level. Instead, click the Edit Album button, and then choose None (Top Level) from the Album Category menu.

Organize by Events

Photos often coincide with events—a birthday party, an afternoon cruise, or even just breakfast. Rather than scroll through all your thumbnails, you may find it easier to locate images based on events you create in the Events view or in the Media Browser.

To create a new event in the Events view:

1. Click Events to switch to the Events view.

2. Click the Suggested tab if it's not already active.

3. Drag the Number of Groups slider from Min to Max to view possible events **(FIGURE 3.85)**. The Organizer collects photos into tracks using their time-stamps, so the Max setting will show more possible events.

4. Click Add Event next to the track's dates.

5. In the Name Event dialog, type a name and click OK. The event shows up on the Named tab **(FIGURE 3.86)**.

To create a new event in the Media Browser:

1. Select the photos that you want to include in the new event.

2. Click the Add Event button in the taskbar.

3. In the Add New Event panel that appears, type a name in the Name field **(FIGURE 3.87)**. The selected photos are automatically added to the event.

4. If there are other photos from that event you want to add, drag them into the panel.

5. Click Done to create the event. It appears in the Events view and in the Events Tags section of the Tags panel.

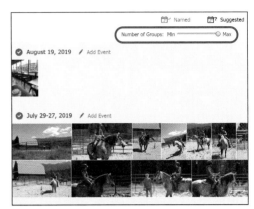

FIGURE 3.85 Use the Number of Groups slider to identify possible events.

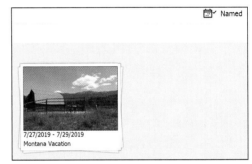

FIGURE 3.86 The new named event appears in the Events view on the Named tab.

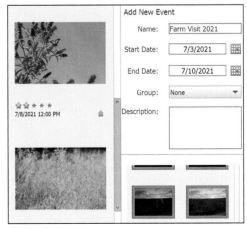

FIGURE 3.87 Create a new event in the Media Browser.

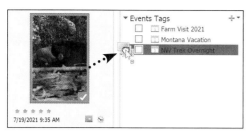

FIGURE 3.88 Drag images to the Events Tags panel to add them to an event.

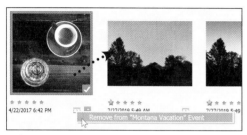

FIGURE 3.89 Remove photos from an event.

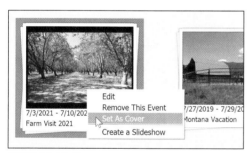

FIGURE 3.90 Choose which photo appears as the cover without even opening the event.

To view an event's photos:

- Double-click an event in the Events view.

- In the Events view, click the Calendar button in the taskbar (if the Calendar isn't visible) and then choose a year, month, and day. Double-click the corresponding event.

- In the Media Browser, select the box next to an event in the Events Tags section in the Tags panel.

To add photos to an existing event:

1. In the Media Browser, expand the Events Tags section of the Tags panel.

2. Select the photos you want to add to an event.

3. Drag the selected images to the event tag **(FIGURE 3.88)**.

To remove photos from an event:

- In the Media Browser, right-click the Event icon below the image and choose Remove From *[Name]* Event **(FIGURE 3.89)**.

To change an event's cover image:

1. Do one of the following:
 - ▸ Double-click a named event to view its photos.

 Or, better yet,
 - ▸ Move the pointer over the event to preview its contents.

2. When you find the photo you want to use as the thumbnail, right-click and choose Set As Cover **(FIGURE 3.90)**.

> **TIP** Clicking an album, folder, or ratings in the Events view narrows the visible matches to events that include only those criteria.

Locate Photos Using Places

Sometimes where you took a photo is as important as what's in the image. The Places feature lets you associate locations with your photos or pull geographic data from photos whose cameras embed it.

To view photos on a map:

1. Open the Places view. Photos that have been tagged with geolocation information appear as pins on the map in the right panel. Images with no location data are listed in the left panel grouped by time **(FIGURE 3.91)**. To view only geo-tagged photos, click the Pinned tab.

2. Use the map controls to zoom in, if needed, to view pins that are initially grouped together due to the map's scale. Drag the map to reposition it.

3. On the map, hover over a pin to reveal a thumbnail preview **(FIGURE 3.92)**. Use the arrows to switch between the photos. To view the images themselves, double-click the thumbnail or click the number at the bottom-right corner.

TIP If the location is not named, click Get Location Name in the pin's preview. The Organizer uses the location data to find a name, such as *Montana, United States*.

TIP The menu at the upper-left corner of the Map panel lets you display the map with different appearances, such as satellite imagery.

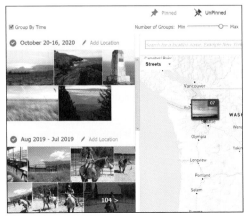

FIGURE 3.91 The Places view lets you plot photos anywhere on the globe.

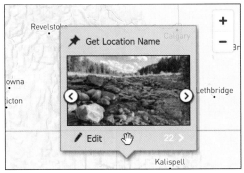

FIGURE 3.92 Preview the photos that were captured at a given location.

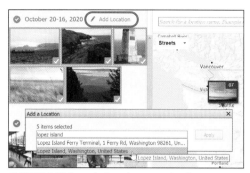

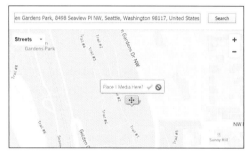

FIGURE 3.93 Search for a location the Organizer knows to apply it to the photos.

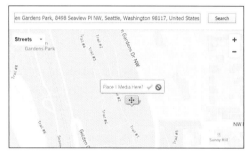

FIGURE 3.94 Confirm that the location is correct.

TIP Warning! It may be tempting to start by using the search field above the map to find a location, but you have to be careful. If you don't choose photos first, the Organizer assumes you want to assign *every unpinned image* in your catalog to that place! If you see a Place All Media Here? dialog, click the red Cancel button.

To place photos in the Places view:

1. Click the UnPinned heading, if it's not already active.

2. Use the Number of Groups slider to narrow the photos into collections based on their capture dates. (To view individual photos in the left panel, turn off the Group By Time option.)

3. Click Add Location next to the date for a group of photos to assign them a location.

4. In the Add a Location dialog, type the name of the location and press Enter/Return (or wait a few seconds) to see possible matches **(FIGURE 3.93)**.

5. Select a location and click Apply.

Or

1. In the left panel, select one or more photos; clicking the checkmark to the left of the date selects all images in that track.

2. In the right panel, enter the name of the location in the search field, choose the match that best fits, and click Search.

3. If the map zoomed to the correct location, click the green Confirm checkmark in the Place Media Here? badge that appears **(FIGURE 3.94)**. If it's incorrect, click the red Cancel button, or manually drag the yellow pin to the right spot.

Or

1. In the left panel, select one or more photos.

2. Drag the selected items to an area of the map to create a new pin.

 If the photos were taken at the same place as an existing pin, drag them onto that pin.

To place photos in the Media Browser:

1. Select one or more photos in the Media Browser.

2. Click the Add Location button in the taskbar. The Organizer opens the Add A Location dialog.

3. Type an address in the search field, and then press Enter/Return, or wait a few seconds.

4. Choose the best result from the list that appears and click Apply **(FIGURE 3.95)**.

The location is applied to the selected photos. To view them on the map, switch to the Places view and click the Pinned heading. You may need to zoom in to locate the pin you just created.

Locations also appear as Places tags in the Tags panel, listed hierarchically **(FIGURE 3.96)**.

To edit Place information:

1. In the Places view, click a pin.

2. Select the photo(s) you want to edit.

3. Click the Edit Location button in the taskbar.

4. Drag the pin to a new location, or use the search feature to find it.

5. Click Done.

To remove Place information from a photo:

1. In the Places view, click a pin to view its photos.

2. Select the photo(s) you want to remove.

3. Click the Remove button in the taskbar.

4. Click OK in the Remove Pin? dialog.

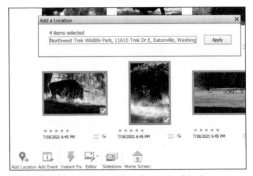

FIGURE 3.95 Add a location from the Media Browser, but without the benefit of the map.

FIGURE 3.96 Places tags are created for each location.

FIGURE 3.97 The Ratings filter quickly brings up all photos in the library rated 3 stars or higher.

FIGURE 3.98 Select tags to further refine the results.

Filter Photos

The Organizer offers many ways to search for photos (explained on the next pages), but often applying a simple filter in the Media Browser will turn up the ones you're looking for.

To filter photos:

- Click a star next to Ratings in the actions bar to view all photos marked with that rating or higher. The default qualifier is the ≥ symbol, which includes all photos greater than or equal to the number of stars you select; for example, clicking three stars reveals all photos rated 3 stars, 4 stars, or 5 stars **(FIGURE 3.97)**.

 To change the parameter of the filter, click the qualifier and choose ≤ (images less than or equal to the selected rating) or = (photos marked only with that rating).

- In the Tags panel, click the boxes next to tags to refine the results. The items are cumulative, so as you mark more of them, the number of matching photos narrows. In my example here, I can bring up only images rated 3 stars or higher that include Jeff in Seattle **(FIGURE 3.98)**.

To clear the filter:

Click the Clear button in the search summary bar above the images, or click the Back button or All Media button that appears in the Options bar.

TIP Selecting a folder in the My Folders list or an album in the Albums panel are other ways to filter your photos.

Search for Photos

In addition to locating photos using keyword tags and albums, the Organizer offers a host of other options for finding and viewing photos in your catalog. The Search feature incorporates all the elements we've talked about in this chapter: text, keyword tags, locations, ratings, and more. It also includes Smart Tags, which the Organizer creates automatically based on the contents of the photos.

To find photos using a text search:

1. Click the Search button in the upper-right corner of the Organizer window to open the Search interface.

2. Type a term in the Search field. The Media Browser searches the photos' metadata and displays matches (including keywords) as you type (**FIGURE 3.99**).

3. Select one of the suggestions, or press Enter/Return to search on the term and view matches (**FIGURE 3.100**).

4. To refine the search, type another term and press Enter/Return. An operator appears between the terms: + (Add), / (Or), or – (Exclude). Click it to change the relationship of the words (**FIGURE 3.101**).

 For example, if you want to view all photos that contain both keywords *coffee* and *cafe*, you'd use the + (Add) operator. Alternately, you could use the – (Exclude) operator to view images tagged with *coffee* but not *cafe* (**FIGURE 3.102**).

5. When you're done searching, click the Grid button to view the results in the Media Browser. The search criteria are saved.

FIGURE 3.99 The word *coffee* has brought up a keyword tag, an album name, and two Smart Tags.

FIGURE 3.100 The search results include all photos tagged with the term *coffee*.

FIGURE 3.101 Choose an operator that affects how multiple terms interact.

FIGURE 3.102 Excluding the keyword *cafe* removes the photos of coffee shops.

— Smart Tags

— People

— Places

— Date

— Folders

— Keywords

— Albums

— Events

— Ratings

— Media Types

FIGURE 3.103 The Search interface lets you access the many types of metadata.

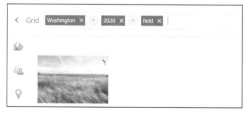

FIGURE 3.104 Find files using multiple types of attributes, including Smart Tags.

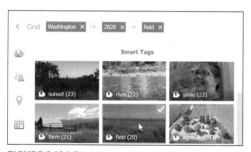

FIGURE 3.105 The search brings up this Washington field photo captured in 2020.

To search using multiple attributes:

1. In the Search interface, hover the pointer over the icons at left to view options for each type **(FIGURE 3.103)**.

2. Select the search terms from the types. For example, I could include a location of *Washington*, a date of *2020*, and the Smart Tag *field* to locate all photos of fields taken in my home state during 2020 **(FIGURE 3.104)**.

 I never set up a keyword for *field*—the Organizer created the Smart Tag by analyzing my photos and finding grass and other elements consistent with what we know as a field **(FIGURE 3.105)**.

3. When you're done searching, click the Grid button to view the results in the Media Browser. The search criteria are saved.

TIP To quickly start over with new criteria, click the **Clear Search** button at the far right of the search field.

TIP The Search tool can also find results for data that might not be immediately obvious, such as camera models, filenames, or text stored in captions or notes. A search such as *Seattle* + *Kim* + *X-T3* would bring up all photos captured in Seattle that contain the person Kim and were shot using a Fujifilm X-T3 camera.

TIP If you're seeing unexpected results with operators, be sure to select specific keywords in your search, instead of generic terms that the Organizer has created as Smart Tags.

To find photos by details (metadata):

1. Choose Find > By Details (Metadata).

2. In the Search Criteria section of the dialog, choose an attribute from the first menu and specify details (such as *Camera Make* in the first menu, *Contains* in the second menu, and typing *Fujifilm* in the field).

3. Click the Add button (+) to add more criteria (such as Capture Date) **(FIGURE 3.106)**. Repeat this step until you've added the attributes you want.

4. Using the Search For Files Which Match buttons, select whether results should include any or all of the criteria.

5. Click Search to display results.

To find photos using the timeline:

1. If the timeline isn't visible, choose Window > Timeline (Ctrl+L / Command+L).

2. In the timeline, click a bar that corresponds to a specific month and year **(FIGURE 3.107)**. The Media Browser automatically scrolls to display the photos for the month you selected.

3. To specify a range of time, drag the edge handles to set the start and end dates **(FIGURE 3.108)**.

TIP A big drawback about the timeline is that there's no easy way to return to the All Media view. You have to drag the edge handles back out to the furthest edges.

TIP From the Find menu, you can search photos by a number of different criteria. Some that you'll probably use most often are by caption or note; by filename; by history (imported on date, and printed on date, among others); and by media type (photos, video, audio, and creations). Choose an option and then fill in its dialog (when applicable) to refine your search.

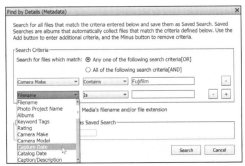

FIGURE 3.106 Find files using more specific metadata.

FIGURE 3.107 Bars in the timeline represent sets of images shot or acquired in specific months—the taller the bar, the more photos exist for that month. Click a timeline marker to view its photos.

FIGURE 3.108 After you set a date range, only those photos that fall within the specified range are visible.

FIGURE 3.109 Visual search brings up related photos.

FIGURE 3.110 Moving the slider toward Color locates photos with colors similar to the reference image.

FIGURE 3.111 Add photos to the Find bar to bring up more visually similar results.

Find photos using visual information

When you want to locate a photo that looks a lot like another one—whether the similiarity is in color scheme or objects that appear—turn to a trio of Organizer features.

To find visually similar photos:

1. Select a photo you want to use as a starting point.

2. Choose Find > By Visual Searches > Visually Similar Photos And Videos.

 The Media Browser displays photos that are like the one you selected, with a percentage badge indicating how similar it thinks the photo is **(FIGURE 3.109)**.

3. Drag the Refine Search slider to display more photos that match the original in terms of color or shape **(FIGURE 3.110)**.

4. Another way to refine the search is to add more photos for the Organizer to compare: Drag an image to the placeholder that appears next to the first photo **(FIGURE 3.111)**.

 You can remove a photo from the search criteria by double-clicking it in the Find bar. (Or, right-click it and choose Remove From Search.)

To find similar objects in photos:

1. Select a photo that contains an object you want to locate.

2. Choose Find > By Visual Searches > Objects Appearing In Photos.

 The Media Browser adds a selection box to the photo.

3. Click the center of the box, drag it to an object in the photo, and resize the box as needed **(FIGURE 3.112)**.

4. Click the Search Object button to view the results.

5. If necessary, drag the Refine Search slider to prioritize the hunt between color or shape **(FIGURE 3.113)**.

To find duplicate images:

1. Choose Find > By Visual Searches > Duplicate Photos. Elements searches your entire collection and brings up the Visually Similarity Photo Search dialog, which arranges the images in rows **(FIGURE 3.114)**.

2. To remove a duplicate photo, select it and click the Remove From Catalog button, and then confirm the deletion.

 To group a row of photos, click the Stack button. (See "Use Stacks to Organize Similar Photos," earlier in this chapter.)

3. Click Done when you're finished.

> **TIP** Make sure no photo is selected before you look for duplicates; otherwise you get an error message.

FIGURE 3.112 Select an object to locate photos containing similar-looking objects.

FIGURE 3.113 The Organizer identifies photos and areas that (roughly) match your source object.

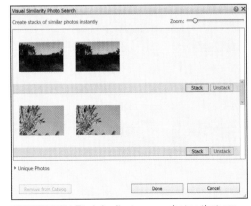

FIGURE 3.114 Find duplicates—or photos that are visually very similar—and put them into stacks.

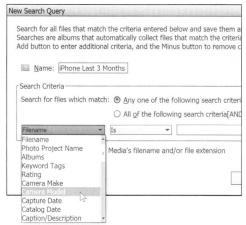

FIGURE 3.115 Choose from several attributes to start building the Saved Search.

FIGURE 3.116 Click here to add additional criteria.

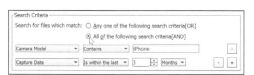

FIGURE 3.117 This Saved Search will display only photos shot with an iPhone within the last three months.

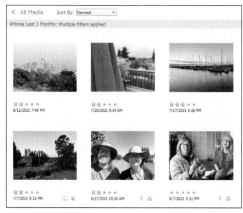

FIGURE 3.118 After the Saved Search is created, the photos that match its criteria are displayed.

Find photos using Saved Searches

One of my grandmother's cupboards was filled with photo albums, organized roughly chronologically, along with a bunch of envelopes and stacks of free-floating pictures that weren't in any order. The problem with lots of photos is that there's only so much time you can spend sorting them.

But what if you had an assistant who could do the organizing for you? Not just once, but ongoing, changing the albums based on new photos or keyword tags or other criteria? Saved Searches operate just like that (and they don't mind the workload).

To create a Saved Search:

1. Choose Find > By Saved Searches.
2. Click the New Search Query button.
3. Type a descriptive title in the Name field.
4. Specify photo attributes using the menus in the Search Criteria section (FIGURE 3.115).

 The other menu and field change depending on the criteria. For example, choosing Keyword Tags presents a list of tags.
5. To add more criteria, click the Add (+) button (FIGURE 3.116) and specify the attributes.
6. By default, the search picks up photos containing any of the criteria you specify. To view only photos that match every attribute, choose the radio button labeled All Of The Following Search Criteria [AND] (FIGURE 3.117).
7. Click OK. Only the images matching the criteria are displayed (FIGURE 3.118).

To re-run a Saved Search:

1. Choose Find > By Saved Searches.
2. Select a search and click Open to view its results.

To modify a Saved Search:

1. Choose Find > By Saved Searches, select one, and click Open.
2. From the Options menu, choose Modify Search Criteria (**FIGURE 3.119**).
3. In the Find By Details (Metadata) dialog that appears, edit the attributes you set up originally.
4. To keep the new criteria, mark the box labeled Save This Search Criteria As Saved Search (**FIGURE 3.120**).
5. Enter a name for the search (and see the tip below).
6. Click Search to save the settings. The images in the Media Browser reflect the new criteria.

To create a Saved Search from search results:

1. Perform a search using the Search interface.
2. From the Options menu at the upper-right corner of the Media Browser, choose Save Search Criteria As Saved Search (**FIGURE 3.121**).
3. In the Create Saved Search dialog, give the search a name and click OK (**FIGURE 3.122**).

TIP If you give a modified Saved Search the same title as the original album you're editing, Elements creates a brand-new search. It does not replace the old one.

TIP To view all photos *except* those in the Saved Search, click the Options menu and choose Show Results That Do Not Match.

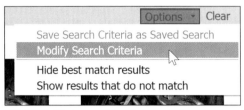

FIGURE 3.119 Choose Modify Search Criteria when you're viewing the contents of a Saved Search.

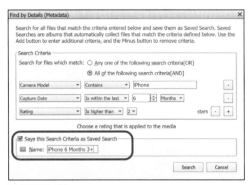

FIGURE 3.120 Make sure you mark the criteria as a Saved Search, or Elements will modify the search for that instance only.

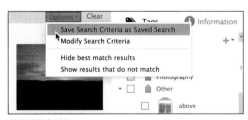

FIGURE 3.121 Save the search so you can run it another time.

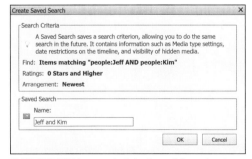

FIGURE 3.122 You can build a Saved Search using the criteria of a regular search.

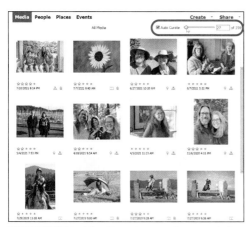

FIGURE 3.123 Let the Organizer curate your photos for you.

FIGURE 3.124 Auto Curate thinks these are the best images in the library.

Auto Curate Photos

The techniques I've discussed during this chapter are devoted to helping you locate your best images, from assigning ratings to grouping photos into albums or events. The Auto Curate feature rolls all that data into a way to surface those better shots using the same media analysis technology used for identifying faces and creating Smart Tags.

To auto curate photos:

1. In the Media Browser, select Auto Curate at the top-right corner of the window. The Organizer shows a limited number of photos compared to the entire library (**FIGURE 3.123**).

2. Drag the Auto Curate slider to adjust the number of visible photos. A smaller number presents fewer "good" pho-tos—in theory, the best of the best (**FIGURE 3.124**).

 I say "in theory," because the software is making value judgments based on several factors. Ratings are part of it, but it also calculates whether the photos contain people you've identi-fied, whether the image is in focus, and other aspects.

3. Deselect Auto Curate to turn off the feature when you're done.

> **TIP** The top thing to keep in mind with Auto Curate is that it's going to be a bit of a mys-tery, because it's using an algorithm to assign quality to photos. Think of it as a quick way to get to several of your better photos, and then build on that.

> **TIP** The Auto Curate feature picks up to 500 photos in your library.

Work with Catalogs

Catalogs are the behind-the-scenes backbone of the Organizer workspace, where all of the information for tags and categories and albums are stored. When you install Elements, the program sets up a default catalog (called My Catalog) for you. That might be enough to work with, but you can also create additional catalogs—for example, you may want discrete catalogs for each person's photos: Bob's Catalog, Sara's Catalog, and so on.

To create a new catalog:

1. Choose File > Manage Catalogs, or press Ctrl+Shift+C/Command+Shift+C.

2. In the Catalog Manager dialog, specify whether the catalog is available to all user accounts on the computer, just the current user, or saved to a custom location (**FIGURE 3.125**).

3. Click the New button.

4. In the text field, enter a name for your new catalog (**FIGURE 3.126**).

 At the bottom of the naming dialog is the Import Free Music Into This Catalog box. I leave this option deselected; the music files used as background tracks for PDF slideshows and other creations will be downloaded automatically as needed.

5. Click OK to create your new catalog.

To switch to a different catalog:

1. Choose File > Manage Catalogs, or press Ctrl+Shift+C/Command+Shift+C.

2. Select the name of the saved catalog you want to open.

3. Click the Open button.

FIGURE 3.125 Choose which users can access the catalogs, as well as the catalogs' locations.

FIGURE 3.126 Make sure your new catalog name is different from any existing catalog names.

Repair and Optimize Catalogs

If your library seems out of sorts—maybe not all thumbnails are appearing, for example—turn to the Catalog Manager for help. Select a catalog name and click the Repair button to scan for problems and fix them.

Clicking the Optimize button pares the catalog size and can also improve performance if the Organizer seems sluggish.

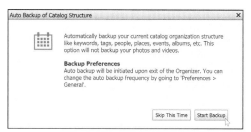

FIGURE 3.127 Start an automatic backup when you exit the Organizer.

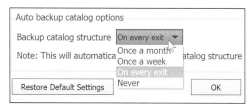

FIGURE 3.128 You can set a less-frequent schedule for backing up the catalog, but I recommend keeping it at On Every Exit.

Back Up Catalogs

Before we get to your catalog, you should have a way to back up your photos—the image files that came from your camera. That can be via backup software on your computer that makes copies of everything, not just images.

The catalog is a separate thing. Because the Organizer's catalog stores everything *about* your photos, from metadata to locations on disk, backing it up helps immeasurably in case something happens to your computer.

The Organizer also includes options to manually back up the catalog and all of the media it contains.

To make an automatic backup of your catalog:

1. Choose File > Exit (Windows) or Elements Organizer > Quit Elements Organizer (macOS).

2. Click the Start Backup button in the dialog that appears **(FIGURE 3.127)**.

 Only the catalog file itself is backed up, not your entire library, so the backup happens pretty quickly.

To change the frequency of the automatic backup:

1. Choose Edit > Preferences > General (Windows) or Elements Organizer > Preferences (macOS).

2. Under Auto Backup Catalog Options, choose a different frequency in the Backup Catalog Structure menu **(FIGURE 3.128)**.

3. Click OK.

To make a manual backup of a full catalog:

1. Choose File > Backup Catalog.

2. In the Backup Catalog dialog, choose Full Backup to make a complete copy of the catalog. On subsequent backups, choose Incremental Backup to copy only new and changed image files.

3. Click Next.

4. Select a destination drive (**FIGURE 3.129**), and optionally specify a location by clicking the Browse button for Backup Path.

5. Click Save Backup when you're ready. The Organizer copies the image files and catalog information to the drive.

To restore a catalog from backup:

1. In the unfortunate event that your catalog becomes unreadable, choose File > Restore Catalog from Hard Drive.

2. In the Restore dialog, choose the media on which the backup is stored (**FIGURE 3.130**); click the Browse button to locate the TLY file that accompanies the backup.

3. Choose where to copy the restored files: the catalog's original location or another location.

4. Click Restore.

TIP The downside to the Organizer's catalog backup scheme is that making an incremental backup creates a new file. So, to restore your catalog, you must have the original backup and all of the incremental ones at hand. Make sure you have another backup of your data as well, using commercial backup software (which is a fantastic idea anyway).

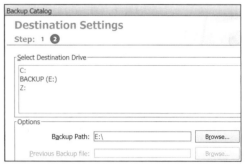

FIGURE 3.129 Specify where your backup files are to be copied.

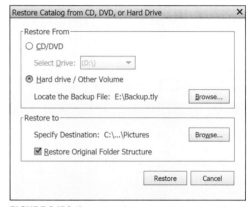

FIGURE 3.130 If you need to reconstruct a catalog from backup, use the Restore Catalog feature.

Cropping and Straightening Images

Have you ever captured a photo, then looked at it later and realized it would be much better if only you had gotten a little closer to your subject, or if a person was to the left of the frame instead of the center? Or maybe the shot is great except for a trash can peeking into the edge of the frame. The ability to crop an image can instantly improve the composition of a photo or remove unwanted elements at its borders.

Another common annoyance is a photo that's just a bit off-kilter. Using the Editor's straightening tools, you can bend that horizon back into line (or skew it further for a dramatic effect).

In This Chapter

Crop an Image

In spite of all of the advances in cameras, rarely is a picture taken with its subjects perfectly composed or its horizon line set at just the proper level. The Editor offers two simple and quick methods for cropping your images.

To crop an image using the Crop tool:

1. In Quick mode or Expert mode, select the Crop tool from the toolbox (or press C) (**FIGURE 4.1**).

2. In the Tool Options bar, move the pointer over the Crop Suggestions thumbnails to see what the tool's quick recommendations are; click one to set the crop.

 Or, in the image window, drag to define the area of the image you want to keep (**FIGURE 4.2**).

 The image outside the selected area dims to indicate the portions that will be deleted.

3. If you want to modify your selection, move the pointer over one of the eight handles on the edges of the selection and drag the handle to resize (**FIGURE 4.3**).

 You can also drag within the selection to recompose the visible content.

4. If you're not satisfied with your selection and want to start over, click the Cancel button.

 When you are satisfied with your crop area, double-click within the selection, press Enter/Return, or click the Commit button (the checkmark) on the lower-right corner of the selection (**FIGURE 4.4**).

 The Editor crops the image to the area you selected (**FIGURE 4.5**).

FIGURE 4.1 The Crop tool in Expert mode

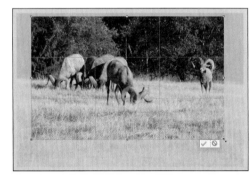

FIGURE 4.2 Elements highlights the image that will be preserved and dims the portions to be deleted.

FIGURE 4.3 Drag the handles around the perimeter of the cropping selection to resize the area you choose to crop.

FIGURE 4.4 The Commit and Cancel buttons appear on the lower edge of the crop selection.

> **TIP** A Crop selection includes an overlay splitting the area into thirds to help you compose the shot. In the Tool Options bar, click one of the other Grid Overlay buttons to change this guide.

> **TIP** You can define color and opacity options for the Crop tool shield (the dimmed area that surrounds your cropped selection) in the Display & Cursors area of the Preferences dialog. The default color is black, and the default opacity is 75 percent.

FIGURE 4.5 The final cropped image

FIGURE 4.6 Use the Crop Preset Options menu to choose common photo dimensions.

FIGURE 4.7 Drag with the Rectangular Marquee tool to define the part of the image you want to crop.

▶ **VIDEO 4.1**
Cropping and Resolution

To resize an image to specific dimensions using the Crop tool:

1. Follow steps 1–3 on the previous page to specify an area to crop.

2. In the Tool Options bar, choose a common photo size from the Crop Preset Options menu (**FIGURE 4.6**).

 Or, enter a size in the W(idth) and H(eight) fields. The double-arrow button between the fields swaps values, making it easy to turn a horizontal crop area into a vertical one, and vice versa.

3. Double-click within the selection, press Enter/Return, or click the Commit button to crop the photo.

To crop an image using the Rectangular Marquee tool:

1. In Expert mode, select the Rectangular Marquee tool from the toolbox, or press M.

2. In the image window, drag to define the area of the image you want to keep (**FIGURE 4.7**).

3. Choose Image > Crop. The Editor crops the image to the area you selected.

TIP If you're planning to print your photos using a commercial print service, be sure to crop your images to a standard size first. The images that digital cameras create don't match standard photo aspect ratios, which can lead to prints with black bars around the edges.

Extend the Background

Usually when you crop a photo, you remove portions of the image. In some situations, however, you can extend the visible area. The Editor then fills in the new areas with pixels based on the edges of the photo.

To extend the background:

1. Open a photo, and switch to Guided mode.

2. Click the Special Edits heading, and then click Extend Background.

3. In the sidebar at right, choose a canvas size from the first menu (**FIGURE 4.8**). Blank areas are added around the original image to expand it to the new size.

4. Normally, the feature fills all of the extended area. If you want to fill just certain areas, click the black arrows in step 2 in the sidebar to make a selection.

5. Click the Autofill button to fill the areas using Content-Aware technology.

 Or, click the Extend button to define areas to be protected (**FIGURE 4.9**). This option stretches the image in unprotected areas instead of creating new pixels based on the edges. Click Done to apply the extension (**FIGURE 4.10**).

6. If needed, use the Spot Healing Brush button or the Clone Stamp Tool button to repair areas that are obviously duplicated or don't look right as part of the extension process. (See Chapter 10 for more on using those tools.)

7. Click Next, and either save the image or continue working in Quick mode or Expert mode.

> **TIP** Choose Edit > Undo at any point to step back through the actions. Or, click the Reset Image button at the top of the sidebar to start over (**FIGURE 4.11**).

FIGURE 4.8 Pick a final canvas size.

FIGURE 4.9 Protect the section of the photo that should remain unchanged when the rest of it expands to fill the empty space.

FIGURE 4.10 Here are the results of using Autofill (left) and Extend (right).

FIGURE 4.11 Reset and start over at any time.

FIGURE 4.12 The Straighten tool

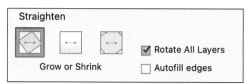

FIGURE 4.13 Choose how the Organizer handles extra space caused by the rotation.

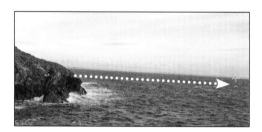

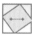

Grow Or Shrink

Remove Background

Original Size

FIGURE 4.14 With the Straighten tool, you simply click and drag within a tilted photo (top) to align it perfectly.

Straighten a Crooked Photo

Sometimes even your most carefully composed photos may be just a little off angle, with a not-quite-level horizon line or tilted portrait subjects. The nifty Straighten tool makes short work out of getting your crooked photos back into alignment.

Or, perhaps you've scanned an image that shifted when you closed the scanner cover. Elements can automatically straighten it, with the option of cropping it to a clean rectangle.

To use the Straighten tool:

1. In Expert mode, select the Straighten tool from the toolbox, or press P (**FIGURE 4.12**).

2. In the Tool Options bar, choose how you want the image cropped after you straighten it (**FIGURE 4.13**).

 Optionally select Autofill Edges to let the tool fill the empty spaces using Content-Aware technology.

3. Using a horizon line or other subject as a point of reference, drag along the line (**FIGURE 4.14**). When you release the drag, your image rotates and aligns along the new horizontal plane you defined.

To let the Editor straighten a photo:

Choose one of the following:

- Image > Rotate > Straighten And Crop Image

- Image > Rotate > Straighten Image

continues on next page

The Straighten And Crop Image command will do its best to both straighten the image and delete the extra background surrounding the image. The Straighten Image command simply straightens without cropping.

Both methods have their own sets of limitations. Straighten And Crop works best if there is a space of at least 50 extra pixels or so surrounding the crop area. If this surrounding border is much smaller, the Editor can have a difficult time distinguishing the actual photograph from the border and may not do a clean job of cropping.

Although you'll still need to manually crop your image, the Straighten Image command is probably a better choice, because you avoid the risk of the Editor indiscriminately cropping out areas of your image you may want to keep.

To straighten an image using the Crop tool:

1. Select the Crop tool from the toolbox.

2. In the image window, drag to select the area of the image you want to crop and straighten.

3. Move the pointer outside the edge of the selection area until it changes to a rotation pointer (**FIGURE 4.15**).

4. Drag outside of the selection until its edges are aligned with the image content.

5. Drag the selection handles, as necessary, to fine-tune the positioning.

6. Press Enter/Return or click the Confirm button (**FIGURE 4.16**). The image is cropped and automatically straightened (**FIGURE 4.17**).

FIGURE 4.15 After you define a preliminary cropping selection, rotate the selection so it's aligned with the image content.

FIGURE 4.16 Make final adjustments to your cropping selection (top) before Elements automatically crops and straightens the image.

FIGURE 4.17 The cropped and straightened image

Making Quick and Guided Edits

As you'll discover in the rest of the book, Photoshop Elements is a sophisticated image editor, enabling anyone to make photo corrections that would have once been absurdly difficult. But what if you don't want to be an image expert? Then you can let the computer do the work for you, analyzing photos and correcting them automatically.

When you don't want to mess with the particulars, or when you know that a photo needs just a bit of tweaking but you want a bit more control over the adjustments, turn to Quick mode. Feel free to experiment on your photo—ranging from slight tonal changes to radical tints and lighting adjustments—and then undo those corrections if they seemed better in your mind's eye than they look on the screen.

The concepts behind the tools in Quick mode, such as adjusting levels and sharpening, are dealt with in more detail later in the book. Use this chapter as a jumping-off point.

In This Chapter

Make Instant Fixes in the Organizer

FIGURE 5.1 The Instant Fix button

When you're in a hurry, or if a photo needs just a few basic adjustments, you can edit it without leaving the Organizer.

To make Instant Fix edits:

1. Select an image in the Organizer, and click the Instant Fix button in the task-bar (**FIGURE 5.1**).

 The Instant Fix editor opens, and a set of tools appears at the right side of the window.

2. Do one of the following:

 ▶ Click Smart Fix (🖌) to correct the image in one go.

 ▶ Click one of the other Instant Fix tools. A sliding scale of adjustments appears alongside the column of tools.

 For example, clicking the Light tool presents a scale of bright (top) to dark (bottom) tone adjustments (**FIGURE 5.2**).

3. Drag the slider up or down to apply the edit. Click the Before/After switch to toggle between the original and edited preview (**FIGURE 5.3**).

4. Click Save to save the edited version in the library in a stack with the original image.

5. Click Done to exit the Instant Fix interface.

 TIP If you want to do more work on the photo than what the Instant Fix tools provide, click the Editor button to open the image in the Editor.

- Crop
- Red Eye
- Effects
- Smart Fix
- Light
- Color
- Clarity

FIGURE 5.2 Drag a tool's slider to apply the amount of the fix.

FIGURE 5.3 View the original and edited versions before you save your changes.

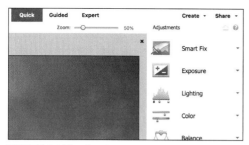

FIGURE 5.4 The Quick mode workspace includes your image and a set of common photo manipulations.

FIGURE 5.5 The Before & After options offer split-screen views of how fixes are affecting the photo.

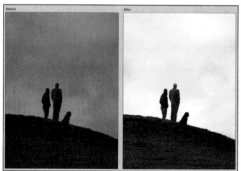

FIGURE 5.6 Use the sliders associated with each type of fix to adjust the After image.

VIDEO 5.1
Quick, Guided, and Expert Edits

Make Quick Edits

When you want Elements to take over and make corrections according to its analysis of a photo, the speediest method is to use Quick mode.

To edit photos in Quick mode:

Open an image in the Editor, and then click Quick at the top of the window. The Quick mode workspace opens (**FIGURE 5.4**).

To set view options:

- From the View menu, choose whether you want to see the end result (After Only), the original (Before Only), or a comparison layout (both the Before & After options) (**FIGURE 5.5**).

- Use the Zoom slider and field to specify how zoomed in you want to be. In the Before & After views, the zoom level applies to both versions.

 When the Zoom or Hand tool is active, you can also click the 1:1, Fit Screen, Fill Screen, or Print Size buttons in the Tool Options bar to switch to those zoom levels.

- If Elements did not rotate your image correctly during import, click the Rotate buttons in the taskbar to turn the image clockwise or counter-clockwise in 90-degree increments.

To apply edits:

1. Click a type of edit (Smart Fix, Exposure, Lighting, etc.) to reveal its controls.

2. If an Auto button is available, click that first to see what Elements suggests.

3. Drag the sliders for specific adjustments to fine-tune the settings (**FIGURE 5.6**).

To apply fixes using previews:

1. Click the name of an adjustment to reveal thumbnails of the range of that fix's settings.

2. Move your pointer over a thumbnail to preview the edit (**FIGURE 5.7**).

3. Click the thumbnail to apply the setting. The slider is still available for fine-tuning.

To select areas for applying edits:

1. The tools apply adjustments to the entire image, but if you want to edit a specific portion of the image, select the Quick Selection tool from the toolbox.

2. Click the Tool Options button, and then click Select Subject to have the Editor automatically make a selection.

 Or, draw within the area that you want to select. Elements makes a selection based on the colors of those pixels (**FIGURE 5.8**).

3. Use the Quick edit tools to adjust only the selected area.

To apply all edits:

1. Choose File > Close, or click the Close button in the upper-right corner of the workspace.

2. When prompted, save your changes.

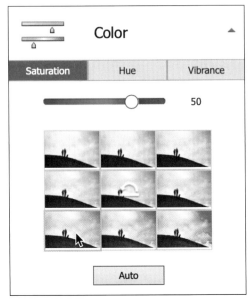

FIGURE 5.7 The preview grid gives you an immediate sense of how the edit will appear.

FIGURE 5.8 Drawing with the Quick Selection tool creates a selection based on that area.

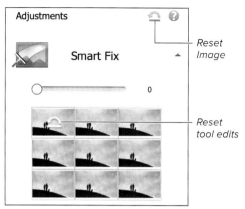

Reset Image

Reset tool edits

FIGURE 5.9 Clicking the Reset Image button restores the image to the state before you made the adjustment(s).

To reset and undo changes:

- After making an adjustment, click the Reset button that appears in the tool's thumbnails (**FIGURE 5.9**).

- Click the Undo button on the taskbar, or choose Edit > Undo to undo the previous command.

- If you've made several edits and want to revert to the original image, click the Reset Image button at the top of the Adjustments panel. This removes any Quick mode adjustments.

TIP The other tools in the toolbox, such as the Spot Healing Brush and Type tools, mirror the functionality of the tools in Expert mode covered later in the book.

TIP It never hurts to play with the Smart Fix slider. Smart Fix adjusts lighting, color, and sharpening based on its algorithms. In some cases, this may be the only edit you need.

Walk Through Guided Edits

If you want to start with a little more hand-holding than what's offered by the Quick edits, try Guided mode; access it by clicking the Guided heading. Edits made in Guided mode streamline complicated tasks or create effects that would be more time consuming in Expert mode.

Clicking a task in this mode provides step-by-step instruction on performing editing tasks (**FIGURE 5.10**).

When you've accomplished each step, click the Next button to apply the changes and save or share the image; or click Cancel to discard them. You can also click the Reset Image button that appears in each category to go back to the state before you applied those particular edits if you want to try a different setting.

Some Guided edit options include:

- Basic adjustments, such as Brightness, Contrast, and Enhance Colors

- Photomerge tools, such as Scene Cleaner and Panorama (see Chapter 10 for more information)

- Photographic effects, such as Depth Of Field (**FIGURE 5.11**), Old Fashioned Photo, and Tilt-Shift

- Fun Edits, such as adding a reflection or making part of the photo pop out from the rest of the image

- Special Edits, such as Perfect Pet and Perfect Landscape

- Effects that replicate cameras or lenses, such as Lomo Camera Effect

TIP The great thing about the Guided edits is that you can switch to Expert mode and view and edit the layers the Guided edits create to achieve the looks and effects.

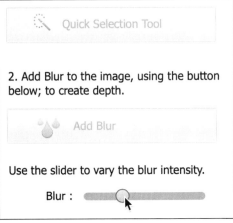

FIGURE 5.10 The Guided mode interface for editing

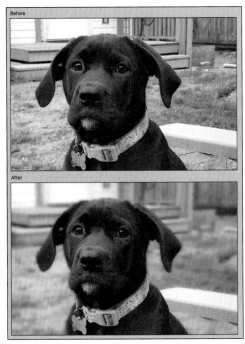

FIGURE 5.11 The Depth Of Field Guided edit separates the foreground from background using a blur effect.

VIDEO 5.2
Perfect Pet Guided Edit

6

Making Selections

One of the advantages of using Photoshop Elements to edit photos is the ability to apply corrections and enhancements to *selected* areas in an image. Many photo-editing programs instead apply fixes to the entire image only.

You can also use selections to create a protective mask for specific portions of an image. It's easy to select one area of an image, apply a change to the rest, and keep the selected area untouched.

In this chapter, you'll learn about the selection tools in the Editor and when to choose one tool over another. You'll also learn how to use these tools in tandem to make the quickest and most accurate selections.

Although we look at the tools in Expert mode in the next pages, Quick mode also uses selection tools, and many Guided mode edits also include them.

In This Chapter

Why Make Selections?

Often, you'll want to change and adjust only a portion of an image. For example, you may want to eliminate a distracting element in your photo, change the color of a specific item, or adjust the brightness of just the background. The Editor gives you a wide variety of selection tools from which to choose.

The selection tools are all grouped near one another at the top of the toolbox in Expert mode (**FIGURE 6.1**). When you use one of them, such as the Elliptical Marquee tool, the selection area is indicated by a row of moving dots, like the sign outside an old-style movie theater—hence the name *marquee* (**FIGURE 6.2**). (The border is also sometimes referred to as "marching ants.")

When you make a selection, edits you then make are restricted to the selected area. For example, if you use the Brush tool to paint the area, the color does not extend beyond the edge of the selection (**FIGURE 6.3**).

FIGURE 6.1 Access additional related tools in the Tool Options bar.

FIGURE 6.2 A selection border is represented by a row of moving dots, called a marquee.

FIGURE 6.3 When painting a selected area, you don't have to be precise about avoiding the edges; the color stays within the selection.

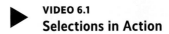

VIDEO 6.1
Selections in Action

Layer mask

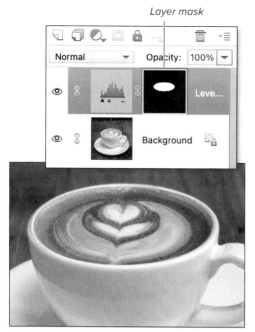

Selections are also invaluable for applying adjustment layers and other tonal edits. You first create a selection to define where the edit should apply, then create a new adjustment layer, such as Levels. The Editor automatically creates a layer mask of the selection so the effects of the edit are applied only in that area; you can then adjust the mask to control where the adjustment is visible (**FIGURE 6.4**). (See Chapter 7 for more on layers and masks.)

When a photo includes an object surrounded by a large background area and you want to select that background, it's often easier to select the object and then invert the selection to shift the selection to "everything but" the object: the background (**FIGURE 6.5**).

After you make a selection, you can copy and paste it into another composition.

FIGURE 6.4 Adding a Levels adjustment layer created a layer mask for the selected area, so changing the tonal levels affects only the coffee, not the cup or surroundings.

FIGURE 6.5 Inverting the same selection as above makes the Levels adjustment affect the area around the coffee. Notice the marquee border along the outside edges of the image.

Use the Auto Selection Tools

The Editor includes several selection tools, which work in different situations. Some make precise selections, some are designed to select areas quickly, and some attempt to do as much of the work for you as possible. Start with the auto-selection tools to see what they grab, and then use the other tools to refine the selection.

To select the subject automatically:

Do one of the following:

- Choose Select > Subject.
- With the Quick Selection tool active, open the Tool Options bar and click the Select Subject button.

 The Editor makes a selection based on what it perceives is the subject of the photo (**FIGURE 6.6**).

To select a subject in an area you specify:

1. Select the Quick Selection tool in the toolbox, and then, in the Tool Options bar, click the Auto Selection tool (**FIGURE 6.7**).

2. Drag a marquee over the object you want to select (**FIGURE 6.8**). The tool makes a selection based on what it identifies within the dragged area.

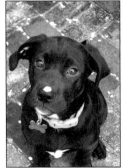

FIGURE 6.6 I added color to the non-selected areas to better show how well Select Subject identified the subject of this photo. It did a pretty good job, with just the areas around the ears incorrectly included in the selection—which are easy to fix.

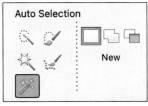

FIGURE 6.7 The Auto Selection tool appears in the Tool Options bar when the Quick Selection tool is active.

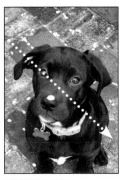

FIGURE 6.8 Drag over a subject with the Auto Selection tool. As you can see, the tool did a better job of picking out the subject, but stopped at the bottom because of the dragged area. (The selection is made as a marquee; here I've added color at right to make the effect more visible.)

SELECT

FIGURE 6.9 The Quick Selection tool

FIGURE 6.10 Painting through an area with the Quick Selection tool creates a new selection.

FIGURE 6.11 To add to a selection, paint in additional brushstrokes (Add To Selection is the default mode).

FIGURE 6.12 Use Subtract From Selection to delete a portion of a selection.

Use the Quick Selection Tool

Most often, the Quick Selection tool is the first one I turn to when I need to make a targeted selection. It will often make an accurate selection of contiguous areas of similar tonal values based solely on the areas you mark with the brush.

To use the Quick Selection tool:

1. From the toolbox, click the Quick Selection tool in the lower-right corner of the Select group (or press A) (**FIGURE 6.9**).

2. In the Tool Options bar, select the Quick Selection tool if it's not already selected.

3. In the Tool Options bar, choose a brush size.

4. In the image window, click or drag in the area where you want to make your selection. As you drag, the tool creates the selection (**FIGURE 6.10**).

5. To add to the selection, drag an area outside the current selection (**FIGURE 6.11**). The Add To Selection mode (also found in the Tool Options bar) is the default for the Quick Selection tool.

6. To subtract from a selection, click the Subtract From Selection button in the Tool Options bar or hold the Alt/Option key, and click (or drag) inside the selection area (**FIGURE 6.12**).

Use the Selection Brush Tool

The Selection Brush tool lets you make a selection by painting over an area; it differs from the Quick Selection tool by selecting only the areas covered by the brush's "paint," instead of contiguous areas of similar tonal values.

Unlike the other selection tools, the Selection Brush offers a Mask mode in addition to the default Selection mode, which allows you to create a visible "protected" or unselected area. You can use the two modes together with great results. It's easy to make your initial selection in the default mode, and then switch to Mask mode to fine-tune your selection.

To make a selection with the Selection Brush:

1. From the toolbox, click the Selection Brush tool in the lower-right corner of the Select group (or press A), and then select the Selection Brush in the Tool Options bar (**FIGURE 6.13**).

2. Make sure the Mode menu at the top of the Tool Options bar is set to Selection.

3. Choose a brush size by dragging the Size slider or typing a specific value to the right of the slider (**FIGURE 6.14**).

4. Choose a Hardness value, which determines how soft the edges of the brush are; a soft brush with a Hardness of 20%, for instance, might work well when selecting something with a soft or diffuse edge.

5. Drag the brush tool over your image to make a selection (**FIGURE 6.15**).

6. To expand the selection, brush on the edge of the selected area (**FIGURE 6.16**).

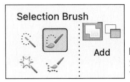

FIGURE 6.13 Access the Selection Brush in the Tool Options bar.

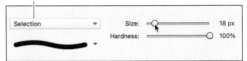

FIGURE 6.14 Choose a size that's a little smaller than the area you want to paint.

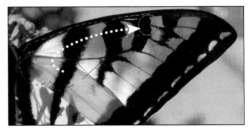

FIGURE 6.15 To make a selection, just "paint" over your image with the Selection Brush.

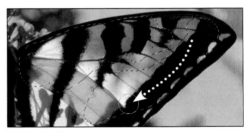

FIGURE 6.16 Any area you paint becomes part of the selection, even if the areas aren't contiguous.

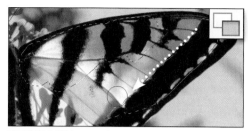

FIGURE 6.17 Use the Subtract From Selection button in the Tool Options bar to remove areas of your selection.

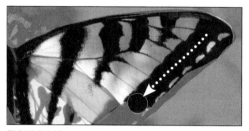

FIGURE 6.18 In the Mask mode, the mask overlay (in red) indicates areas outside the selection. It's often easier to make small adjustments with the mask visible.

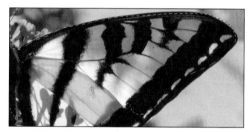

FIGURE 6.19 The areas that were not covered in red become the active selection when you switch to the Selection Brush's Selection mode or change tools.

TIP A quick way to change the size of the Selection Brush is to press the bracket keys on your keyboard: Press [to reduce the size and] to increase the size.

TIP If the selection area is close to the overlay color (the default is red), click the Overlay Color box in the Tool Options bar, and then choose a different color from the Color Picker.

To make a selection in another portion of your image, drag elsewhere from the original selection.

7. To subtract from your selection, click the Subtract From Selection button in the Tool Options bar, and then drag through any portion of the selection (**FIGURE 6.17**).

To make a selection with the Selection Brush in Mask mode:

1. From the toolbox, click the Selection Brush tool.

2. From the Mode menu in the Tool Options bar, choose Mask.

 If nothing is currently selected, the image appears normal.

 If you'd already made a selection using another tool, the selected areas appear normal and the rest is covered with the mask overlay.

3. If necessary, set the brush size and hardness.

4. Set the opacity of the mask using the Overlay slider if you need to view the underlying image better.

5. Using the Add To Selection and Subtract From Selection options in the Tool Options bar, drag to paint areas that will be revealed or hidden by the mask (**FIGURE 6.18**). Color indicates lack of selection; no color indicates part of the selection.

 As soon as you select another tool or switch back to the Selection mode, the mask overlay area changes to a selection border (**FIGURE 6.19**). If you want to modify the mask, select the Brush Selection tool again. The mask automatically appears over the image, and you can continue to paint in additional masked areas.

Use the Marquee Tools

The Rectangular and Elliptical Marquee tools are the easiest and most straightforward selection tools to use. You'll often want to move a selection area to align the area perfectly, and the Editor offers a couple of quick and simple ways to make these kinds of adjustments.

To make a rectangular or elliptical selection:

1. From the toolbox, select the Marquee tool, and select either the Rectangular Marquee or Elliptical Marquee in the Tool Options bar (**FIGURE 6.20**).

2. Drag to define the selection area (**FIGURE 6.21**).

 The default setting for the tool, New Selection, creates a new selection when you drag, resetting any previous selections. See "Add or Subtract Selections," later in this chapter, for more information on other options when creating selections.

> **TIP** You can create a perfect circle or square selection using the marquee tools by holding the Shift key as you drag (**FIGURE 6.22**).

> **TIP** Draw a marquee from the center outward by holding the Alt/Option key as you drag (**FIGURE 6.23**).

> **TIP** To toggle between marquee tools, press the M key. In fact, this works for any tool with hidden tools. Press the keyboard shortcut key repeatedly to toggle through all of the choices.

FIGURE 6.20 Select the Marquee tool in the toolbox (left), and then select the Rectangular or Elliptical Marquee tool in the Tool Options bar (right).

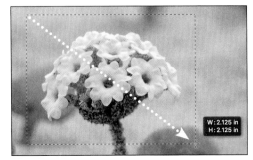

FIGURE 6.21 Drag to make a selection using one of the marquee tools.

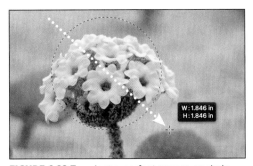

FIGURE 6.22 To select a perfect square or circle, hold the Shift key while dragging.

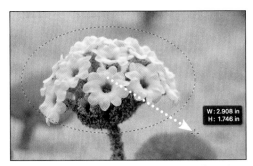

FIGURE 6.23 To draw a selection outward from the center, hold the Alt/Option key as you drag.

FIGURE 6.24 To move the selection area, position the pointer within the selection boundary.

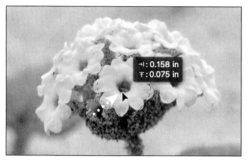

FIGURE 6.25 Drag the selection border to a new location.

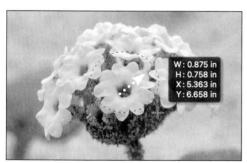

FIGURE 6.26 To move a new marquee during its creation, press and hold the spacebar while holding down the mouse button and adjust the border's location.

To reposition a selection border:

1. Position the pointer anywhere in the selection area.

The pointer displays a small selection icon next to it (**FIGURE 6.24**). Note that if the Add, Subtract, or Intersect mode (versus the default New mode) is active in the Tool Options bar, the pointer indicates that choice and the selection can't be moved.

2. Drag to reposition the selection area.

As you move the selection, the pointer arrow changes to solid black and a tooltip displays the distance moved (**FIGURE 6.25**).

To reposition a selection border while making a new selection:

1. Drag to create the selection area, but don't release the drag yet.

2. Press the spacebar. The pointer arrow shows a set of crosshairs whether or not the spacebar is pressed.

3. Move the selection area to the desired location (**FIGURE 6.26**). The tooltip that appears shows not only the size (W, H) but also the new location (X, Y).

4. Release the spacebar and the drag to finish creating the selection.

TIP You can use the arrow keys on your keyboard to move a selection in 1-pixel increments. Hold the Shift key at the same time to move the selection in 10-pixel increments.

Use the Lasso Tools

Use the Lasso tools to select areas with irregular shapes. The standard Lasso tool lets you draw or trace around an object or area freehand, much as you would draw with a pencil. This method takes patience, but with practice you can use the Lasso tool to make accurate selections.

The Polygonal Lasso tool is useful for selecting areas that include straight edges.

As you trace around an area using the Magnetic Lasso tool, it automatically "snaps" the selection border to edges based on differences in color and tonal values in adjoining pixels. For this reason, the tool usually works best on high-contrast images. Experiment with the settings in the Tool Options bar to get the best results.

The Lasso tools share the lower-left quadrant of the Select tools area of the toolbox. The currently active tool is displayed. Click the tool to select it, or select a different Lasso tool from the Tool Options bar.

To select with the Lasso tool:

1. From the Tool Options bar, select the Lasso tool (or press L) (**FIGURE 6.27**).

2. Keeping the mouse button pressed, drag all the way around an object or area in your image (**FIGURE 6.28**).

 When you release the mouse button, the open ends of the selection automatically join together (**FIGURE 6.29**).

> **TIP** Use the Alt/Option key to switch between the Polygonal Lasso and regular Lasso tools as you draw.

> **TIP** Making lasso selections is much easier with a pressure-sensitive drawing tablet.

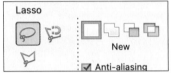

FIGURE 6.27 Select the Lasso tool in the toolbox (left) and then select the Polygonal or Magnetic Lasso tool in the Tool Options bar (right).

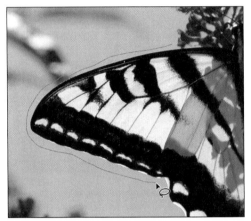

FIGURE 6.28 Select any area by tracing around it with the Lasso tool.

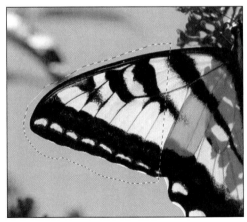

FIGURE 6.29 When you release the mouse button, the ends of the drawn path automatically join together to complete the selection.

FIGURE 6.30 The Polygonal Lasso tool creates a border of straight-line segments.

FIGURE 6.31 To start a selection border with the Magnetic Lasso tool, click the edge of the area you want to trace to create the first fastening point.

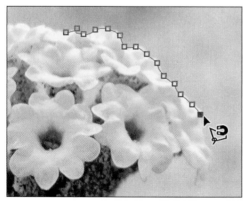

FIGURE 6.32 As you trace with the Magnetic Lasso tool, it places additional fastening points along the selection edge.

To select with the Polygonal Lasso:

1. From the Tool Options bar, select the Polygonal Lasso tool.

2. Click points along the edge of the object to create straight-line segments for your selection (**FIGURE 6.30**).

3. Click back at the original starting point to join the open ends of the selection.

 You can also Ctrl/Command-click or double-click anywhere to close the selection.

To select with the Magnetic Lasso:

1. From the Tool Options bar, select the Magnetic Lasso tool.

2. Click on or very close to the edge of the area you want to trace to establish the first fastening point (**FIGURE 6.31**).

3. Move the pointer along the edge you want to trace. The Magnetic Lasso tool traces along the selection border to the best of its ability and places additional fastening points along the way (**FIGURE 6.32**).

4. If the selection line jumps to the edge of the wrong object, place the pointer over the correct edge and click to establish an accurate fastening point.

5. To close the selection line, click the starting point. You can also Ctrl/Command-click, double-click anywhere on the image, or press Enter/Return.

TIP Be warned: The Polygonal Lasso tool can sometimes slip out of your control, creating line segments where you don't want them to appear. If you make a mistake or change your mind, you can erase line-segment selections as long as you haven't closed the selection. Just press the Backspace or Delete key, and one by one the segments will be removed, starting with the most recent one.

To set Magnetic Lasso tool options:

1. Select the Magnetic Lasso tool.

2. Set any of the options in the Tool Options bar (**FIGURE 6.33**):

 ▸ **Width** sets the size of the area the tool scans as it traces the selection line. Wide values work well for images with high contrast, and narrow values work well for images with subtle contrast and small shapes that are close to each other.

 ▸ **Contrast** sets the amount of contrast between shapes required for an edge to be recognized and traced (**FIGURE 6.34**). This option is indicated by the percentage of contrast (from 1 to 100 percent). Try higher numbers for high-contrast images, and lower numbers for flatter, low-contrast images (just as with the Width option).

 ▸ **Frequency** specifies how close the fastening points are to each other. Enter a number from 1 to 100. In general, you'll need to use higher frequency values when the edge is very ragged or irregular (**FIGURE 6.35**).

 ▸ If you are using a stylus tablet, select the Stylus Pressure button to increase the stylus pressure and so decrease the edge width. That's right: With the button enabled, pressing harder on the stylus will yield a smaller, more precise edge.

TIP Press Alt/Option and click to use the Polygonal Lasso tool while the Magnetic Lasso tool is selected. Press Alt/Option and drag to use the standard Lasso tool.

FIGURE 6.33 Control how magnetic the tool acts using controls in the Tool Options bar.

FIGURE 6.34 The Contrast setting finds an edge in high-contrast areas (left, set to 80 percent) and low-contrast areas (right, set to 5 percent).

FIGURE 6.35 The Frequency option lets you set how closely the fastening points are spaced. The top is set to 7, and the bottom is set to 70.

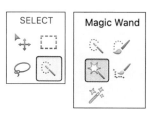

FIGURE 6.36 Access the Magic Wand and its settings in the Tool Options bar.

Tolerance: 32 *Tolerance: 90*

FIGURE 6.37 The Tolerance setting determines how wide a range of colors is included in the selection.

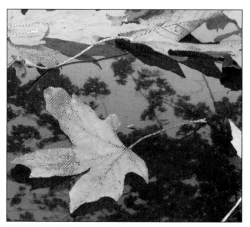

FIGURE 6.38 Deselect Contiguous if you want to select similar colors throughout the image.

Make Selections by Color

The Magic Wand tool allows you to make selections based on a selected color or tonal value. It can seem truly magical—or wildly unpredictable—at first. When you select an area of an image, the tool selects all of the pixels within a color or tonal range close to the pixel you've initially selected.

The Grow and Similar commands, found in the Select menu, can be used to expand the selection area. The Grow command expands the range of adjacent pixels, and the Similar command expands the selection based on the pixel colors.

To use the Magic Wand:

1. Select the tool in the lower-right corner of the Select group in the toolbox and, in the Tool Options bar, select the Magic Wand (or press A until it's selected) (**FIGURE 6.36**).

2. Select the tolerance (a range of colors from 0 to 255) to establish how wide a tonal range you want to include in your selection.

 The default tolerance level is 32. To pick colors or tonal values very close to the selected pixel, choose lower numbers. Entering higher numbers results in a wider selection of colors (**FIGURE 6.37**).

3. If you want your selection to have a smooth edge, select Anti-aliasing.

4. If you want to select similarly colored pixels that are not adjacent to the original pixel, deselect Contiguous (**FIGURE 6.38**).

5. Click a color or tone in the image to make the selection.

To expand the selection area:

1. Select the Magic Wand tool.

2. Click a color or tonal value in the image.

3. Choose Select > Grow to expand the selection of adjacent pixels (**FIGURE 6.39**).

 Each time you select Grow, the selection is expanded by the Magic Wand's Tolerance value.

To include similar colors:

1. Select the Magic Wand tool.

2. Click a color or tonal value in the image.

3. Choose Select > Similar to expand the selection of nonadjacent pixels.

 The selection is extended through the image to similar tonal values using the tolerance amount set in the Tool Options bar (**FIGURE 6.40**).

TIP When you make a selection with the Magic Wand, it takes a color "sample" from your image, typically a single pixel. Using the Eyedropper tool, you can adjust the sample size. Select the Eyedropper tool and then, in the Tool Options bar, click one of the following Color Picker options: Point Sample (1 pixel); Average (3x3), which uses an area measuring 9 pixels total; or Average (5x5), which uses a 25-pixel area. The active option determines how the Magic Wand establishes the sample color.

TIP You can also access the Grow and Similar commands by right-clicking after you have made a selection with the Magic Wand. A context menu appears in the image window, which includes Grow, Similar, and a number of other useful selection commands.

FIGURE 6.39 Making a selection missed the left section of the leaf (top). After choosing Select > Grow, the selection expands to adjacent, similarly colored areas (bottom).

FIGURE 6.40 Choose Select > Similar to add pixels throughout the image to your selection.

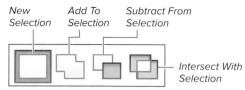

New Selection | Add To Selection | Subtract From Selection

Intersect With Selection

FIGURE 6.41 To add to the current selection, either click the Add To Selection icon in the Tool Options bar or hold the Shift key while making another selection.

W: 0.971 in
H: 0.742 in

FIGURE 6.42 In this example, two selections combine to form a single selection.

Add or Subtract Selections

You can tell by now that a little fine-tuning is needed to make selections just the way you want them. For example, imagine you're using the Magnetic Lasso tool to trace the outline of a face, but then realize you didn't include the ear in your selection. Rather than start again from scratch, you can add to or subtract from your selection until you've included every part of the image you want. The Editor even lets you select just the intersection (or overlapping area) of two independent selections.

To add to a selection:

1. Make a selection in your image with any of the selection tools.

2. With the selection still active, do one of the following:

 ▸ Using the same selection tool or another one, click the Add To Selection button in the Tool Options bar (**FIGURE 6.41**). If that button is already highlighted, skip to step 3.

 ▸ Hold the Shift key. A plus sign appears next to the pointer, indicating that you are adding to the current selection.

3. Make a new selection in your image (**FIGURE 6.42**). If you want to add to your existing selection, make sure your new selection overlaps the original. If you want to create an additional selection, make sure you click outside the original selection. The newly selected area is added to your first selection.

To subtract from a selection:

1. Make a selection with any of the selection tools.

2. With the selection still active, do one of the following:

 ▸ Select the Subtract From Selection button in the Tool Options bar, optionally choosing a different selection tool.

 ▸ Hold the Alt/Option key.

 A minus sign appears on the pointer, indicating that you are subtracting from the current selection.

3. Drag the pointer through the area you want to subtract.

 The area you defined is removed from the selection (**FIGURE 6.43**).

To select the intersection of two selections:

1. Make a selection with any of the Marquee or Lasso selection tools.

2. With the selection still active, do one of the following:

 ▸ Select the Intersect With Selection button in the Tool Options bar and create a new selection that overlaps the current selection.

 ▸ Hold Alt+Shift/Option+Shift and create a new selection that overlaps the current selection. An X appears, indicating that you are selecting an area of intersection.

3. A new selection area is formed based on the intersection of the two selections (**FIGURE 6.44**).

FIGURE 6.43 A pie-shaped cutout is left where the rectangle selection was subtracted.

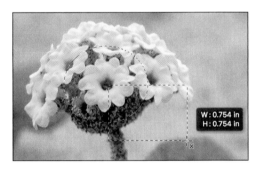

FIGURE 6.44 In this example, only the area of intersection remains.

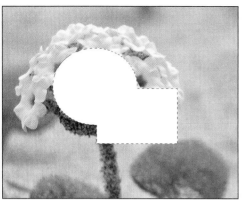

FIGURE 6.45 When you delete a selection, the selected area disappears, and your current background color (or lower layer) shows through.

To deselect the current selection:

From the Select menu, choose Deselect, or press Ctrl+D/Command+D.

To reselect the last selection:

Choose Select > Reselect, or press Ctrl+Shift+D/Command-Shift+D.

To delete a selection:

Choose one of the following methods:

- From the menu bar, choose Edit > Cut, or press Ctrl+X/Command+X.
- Press Backspace/Delete.

 When you delete a selection, the portion of the image within your selection disappears entirely, leaving a hole in your image (**FIGURE 6.45**). If you accidentally delete a selection, choose Undo from the Edit menu or press Ctrl+Z/Command+Z.

To hide a selection border:

From the View menu, uncheck Selection, or press Ctrl+H/Command+H.

Sometimes, after you've made a selection, you want to hide the selection marquee while you edit the image; this prevents the selection border from obscuring your view. Be sure to make the selection visible once you're done—otherwise, you might lose track of it.

TIP You can deselect an entire selection at any time by pressing the Esc key.

Refine the Edges of a Selection

Selections often work best when their edges are smooth, instead of hard. Anti-aliasing adds blended pixels to create a smooth edge instead of a stairstepped or jagged edge (**FIGURE 6.46**). Most selection tools offer an Anti-aliasing option in the Tool Options bar. That option is usually checked by default, and you almost always want to leave anti-aliasing enabled. When you're compositing images (combining several pieces into one), anti-aliasing smooths the border between elements.

But when you're making selections, sometimes anti-aliasing isn't enough. For example, selecting a person's hair is often tricky: Although the Select Subject command works really well in general, you can still end up with jagged edges around the hair (**FIGURE 6.47**).

The Refine Edge feature uses several techniques to deal with this issue. I'm using a person as the image for the following technique, which will give you an idea of what the controls can do.

To refine the edge of a selection:

1. With a selection made, click the Refine Edge button in the Tool Options bar, or choose Select > Refine Edge.

2. Adjust the Radius slider to change the width of the selection edge. When you select the Smart Radius checkbox, the Editor analyzes the hard and soft areas of the border region. (Click Show Radius to view just the selection border.)

3. In the Refine Edge dialog, increase the Feather value to soften the outside edge (**FIGURE 6.48**).

FIGURE 6.46 Anti-aliasing automatically smooths a selection edge by adding pixels that blend the color transition.

FIGURE 6.47 Select Subject did a fine job of identifying the person, but the selection edge is pretty rough.

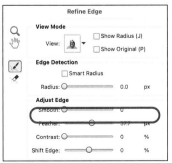

FIGURE 6.48 Increasing the Feather amount blends the edge with the background.

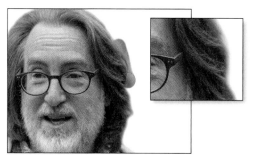

FIGURE 6.49 Use the Refine Radius tool to blend stray hairs and background color at the edges.

Original photo

After using Refine Edge

FIGURE 6.50 By refining the selection, the subject blends into a new background.

4. Increase the Contrast value to keep the feathered edge but also add some definition to it.

5. For areas that still show some of the original background bleeding through (a common occurrence with hair), select the Refine Radius tool in the dialog (which is enabled by default) and drag over the section (**FIGURE 6.49**). The tool expands the detection area and recalculates the blend there. You can use the Erase Refinements tool to restore the original selection in areas, using the same types of calculations, if the Refine Radius tool went too far.

6. If needed, use the Shift Edge control to expand or contract the selection.

7. Click the Decontaminate Colors checkbox and drag the Amount slider to remove any additional color fringe around the selection.

8. From the Output To menu, choose how to save the refined edge: as a new selection, layer, or document, each with the option of defining the selection using a layer mask.

 Some of the adjustments can dramatically affect the pixels in the selection border, so I prefer to use New Layer With Layer Mask; it blends with the original layer if needed, and exists as a separate layer item in case you want to discard or adjust it later. (See Chapter 7, "Working with Layers.")

9. Click OK to apply the changes and output them to a new layer, with the selection applied as a layer mask (**FIGURE 6.50**).

TIP The Marquee and Lasso tools include a Feather slider in the Tool Options bar, which can also be helpful. However, I prefer the greater amount of control offered by the Refine Edge feature when refining selections.

Modify Selection Borders

There are other ways to make subtle—or not so subtle—changes to a selection border. The Border feature lets you change the width of the selection border. The Smooth command smooths out a jagged or irregular selection edge. To increase or reduce the size of a selection, use Expand or Contract.

To change the width of the border:

1. Make a selection in your image with any of the selection tools.
2. Choose Select > Modify > Border.
3. Enter a value for the border width.

 The selection border changes based on the number you enter (**FIGURE 6.51**).

To smooth the edge of a selection:

1. Choose Select > Modify > Smooth.
2. Enter a value for the radius of the smoothing effect.

 The radius values range from 1 to 100 and define how far away from the current edge the selection will move to create a new, smoother edge.

To expand or contract the selection area:

1. Choose Select > Modify > Expand or Select > Modify > Contract.
2. Enter a value for the number of pixels you would like the selection to either grow (expand) or shrink (contract) (**FIGURE 6.52**).

FIGURE 6.51 The Border command lets you control the width of a selection border. In this example, a 100-pixel border is selected at left, then filled with color at right.

Selection *Expanded*

Contracted

FIGURE 6.52 You can expand or contract the size of a selection border from the Modify menu.

Working with Layers

One feature that sets Photoshop Elements apart from other image editors is the ability to work on multiple layers. Layers provide a lot of flexibility while editing, enabling you to merge separate images into creative compositions.

Layers are also immensely important when making multiple edits to photos. Instead of altering the pixels on the image itself, you can add adjustment layers that change brightness, color, saturation, and other attributes. Separating the edits from the image on layers means you can try several settings without having to roll back your changes every time.

In this chapter, you'll learn how layers are created, and then explore several methods and techniques to help you take advantage of one of the Editor's essential features.

In This Chapter

Understand Layers

When you first import or scan an image into Photoshop Elements, it consists of one default layer. When you begin working with some of the more involved and complex image manipulation and retouching tools, you'll find that layers make things a whole lot easier.

Layers act like clear, transparent sheets stacked one on top of another, and yet, when you view a final image, they appear as one unified picture (**FIGURE 7.1**). As you copy and paste selections, you may notice these operations automatically create new layers in your image.

You can edit only one layer at a time, which allows you to select and modify specific parts of your photo without affecting the information on other layers. This is the real beauty of layers: the ability to work on and experiment with one part of your image while leaving the rest of it completely untouched.

Adjustment layers are even more flexible, letting you make color and tonal corrections to individual or multiple layers below them without changing the actual pixels.

Layers appear in your image in the same order as they appear on the Layers panel. The top layer of your image is the first layer listed on the Layers panel, and the Background layer is at the bottom of the list.

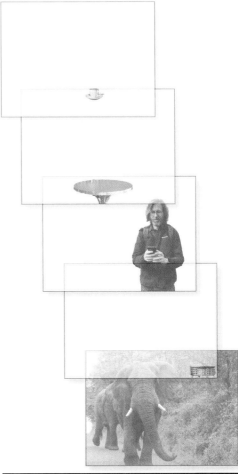

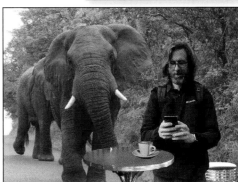

FIGURE 7.1 Layers act like clear acetate sheets, where transparent areas let you see through to the layers below. (It's a good thing I showed the layers, or you might think the photo was straight out of the camera!)

New Create Fill/ Add
Layer/ Adjustment Layer Delete Panel
Group Layer Mask Lock Layer menu

Show or hide layers *Fully locked*

Active layer *Transparent*
pixels locked

FIGURE 7.2 The Layers panel gives you complete control over the stacking order of your layers, whether they're visible or hidden.

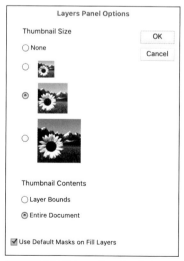

FIGURE 7.3 Change thumbnail views from the Layers Panel Options dialog.

Use the Layers Panel

The Layers panel appears in Expert mode. You can select which layer to make active, display and hide layers, and lock layers to protect them from unintentional changes (**FIGURE 7.2**). You can also change layer names, set the opacity (transparency) of individual layers, and apply blending modes.

The panel menu offers quick access to many of the same commands found on the Layer menu, plus options for changing the appearance of the panel thumbnails.

To view the Layers panel:

Do one of the following:

- Choose Window > Layers.
- Click the Layers button in the taskbar.
- Choose Window > Reset Panels to return all the panels to their default locations, including Layers.

To view the Layers panel menu:

Click the Panel Options button in the top-right corner of the Layers panel. Once the Layers panel menu is open, you can select a command from the menu.

TIP To change the appearance of the layer thumbnail views, choose Panel Options from the Layers panel menu and click the size you want (**FIGURE 7.3**). The smaller the icon, the more layers you're able to view at a time.

TIP Normally the Layers panel sits at the right side of the workspace, but you can also make it free floating. Click the triangle next to the More button in the taskbar and choose Custom Workspace. The panels become tabbed; drag the Layers tab out of the Panel Bin and position it wherever you like. Choose Basic Workspace from the same menu to return to the incorporated panel.

Layer Fundamentals

To begin working with layers, you need to master just a few fundamental tasks. Start by creating and naming a new layer, and then add an image to it. Once you've constructed an image file of multiple layers, you need to select the individual layer before you can work on that layer's image. Keep in mind that any changes you make will affect only the selected (active) layer.

To create a new layer:

1. Choose Layer > New > Layer. You can also click the Layers panel menu and choose New > Layer, or press Ctrl+Shift+N/Command+Shift+N.

2. In the New Layer dialog, choose from the following options:

 ▸ Rename the layer with a more meaningful and intuitive name. The default names are Layer 1, Layer 2, Layer 3, and so on (**FIGURE 7.4**).

 ▸ Optionally choose a color, which makes it easy for you to identify related layers in compositions with many layers (**FIGURE 7.5**).

 ▸ Optionally choose a blending mode for the layer from the Mode menu. The default is Normal, meaning that no change will be applied to the layer. See "Set Opacity and Blending Modes," later in this chapter.

 ▸ Optionally set the layer's opacity level. Opacity can also be adjusted at any time from the Layers panel.

 ▸ Optionally apply a clipping mask over a previous (or lower) layer. The lower layer acts as a window for the upper layer's image to show through. See "Create Clipping Masks," later in this chapter.

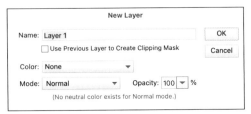

FIGURE 7.4 Default layer names are Layer 1 for the first layer you create, Layer 2, Layer 3, and so on. You can enter a new name when creating a layer, or you can rename it later.

FIGURE 7.5 Color-coding can help make sense of files with multiple layers.

FIGURE 7.6 Click the New Layer button to quickly create a new, blank layer.

TIP A faster method to create a new layer, and the one I prefer, is to click the New Layer button on the Layers panel, which bypasses the New Layer dialog (**FIGURE 7.6**). The new layer appears as the top layer in the panel with the default blending mode and opacity applied. To rename the new layer, double-click its name in the Layers panel and enter a new name.

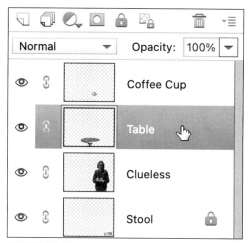

FIGURE 7.7 Click the layer name or thumbnail to make it the active (editable) layer.

FIGURE 7.8 When you click a layer in the image window, a bounding box appears to show you that it is the selected, active layer.

Visible Hidden

FIGURE 7.9 Click the eye icon to hide a layer; click again to make the layer visible.

To select a layer:

- On the Layers panel, click the Layer thumbnail or name to make that layer active **(FIGURE 7.7)**.

 If you've imported an image from a camera, by default it will have only one layer—the Background layer, which is selected automatically.

- Select the Move tool and click directly on a layer in the image window. A border with selection handles appears around the layer to indicate that it's selected **(FIGURE 7.8)**. (If this isn't working, make sure Auto Select Layer is enabled in the Tool Options bar.)

To show or hide a layer:

On the Layers panel, click the Visibility icon (the eye) to hide the layer (a red line appears over the eye). Click again and the layer becomes visible **(FIGURE 7.9)**.

TIP When you try to select or make changes to an area in your image, you might encounter weird and unexpected results. For example, you can't copy a selection, or you apply a filter but nothing happens. More often than not, this is because you don't have the correct layer selected. Refer to the Layers panel to see if this is the case. Remember that the active layer is always highlighted.

TIP Quickly show or hide multiple layers by clicking and dragging through the Visibility column.

TIP You can assign a color to a layer: Right-click the layer and choose one of the colors from the menu. This feature is especially helpful when working with multiple layers in groups (see "Group Layers," later in this chapter).

TIP To quickly display just one layer and hide the others, Alt-click/Option-click its Visibility (eye) icon. Alt-click/Option-click again to show all layers.

To delete a layer:

1. Select a layer on the Layers panel.
2. Do one of the following:
 - ▶ With the layer selected, click the Delete Layer button (the trash can icon) on the Layers panel **(FIGURE 7.10)**, and then click Yes in the dialog that appears.
 - ▶ From the Layer menu or from the Layers panel menu, choose Delete Layer.
 - ▶ Drag the layer to the Delete Layer button on the Layers panel.

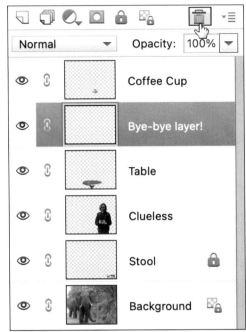

FIGURE 7.10 Clicking the Delete Layer button removes the selected layer.

Background Layers

When you open a photo imported from a digital camera or scanner, the photo appears on the Background (or base) layer. In fact, when you open an image file from just about any source, chances are it contains only a Background layer. This layer cannot be reordered (that is, its relative position or level cannot be moved), and it cannot be given a blending mode or assigned a different opacity.

When you create a new image and choose Transparent for its background, the bottom layer is called Layer 1. If additional layers are added, this layer can be reordered, and you can change its blending mode or opacity just as with any other layer.

A simple Background layer can never be transparent, but that's okay if you're not concerned with changing opacity or applying blending modes. However, if you want to take advantage of the benefits transparency offers, start by creating an image with transparent background contents, or converting an existing Background layer to a regular layer.

See "Convert and Duplicate Layers," later in this chapter, for details on turning Background layers into regular layers (and vice versa).

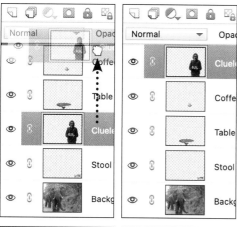

FIGURE 7.11 Drag a layer up or down on the Layers panel to change its stacking order.

Change the Layer Order

The layer stacking order determines which layers are on top of others, and plays a big role in determining how your image looks. As you build a composition, you may decide you want to change the layer order, either to help you work more easily on a particular layer, or to get a particular result or effect. The visible overlapping of elements is determined by the layer order, so you may need to reorder layers frequently when you work on complex images.

The Editor provides two main ways to change the stacking order of your layers. The most common and versatile approach is to drag the layer within the Layers panel. The second way is to select the Layer > Arrange menu, and then choose such commands as Bring To Front and Send To Back—a method similar to what you use to arrange objects in a drawing program.

To change the layer order by dragging:

1. On the Layers panel, select the layer you want to move.

2. Drag the layer up or down on the Layers panel (**FIGURE 7.11**).

 You will see a thick double line between the layers, indicating the new layer position.

3. Release the drag when the layer is in the desired location.

To change the layer order by arranging:

1. Select the layer you want to move on the Layers panel.

2. Choose Layer > Arrange, and then choose one of the following commands from the submenu; or use the keyboard shortcuts noted for each (**FIGURE 7.12**).

 ▸ Bring To Front (Ctrl+Shift+]/Command+ Shift+]) moves the layer to the top of the Layers panel and the image (**FIGURE 7.13**).

 ▸ Bring Forward (Ctrl+]/Command+]) moves the layer up by one step in the stacking order (**FIGURE 7.14**).

 ▸ Send Backward (Ctrl+[/Command+[) moves the layer down by one step in the stacking order.

 ▸ Send To Back (Ctrl+Shift+[/Command+ Shift+[) makes the layer the bottom layer on the Layers panel (but see the tip below).

 You can also Shift-click to select two layers on the Layers panel, and choose Reverse to swap their order in the layer stack.

> **TIP** If your image contains a Background layer and you choose the Send To Back command, you'll find that the Background layer stubbornly remains at the bottom of your Layers panel. By default, the Background layer is locked in place and can't be moved. To get around this, double-click and rename the Background layer to convert it to a functional layer. Then you can move it wherever you like.

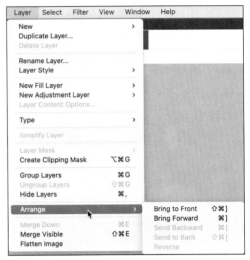

FIGURE 7.12 Change a layer's position using the options on the Layer > Arrange menu.

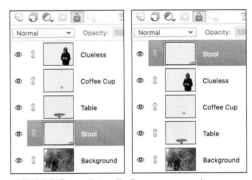

FIGURE 7.13 The Bring To Front command moves the selected layer to the top level in your image.

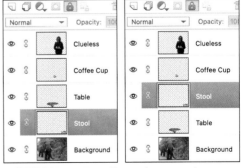

FIGURE 7.14 The Bring Forward command moves the selected layer up just one level.

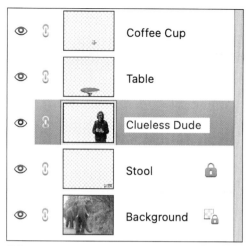

FIGURE 7.15 To rename a layer, double-click its name on the Layers panel.

Link button

FIGURE 7.16 Link icons indicate which layers are linked together.

Manage Layers

As your image becomes more complex, consider renaming your layers—it's much easier to find a cloud image on a layer called Clouds than it is to remember that it's on Layer 14.

You can also link layers together, so that any changes, such as moving and resizing, happen to two or more layers together.

And you can protect layers from unwanted changes by locking them. All layers can be fully locked, so that no pixels can be changed, or you can lock just the transparent pixels, so that any painting or other editing happens only where opaque (non-transparent) pixels are present. This partial locking is useful if you know that you want to preserve certain areas as transparent (like for a graphic you want to incorporate into a web page). Locking an image protects it in other ways, too: You can move a locked layer's stacking position on the Layers panel, but the layer can't be deleted.

To rename a layer:

1. Double-click the layer's name on the Layers panel to display the text cursor and make the name editable **(FIGURE 7.15)**.

2. Enter a new name for the layer and press the Enter/Return key. The new name appears on the Layers panel.

To link layers:

1. Ctrl-click/Command-click (or Shift-click) to select the layers on the Layers panel that you want to link.

2. Click the Link button in any of the selected layers. The Link icon appears yellow in each linked layer **(FIGURE 7.16)**.

To lock all pixels on a layer:

1. Select the layer on the Layers panel.
2. Click the Lock All Pixels button.

 The Lock All Pixels icon appears to the right of the layer name on the Layers panel (**FIGURE 7.17**).

To lock transparent pixels on a layer:

1. Select the layer on the Layers panel.
2. Click the Lock Transparent Pixels button.

 The Lock Transparent Pixels icon appears to the right of the layer name on the Layers panel (**FIGURE 7.18**).

To unlock pixels on a layer:

1. Select a layer with locked pixels (all or transparent).
2. Click the Lock All Pixels or Lock Transparent Pixels button to release the lock.

 The Lock icon on the layer disappears.

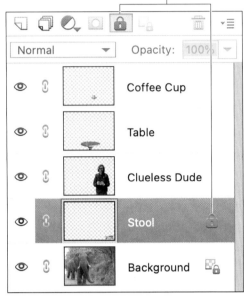

FIGURE 7.17 The Lock All Pixels icon indicates that the layer's pixels are completely locked. Also notice that the Delete Layer button is dimmed to protect against accidentally trashing the layer.

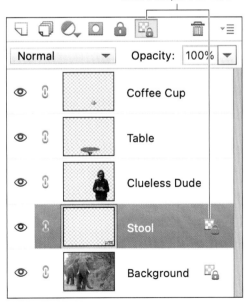

FIGURE 7.18 The Lock Transparent Pixels icon indicates that the transparent pixels are locked.

FIGURE 7.19 Select an area to convert to its own layer.

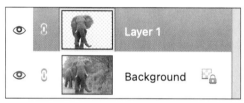

FIGURE 7.20 Copying the selection to a new layer leaves the original selection unchanged.

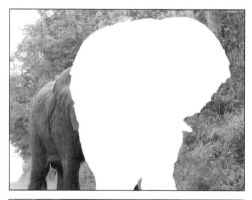

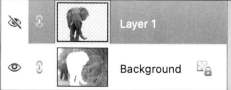

FIGURE 7.21 The Layer Via Cut command cuts the selected pixels to a new layer. (The new layer has been hidden here to demonstrate that it's actually cut, not copied.)

Convert and Duplicate Layers

You now know you can create new layers; in addition, the Editor creates layers in all sorts of ways. For example, whenever you copy and paste a selection into an image, it's automatically added on a new layer.

When you start editing an image, you'll often find it convenient to create a selection and convert that to a layer to keep it isolated and editable within your photo. Duplicating a layer is useful when you want to copy an existing layer as is, or use it as a starting point and then make changes while keeping the original layer intact.

The Background layer is unique and by default can't be moved, but sometimes you will need to move it, change its opacity, or apply a blending mode. To do any of those things, you'll need to convert it to a regular layer. And sometimes you'll want to convert an existing layer to the Background layer.

To convert a selection to a layer:

1. Make a selection using any of the selection tools (FIGURE 7.19).

2. Choose Layer > New, and then one of the following commands:

 ▸ Layer Via Copy (Ctrl+J/Command+J). The selection is copied to a new layer, leaving the original selection unchanged (FIGURE 7.20).

 ▸ Layer Via Cut (Ctrl+Shift+J/Command+Shift+J). The selection is cut to a new layer, leaving a gaping hole in the original layer, with the current background color showing through (FIGURE 7.21). (See Chapter 12 for more on foreground and background colors.)

To duplicate a layer:

1. Select the layer on the Layers panel.

2. Duplicate the layer using one of the following methods:

 ▸ If you want to give the layer a unique name (not just adding *copy* to the end of the original layer name), choose Layer > Duplicate Layer. The Duplicate Layer dialog appears. Enter a new name for the layer in the As field (**FIGURE 7.22**). Note that you can also get to this dialog from the Layers panel menu.

 ▸ If you're not concerned with renaming the layer right now, just drag the selected layer to the New Layer icon on the Layers panel (**FIGURE 7.23**). The new layer appears above the original layer with *copy* added to the name (**FIGURE 7.24**).

TIP Perhaps because it's the method I originally learned, but I always duplicate layers by dragging them to the New Layer button. I then double-click the layer's name to type a new name.

FIGURE 7.22 Use the Duplicate Layer dialog to rename your new duplicate layer.

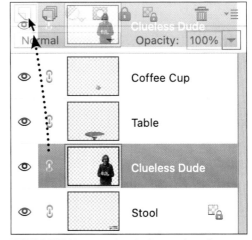

FIGURE 7.23 You can also duplicate a layer by dragging any existing layer to the New Layer button.

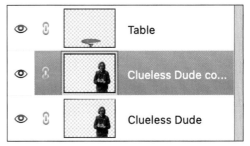

FIGURE 7.24 The new layer appears right above the original layer on the Layers panel.

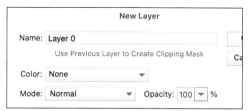

FIGURE 7.25 You can convert the Background layer to a regular layer and rename it.

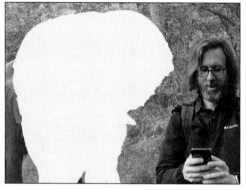

FIGURE 7.26 With no Background layer present, cutting a section of a layer reveals a transparent section.

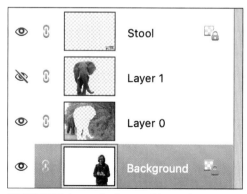

FIGURE 7.27 A new Background layer always appears at the bottom of the Layers panel.

To convert a Background layer to a regular layer:

1. Double-click the Background layer, or choose Layer > New > Layer From Background.

2. Type a new name for the layer, and click OK (**FIGURE 7.25**).

 When the Background layer becomes a regular layer, there's no longer a background, so the pixels under it are transparent. If you cut a selection using the Layer > New > Layer Via Cut technique mentioned earlier, the empty space is transparent instead of filled with the current background color (**FIGURE 7.26**).

To convert a layer to a Background:

1. Select a layer on the Layers panel.

2. Choose Layer > New > Background From Layer.

3. The new Background layer appears at the bottom of the Layers panel and loses its custom name (**FIGURE 7.27**).

TIP The Background From Layer command won't work if you already have an existing Background layer in your Layers panel. Why? Because there can be only one Background layer. To get around this, convert the current Background to a regular layer. Then, follow the steps to convert a regular layer into a Background layer.

TIP The Type and Shape tools also each automatically generate new layers when you use them, keeping those elements isolated on their own unique layers (see Chapter 13).

Group Layers

Once you begin to create projects of even moderate complexity, the number of layers in your project can add up fairly quickly. To reduce visual clutter and organize it better, combine layers into groups. That also allows you to reorder related objects by moving the group, not multiple individual layers. The groups can also be color-coded for easier reference.

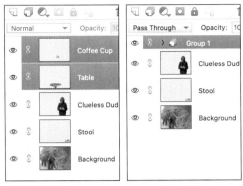

FIGURE 7.28 Create a group out of multiple layers.

To group layers:

1. Select two or more layers you want to include in a group.

2. Click the Create A New Group button on the Layers panel, or choose Layer > Group Layers.

 The selected layers appear in a new grouping called Group 1 (**FIGURE 7.28**).

3. Click the > icon to the left of the group name to view the group's layers (**FIGURE 7.29**).

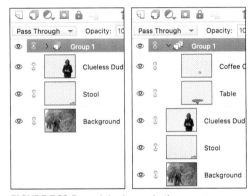

FIGURE 7.29 Reveal the layers in the group.

To assign a color to a group:

Right-click the group name and choose a color from the menu. The Editor assigns the color to all layers in the group (**FIGURE 7.30**).

To ungroup layers:

1. Select the group name.

2. Choose Layer > Ungroup Layers, or right-click and choose Ungroup Layers from the menu.

> **TIP** The blending mode for a group changes from **Normal** to **Pass Through**, which just means that the layers' blending modes are kept unchanged. You can change the group's blending mode, but the individual layers still retain their modes, leading to an interesting mix of modes. (See "Set Opacity and Blending Modes," later in this chapter.)

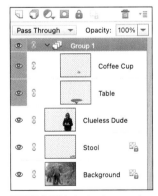

FIGURE 7.30 Assigning a color to the group applies it to each of the group's layers.

FIGURE 7.31 This image is a composite of a number of layers from a 3D rendering program: a Background layer, the pole, the sign's shadow on the pole, and three layers for the sign itself. To simplify the file, the three sign layers were merged into a single layer, and the pole and the shadow were combined (right). The finished image looks the same, but because it's composed of fewer layers, its file size will be significantly smaller.

FIGURE 7.32 Combine layers using the Merge Layers command.

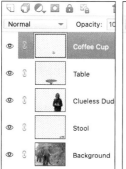 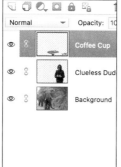

FIGURE 7.33 The three linked layers are merged into one using the Merge Linked command.

Merge Layers

Another, more drastic, way to organize layers is to merge them **(FIGURE 7.31)**. There are a few situations when you may want to merge layers instead of group them.

From a workflow perspective, layers you've finished editing can be merged to lock in those changes, freeing you up for other areas of the image, particularly with large compositions. You may also want to combine linked layers, merge just the layers that are visible, or flatten the entire file by combining all the layers into one.

On a technical level, every layer you add requires a little more of your system's memory. Continue to add layers, and you may notice a decrease in your computer's performance. More layers also equate to a larger file size on disk.

I rarely merge layers (except for cases like the first tip on the next page), but it's good to know the ability is there.

To merge layers:

1. On the Layers panel, select two or more layers you want to merge.

2. Choose Layer > Merge Layers **(FIGURE 7.32)**.

To merge linked layers:

1. Select one layer that's already linked with others.

2. Choose Layer > Merge Linked **(FIGURE 7.33)**.

TIP If a single layer is selected and you want to merge it with the layer directly below it, skip selecting the other layer and just choose **Layer > Merge Down.**

TIP Depending on what's selected, the shortcut **Ctrl+E/Command+E** is used for Merge Layers, Merge Down, and Merge Linked.

To merge visible layers:

1. Hide the layers you don't want to merge.

2. Choose Layer > Merge Visible, or press Ctrl+Shift+E/Command+Shift+E. The visible layers are merged into one layer.

To flatten an image:

1. Choose Layer > Flatten Image.

2. If any layers are not visible, a warning box appears asking if you want to discard the hidden layers. If so, click OK.

 The entire layered file is flattened into one layer (**FIGURE 7.34**).

> **TIP** You can create a merged copy of all of the visible layers on a new layer by holding the Alt/Option key while choosing Layer > Merge Visible. The visible layers themselves aren't merged and so remain separate and intact (**FIGURE 7.35**). This technique offers a way to capture a merged snapshot of your current file without actually merging the physical layers. It can be a handy tool for brainstorming and comparing different versions of the same layered file. For instance, take a snapshot of a layered file, change the opacity and blending modes of several layers, and then take another snapshot. You can then compare the two snapshots to see what effect the different settings have on the entire file.

> **TIP** If there's any chance you may eventually want to make revisions to your layered image, always create a duplicate file before flattening, so the layers are safely preserved in your original. Once you've flattened, saved, and closed a file, there's no way to recover those flattened layers.

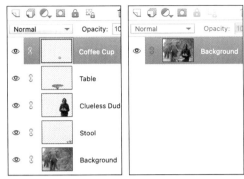

FIGURE 7.34 Use the Flatten Image command to combine all the layers into a single layer.

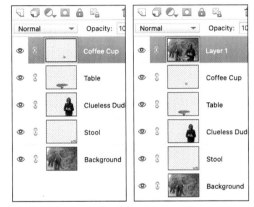

FIGURE 7.35 Hold the Alt/Option key and choose Merge Visible from the Layers panel menu. All visible layers are merged and copied to a new layer, as shown on the right.

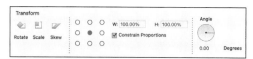

FIGURE 7.36 You can enter precise scale and rotation values for any shape.

100% scale

50% scale, center reference point

50% scale, top-left reference point

FIGURE 7.37 When reducing the layer's image size by half, the reference point determines which direction the scaling is applied.

Transform Layers

So far we've talked about stacking images on separate layers and organizing them, but don't forget that layers are malleable. You can scale (resize), rotate, and distort the pixels either numerically, by entering specific values on the Tool Options bar, or manually, by dragging their control handles in the image window. Constraint options, such as proportional scaling, are available for most transformations, and a set of keyboard shortcuts helps to simplify the process of adding distortion and perspective.

To scale a layer:

1. Select a layer on the Layers panel.

2. Choose Image > Transform > Free Transform, or press Ctrl+T/Command+T. The Tool Options bar displays the scale fields and the reference point locator **(FIGURE 7.36)**.

3. In the Tool Options bar, click the grid to set a reference point location. The reference point determines what point your layer will be scaled to: toward the center, toward a corner, and so on.

4. Enter a value in either the height (H) or width (W) field. The layer is scaled accordingly **(FIGURE 7.37)**.

5. At the lower-right corner of the object, click the Commit button, or press Enter/ Return.

> **TIP** You can also scale a layer manually by selecting it with the Move tool and then dragging any one of the eight handles on the selection border. Constrain the scaling by holding the **Shift** key while dragging one of the corner handles.

To rotate a layer:

1. With a layer selected on the Layers panel, choose Image > Rotate > Free Rotate Layer.

 The Tool Options bar will look familiar: it's the same as the Free Transform option on the opposite page, but with the Rotate option selected **(FIGURE 7.38)**.

2. In the Tool Options bar, click to set a reference point location around which the image will rotate.

3. Drag any handle to turn the image on its axis **(FIGURE 7.39)**. Or, in the Tool Options bar, drag the Angle proxy or enter a value in the Degrees field.

4. Click the Commit button, or press Enter/Return.

TIP To rotate the image in 90- or 180-degree increments or to flip it horizontally or vertically, choose Image > Rotate; then choose from the list of five menu commands below the Free Rotate Layer command. Or, hold Shift while dragging to rotate in 15-degree increments.

TIP You can rotate a layer manually by selecting it with the Move tool, and then moving the pointer outside of the selection border until it becomes a rotation cursor. Drag to rotate the image.

TIP If you simply want to reposition a layer in the image window, click anywhere inside the image with the Move tool, and then drag the image to its new position. Or, with Free Transform already active, drag within the image to reposition it.

FIGURE 7.38 Rotate is another method of transforming the layer.

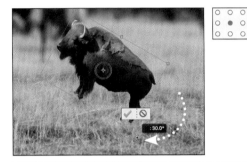

FIGURE 7.39 To rotate the image around the reference point, drag the handles (top) or drag the Angle proxy in the Tool Options bar. You can also enter a specific number in the Degrees field.

Skew

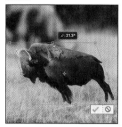

Distort

Perspective

Warp

FIGURE 7.40 Manipulate the pixels by skewing, distorting, applying perspective, or warping the object.

Before

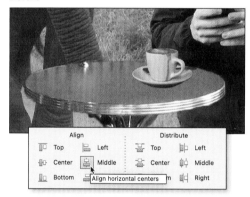

After

FIGURE 7.41 Three selected layers are aligned along their horizontal center axes.

To distort a layer:

1. Click a layer on the Layers panel to make it active.

2. Choose Image > Transform; then choose Skew, Distort, Perspective, or Warp.

3. In the Tool Options bar, check that the reference point location is set to the center.

 The reference point can, of course, be set to any location, but the center seems to work best when applying any of the three distortions.

4. Drag any of the layer's control handles to distort the image.

 Dragging the control handles yields different results depending on the distort option you choose **(FIGURE 7.40)**.

5. In the Tool Options bar, click the Commit button, or press Enter/Return.

To align or distribute layer objects:

1. To align objects, select two or more layers on the Layers panel. Or, to distribute objects (space them evenly in relation to one another), select three or more layers.

2. Select the Move tool.

3. From the Tool Options bar, click Align or Distribute for how you'd like the layer objects repositioned **(FIGURE 7.41)**.

Set Opacity and Blending Modes

One of the most effective and simple ways to enhance your layered image is to create the illusion of combining one layer's image with another by blending their pixels. This differs from merging layers because the layers' pixels aren't actually combined, but rather appear to mix together while retaining the ability to change or undo the effect. The Editor provides two tools at the top of the Layers panel that can be used alone or in tandem for blending multiple layers: Opacity and Blending mode.

The Opacity controls adjust the degree of transparency of one layer over another. If a layer's opacity is set at 100 percent, the layer is totally opaque, and any layers beneath it are hidden. If a layer's opacity is set to 30 percent, 70 percent of any underlying layers are allowed to show through **(FIGURE 7.42)**.

Blending modes are a little trickier. Whereas opacity settings strictly control the opaqueness of one layer over another, blending modes act by mixing or blending one layer's color and tonal value with the one below it. The Difference mode, for example, combines one layer's image with a second, and treats the top layer like a sort of negative filter, inverting colors and tonal values where dark areas blend with lighter ones **(FIGURE 7.43)**.

FIGURE 7.42 Two separate layers (top) compose this image. At an opacity of 100 percent (middle), the bison is opaque. Setting opacity to 50 percent (bottom) reveals the mythical ghost bison.

FIGURE 7.43 This version has opacity set to 100 percent, but a Difference blending mode is applied.

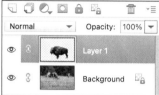

FIGURE 7.44 The top layer's opacity is set at 100 percent.

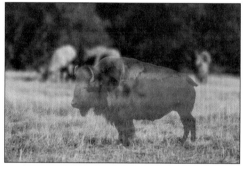

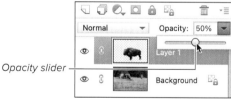

Opacity slider

FIGURE 7.45 Drag the Opacity slider to change a layer's transparency from 0 to 100 percent.

To set a layer's opacity:

1. On the Layers panel, select the layer whose opacity you want to change **(FIGURE 7.44)**.

2. To change the opacity, do one of the following:

 ▸ Enter a percentage in the Opacity text field, which is located at the top of the Layers panel.

 ▸ Click the arrow to activate the Opacity slider and then drag the slider to the desired opacity **(FIGURE 7.45)**.

TIP You can change the opacity settings in 10-percent increments directly from the keyboard. With a layer selected on the Layers panel, press any number key to change the opacity: 1 for 10 percent, 2 for 20 percent, and so on. Also, you can press two number keys in rapid succession—for example, 6 and 6 to set opacity to 66 percent. If this technique doesn't seem to be working, make sure you don't have a painting or editing tool selected in the toolbox. Many of the brushes and effects tools can be sized and adjusted with the number keys, and if any of those tools are selected, they take priority over the Layers panel commands.

TIP A Background layer contains no transparency, so you can't change its opacity until you first convert it to a regular layer (see "To convert a Background layer to a regular layer," earlier in this chapter).

To apply a blending mode to a layer:

1. On the Layers panel, select the upper-most layer to which you want to apply the blending mode.

 Remember, blending modes work by mixing (blending) the image pixels of one layer with the layers below it, so your project will need to contain at least two layers in order for a blending mode to have any effect.

2. Select the desired blending mode from the Blending Mode menu (**FIGURE 7.46**).

TIP You can apply only one blending mode to a layer, but it's still possible to apply more than one blending mode to the same image. After assigning a blending mode to a layer, duplicate the layer and then choose a different blending mode for the duplicate. There are no hard-and-fast rules to follow, and the various blending modes work so differently with one another that getting what you want is largely an exercise of trial and error. But a little experimentation with different blending mode combinations (and opacity settings) can yield some very interesting effects that you can't achieve any other way.

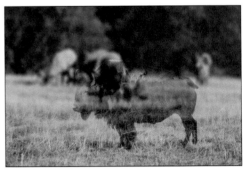

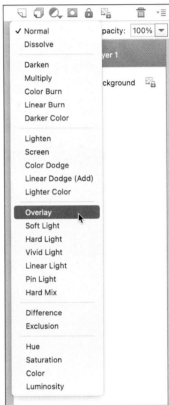

FIGURE 7.46 Select a blending mode from the Blending Mode menu on the Layers panel.

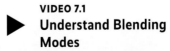

VIDEO 7.1
Understand Blending Modes

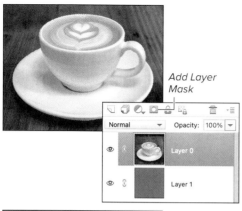

Add Layer
Mask

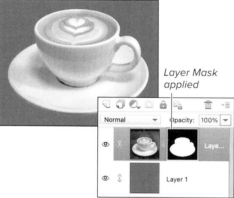

Layer Mask
applied

FIGURE 7.47 The black areas of the mask hide the layer's pixels without deleting them.

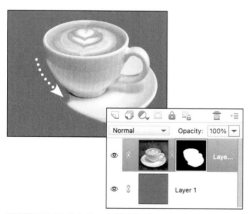

FIGURE 7.48 Painting with black in the layer mask "erases" the visible portion of the image.

Use Layer Masks

In several examples in this chapter, objects (such as the coffee cup or table) have been removed from their backgrounds. In those cases, I made a selection, then deleted the surrounding pixels. The problem, of course, is that I can't get those pixels back without returning to the unedited source files.

There's a better way. Instead of deleting pixels, you can hide them using a layer mask. That enables you to edit what appears at any point, keeping your precious pixels intact.

Layer masks are always grayscale: black pixels hide content, white pixels reveal it. Gray pixels, however, become transparent depending on how dark they are, opening up all sorts of possibilities for compositions.

To create a layer mask:

1. Make a selection of the area in your image you want to keep visible.

2. On the Layers panel, click the Add Layer Mask button. A mask is created and appears to the right of the image thumbnail **(FIGURE 7.47)**.

 To reverse the mask (make the selection transparent) when you create it, Alt-click/Option-click the Add Layer Mask button.

To edit a layer mask:

1. Click the layer mask thumbnail for the layer you want to edit.

2. Use the editing tools to change the contents of the mask. For example, paint with the brush tool set to black to make more areas transparent **(FIGURE 7.48)**.

To unlink a layer mask:

Click the link icon between the image thumbnail and the mask thumbnail. While the mask is selected on the Layers panel (indicated by a blue outline), it can be moved independently of the image **(FIGURE 7.49)**.

To disable a layer mask:

With the layer selected, Shift-click the mask, or choose Layer > Layer Mask > Disable. A red X appears over the mask to indicate that it's not currently active **(FIGURE 7.50)**. To turn it back on, Shift-click it again or choose Layer > Layer Mask > Enable.

To delete a layer mask:

Select the layer and choose Layer > Layer Mask > Delete. The mask is removed, leaving the image untouched.

To apply a layer mask:

If you want to make the mask permanent, choose Layer > Layer Mask > Apply. Transparent pixels are erased from the image on that layer.

TIP The Layer Mask commands are also available by right-clicking and choosing them from the menu that appears. I much prefer this approach, since my pointer is usually already there within the Layers panel.

TIP Ctrl-click/Command-click a layer mask to select its contents without needing to make a new selection.

TIP Because a mask is just a grayscale image, you can apply filters and other interesting effects to it **(FIGURE 7.51)**.

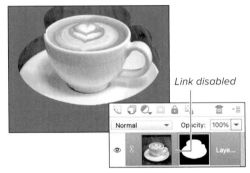

Link disabled

FIGURE 7.49 With the mask unlinked, moving its contents shifts the visible portion of the image, not the image itself.

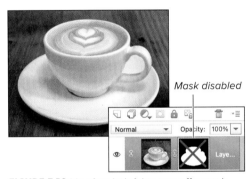

Mask disabled

FIGURE 7.50 It's often helpful to turn off a mask without deleting it when you need to view the full image.

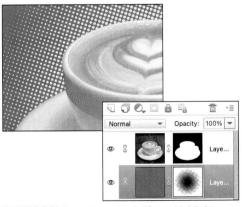

FIGURE 7.51 To achieve this halftone highlight effect, I created a new empty layer below the cup layer, filled it with color, and created a circular gradient within the mask. I then applied the Color Halftone filter to the mask.

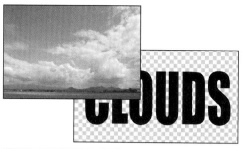

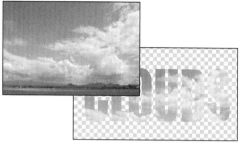

FIGURE 7.52 This file is composed of two layers: a photo of clouds and the CLOUDS text layer. The photo completely covers the text layer in the image at top, but when set as a clipping mask, the clouds peek through only where the text is visible.

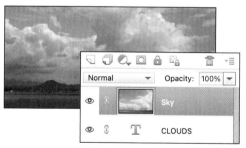

FIGURE 7.53 The CLOUDS text layer serves as the base layer. It will soon be grouped with the Sky layer, which is directly above it.

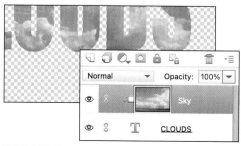

FIGURE 7.54 A clipping mask appears indented.

Create Clipping Masks

A clipping mask is a special way to connect two adjacent layers. You're familiar with the concept of masking—now think of that working between layers. Imagine the upper layer is projected onto the lower layer, and any parts of the upper layer that don't hit the pixels in the lower layer are invisible **(FIGURE 7.52)**. Once applied, any layer mask can be repositioned independently of the others, or all masks can be linked and moved as a group.

To create a clipping mask:

1. On the Layers panel, identify the layer you want to use as your base layer **(FIGURE 7.53)**. Your layers must be arranged so that the layer you want to mask is directly above the base layer.

2. Select the layer above the base layer.

3. Choose Layer > Create Clipping Mask, or press Ctrl+G/Command+G. The two layers are now grouped, and the upper layer is visible only in those areas where the base layer object is present **(FIGURE 7.54)**.On the Layers panel, the base layer's name is underlined, and the masked layer is indented.

To remove a clipping mask:

1. On the Layers panel, select the base layer.

2. Choose Layer > Release Clipping Mask, or press Ctrl+G/Command+G.

TIP For a faster way to create a clipping mask, Alt-click/Option-click the line between the two layers.

Make Color and Tonal Changes with Adjustment Layers

An adjustment layer lets you make color and tonal adjustments to your image without changing the actual pixels in your image. Edits are contained only on the adjustment layer, but their effects apply to any image layers below it. It's especially useful when you want to experiment with different settings or compare the effects of one setting over another.

Because you can apply opacity and blending mode changes to adjustment layers (just as you would to any other layer), they offer a level of creative freedom not available from the adjustment commands found in the Enhance menu (which I cover in Chapter 8). For instance, you could create a Levels adjustment layer above an image, and then change the opacity of that adjustment layer to fine-tune the amount of tonal correction applied.

To create an adjustment layer:

1. On the Layers panel, select the topmost layer to which you want the adjustment layer applied.

 Remember that the adjustment layer affects all layers below it on the Layers panel, not just the one directly below it.

2. From the Create New Fill Or Adjustment Layer menu at the top of the Layers panel, choose an adjustment from the list (**FIGURE 7.55**). The new adjustment layer is created above the selected layer.

3. In the floating panel that appears, use the sliders to adjust the settings (**FIGURE 7.56**).

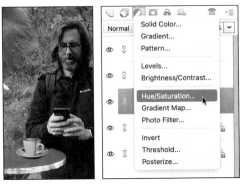

FIGURE 7.55 Choose an adjustment from the Create New Fill Or Adjustment Layer menu.

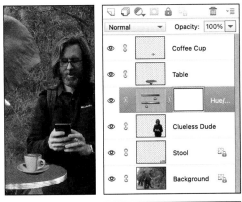

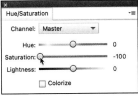

FIGURE 7.56 The edits you make in the adjustment dialog apply to all layers below the adjustment layer, but do not change those layers' pixels. The Coffee Cup and Table layers remain untouched, while the lower three layers appear with the Hue/Saturation adjustment.

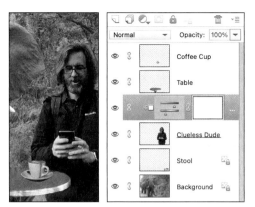

FIGURE 7.57 The adjustment layer is clipped to the object layer directly below it, so only the Clueless Dude layer is affected by the Hue/Saturation settings.

▶ **VIDEO 7.2**
The Superiority of Adjustment Layers

4. Optionally close the floating panel by clicking the X in its title bar.

5. To return to the adjustment layer's settings later, double-click its layer thumbnail.

To apply an adjustment layer to a single layer:

1. On the Layers panel, move the adjustment layer directly above the layer to which you want it applied.

2. With the adjustment layer still selected, choose Layer > Create Clipping Mask, or press Ctrl+G/Command+G.

The adjustment layer and the one directly below it are grouped, and the effects of the adjustment layer are applied only to that single layer **(FIGURE 7.57)**.

TIP A much faster way to create a clipping mask is to Alt-click/Option-click the line between the two layers.

Apply Texture or Color with Fill Layers

The Create New Fill Or Adjustment Layer menu includes not only tonal correction options such as Levels, but also three layer fill options: Solid Color, Gradient, and Pattern. When you combine them with the ability to make clipping masks, you can add a texture or color cast to an image.

For example, suppose you want to make a photo appear as if it were printed on rough paper stock. A Pattern fill layer works well.

To add a texture using a fill layer:

1. From the Create New Fill Or Adjustment Layer menu on the Layers panel, choose Pattern.

2. In the Pattern Fill dialog that appears, click the pattern thumbnail at left to choose from a grid of available patterns (**FIGURE 7.58**).

3. Drag the Scale slider to make the pattern appear larger or smaller (usually making it coarser or finer).

4. Click OK. The pattern covers your photo at this point.

5. On the Layers panel, adjust the opacity setting for the fill layer to bring the photo back into view (**FIGURE 7.59**).

6. If you want to change the attributes of the pattern, double-click the fill layer to bring up the Pattern Fill dialog.

7. Experiment with the settings until you arrive at the look you want (**FIGURE 7.60**).

> **TIP** If you hit upon a combination of pattern and size that you want to reuse, click the Create a New Preset button (the document icon to the right of the pattern thumbnail) in the Pattern Fill dialog to save the settings.

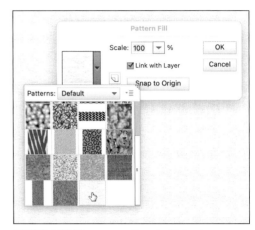

FIGURE 7.58 Choose a pattern to fill the layer.

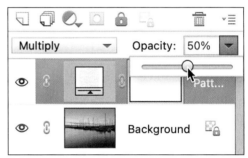

FIGURE 7.59 Reducing the opacity and setting the blending mode to Multiply reveals the photo.

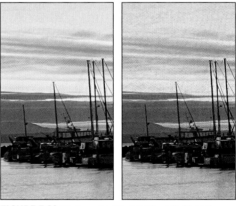

FIGURE 7.60 Texture applied, before (left) and after (right).

Adjusting Lighting and Color

Almost any photograph can benefit from some simple color and lighting corrections. For example, you might find that a vivid sunset you photographed ends up looking rather dull and ordinary because of the camera's attempt to balance the bright light, or that a portrait taken in the shade is too dark to discern any details. Luckily, you're never stuck with a set of inferior images. The Editor provides a powerful set of lighting and color correction tools, with both automatic and manual adjustments, so you can fine-tune your images as much as you want.

In this chapter, I'll review the lighting and color correction tools, and discuss which ones you may want to use and when you'll most likely want to use them. I'll also show you how to help colors display and print accurately (also known as *color management*).

In This Chapter

Understand Tonal Correction

Before we jump into buttons and sliders, let's step back and take a quick look at what we're doing. In plain terms, correcting tonal range simply comes down to adjusting brightness and contrast. The Editor offers several ways to make brightness and contrast adjustments.

One way to understand an image's tones is to view its histogram: choose Window > Histogram to reveal the floating Histogram panel. (I've set the channel to Luminosity in the examples here for simplicity's sake.)

A *histogram* is a graphic representation of the tonal range of an image. The lengths of the bars represent the number of pixels at each brightness level: from the darkest on the left to the lightest on the right. If the bars on both sides extend all the way to the left and right edges of the histogram box, the darkest pixels in the image are black, the lightest pixels are white, and the image is said to have a *full tonal range* (**FIGURE 8.1**).

If, as in many images, the bars stop short of the edges, the darkest and lightest pixels are some shade of gray, and the image may lack contrast. In extreme circumstances, the bars may be weighted heavily to the left or right, with the tonal range favoring either the shadows or highlights (**FIGURE 8.2**).

Whatever the tonal range, the brightness and contrast of an image can be adjusted using sliders located beneath the histogram in the Levels dialog or a Levels adjustment layer (see "Adjust Levels Manually," a few pages ahead).

FIGURE 8.1 A photo displaying full tonal range and its accompanying histogram. Note how the histogram extends all the way to the left and right, indicating that pure blacks are present in the darkest shadow areas and pure whites are present in the lightest highlight areas. The fairly uniform peaks and valleys throughout the middle portion of the histogram also indicate sufficient pixel data present in the midtones.

FIGURE 8.2 Here's the same image, this time too bright. Note the lack of data on the left end of the histogram, indicating a lack of black pixels, and the abundance of data on the right, indicating very light tones.

FIGURE 8.3 The photo on the top lacks sufficient tonal range, particularly in the highlight and lighter midtone areas. The same photo below it, corrected by clicking Auto on a Levels adjustment layer, reveals more detail in both the shadow and highlight areas because the pixels have been distributed across the full tonal range.

Get Smart

Finessing an image's levels and other settings gives you an enormous amount of power to correct tonal ranges—but maybe you don't have the time or desire to mess with sliders. The Auto Smart Fix command under the Enhance menu does it all for you. If you don't like the result, build from there or start over and tackle each setting yourself.

Adjust Lighting

No matter what the photo is, I always start editing by adjusting the lighting. Often an automatic adjustment or a few pulls of a slider can bring out detail that otherwise appears muddy or faint.

Adjust levels automatically

Although I recommend adjusting levels manually, the Auto commands can be a good jumping-off point before launching into more controlled, manual image correction.

The Auto commands tend to be most successful when applied to a photo that contains an average tonal range: one where most of the image detail is concentrated about halfway between the darkest and lightest values. Severely overexposed or underexposed images may be beyond help. If the camera or scanner didn't capture the detail in the first place, it's not there to be corrected.

To apply Auto Levels to an image:

Do one of the following:

1. In the Layers panel, click the Create New Fill Or Adjustment Layer button and choose Levels.

2. In the Adjustments panel that appears, click the Auto button. The image's tonal values are instantly improved **(FIGURE 8.3)**.

Or

Choose Enhance > Auto Levels, or press Ctrl+Shift+L/Command+Shift+L.

If you're not happy with the result, select Edit > Undo, or press Ctrl+Z/Command+Z.

To apply Auto Contrast to an image:

1. Choose Enhance > Auto Contrast, or press Ctrl+Alt+Shift+L / Command+Option+Shift+L.

 The Editor instantly adjusts the image's contrast (**FIGURE 8.4**).

2. To undo, choose Edit > Undo Auto Contrast, or press Ctrl+Z/Command+Z.

TIP As mentioned earlier, the Auto commands work best in specific circumstances (as when the image's tonal range favors the midtones) and should be used sparingly. The Auto Levels command, in particular, can yield surprising and unexpected color shifts. In some instances it seems to overcompensate by swapping out one undesirable color cast for another, whereas in others it may ignore the color altogether and throw the contrast way out of whack. Give these Auto commands a try, but be prepared to commit that Undo keyboard shortcut to memory.

TIP If you're looking for a more straightforward way to make adjustments, the Quick mode groups a cross-section of some of the more commonly used commands and functions into one convenient, interactive workspace. See Chapter 5.

FIGURE 8.4 The photo on the top lacks sufficient contrast, so detail is lost in both the shadow and highlight areas. The photo on the bottom, corrected with Auto Contrast, reveals detail not visible in the original.

Editing with Adjustment Layers versus Editing Image Layers

For ages, I used the Levels command under the Enhance menu to apply levels adjustments directly to each image I edited. It works, certainly, but I've since seen the light: adjustment layers. The problem with correcting levels on the image layer is that the pixel values change. If you want to go back to a previous state, you must wipe out all changes you made in the interim.

Adding an adjustment layer gives you the same benefits without the inflexibility. A Levels adjustment layer makes the same changes but on a separate layer that you can hide or delete without affecting the image layer's original pixels. You can also add several adjustment layers to experiment with different looks. For example, one layer can be set for a high exposure while another emphasizes a darker look; toggle the visibility of each to see which you like better, without having to redo the sliders.

Adjustment layers aren't appropriate in all situations; for example, the Shadows/Highlights dialog can often create slightly better results than just adjusting midtones with a Levels correction. When you want to use a control that isn't an adjustment layer, I recommend duplicating the pixel layer and applying it to that copy. But my advice is: If you can make an edit using an adjustment layer, try that first.

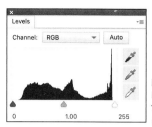

FIGURE 8.5 The Levels controls in the Adjustments panel

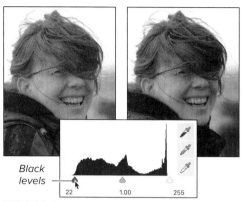

FIGURE 8.6 Moving the left slider underneath the left edge of the histogram spreads the darker pixels more evenly into the dark areas of the midtones and shifts the darkest pixels to black.

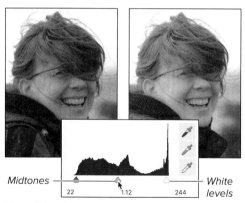

FIGURE 8.7 The right slider affects the lightest pixels in the image. Moving the right slider underneath the right edge of the histogram spreads the lighter pixels more evenly into the light areas of the midtones and shifts the lightest pixels to white, resulting in more detail in the highlight areas.

Adjust levels manually

Is your image washed out or perhaps too dark? Adjusting the levels by hand gives you more control and can result in dramatic improvements.

To adjust the tonal range:

1. Do one of the following:

 ▸ In the Layers panel, click the Create New Fill Or Adjustment Layer button and choose Levels. The Levels panel opens with Levels settings **(FIGURE 8.5)**.

 ▸ Choose Enhance > Adjust Lighting > Levels, or press Ctrl+L/Command+L to open the Levels dialog.

2. Drag the slider on the left until it rests directly below the left edge of the histogram **(FIGURE 8.6)**. The image darkens as the darkest pixels in the image move closer to black.

3. Drag the slider on the right until it rests directly below the right edge of the graph. The image lightens as the lightest pixels move closer to white.

4. Drag the middle slider to the left or right to adjust the brightness level of the pixels that fall in the midtones **(FIGURE 8.7)**.

5. If you're using the Levels dialog, click OK to close it.

TIP These adjustments apply to the entire color range of the image. To modify just the reds, greens, or blues, choose the corresponding color channel from the menu above the histogram.

TIP What about the Brightness/Contrast adjustments? I never use them. Brightness/Contrast indiscriminately lightens or darkens pixels across the entire tonal range, typically creating more problems than it solves.

Adjust shadows

Another way to fix images with over-exposed background images and underexposed foreground subjects is the Shadows/Highlights dialog. Although you could adjust the midtones using a Levels adjustment layer, the Editor uses its smarts in this feature to avoid making the image appear flat.

To lighten detail in shadow:

1. Choose Enhance > Adjust Lighting > Shadows/Highlights.

 The Shadows/Highlights dialog appears **(FIGURE 8.8)**.

2. Do one or all of the following:

 ▸ Drag the Lighten Shadows slider to the right to lessen the effect of the shadows, or to the left to introduce shadow back into the image.

 ▸ Drag the Darken Highlights slider to the right until you're satisfied with the detail in the foreground or other brightly lit areas.

 ▸ Drag the Midtone Contrast slider to the right to increase the contrast, or to the left to decrease the contrast.

3. Click OK to close the dialog and apply the changes **(FIGURE 8.9)**.

> **TIP** Use the **Midtone Contrast slider** sparingly. **A little goes a long way, and adjustments of more than plus or minus 10 percent can quickly wash out or flatten an image's details.**

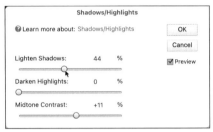

FIGURE 8.8 The Shadows/Highlights dialog

Original image

Levels midtones adjustment

Shadows/Highlights dialog adjustment

Shadows/Highlights edited version

FIGURE 8.9 To lighten the underexposed rocks, I selected them and compared two techniques. The Levels midtones adjustment brightens them but washes out the detail. The Shadows/Highlights dialog retains detail and contrast.

Before　　　　　*After*

FIGURE 8.10 Choose Auto Color Correction from the Enhance menu to automatically remove color cast from your image.

Your Friend, Roy G. Biv (RGB)

RGB stands for red, green, and blue, which are the three color channels your eyes perceive, the three color phosphors used in your computer monitor to display color, and the three channels digital cameras record **(FIGURE 8.11)**. The combination of these channels creates the full-color image you see. Many correction tools allow you to adjust these colors independently.

Red　　　　*Green*　　　*Blue*

FIGURE 8.11 Grayscale versions of each channel's hues

Adjust Color

Color cast refers to a general shift of color to one extreme or another: An image can be said to have a yellow or red cast, for instance. Although sometimes introduced into images intentionally (to create a certain mood or effect), color casts are usually unhappy accidents. They can result from any number of circumstances, from light cast by a fluorescent bulb to a scanner in need of calibrating.

The Editor gives you several ways to deal with color cast or adjust colors that are a little out of whack.

To adjust color with the Auto Color Correction command:

Choose Enhance > Auto Color Correction, or press Ctrl+Shift+B/Command+Shift+B.

That's it. The Editor performs some elegant, behind-the-scenes magic, examining the image's color channels and histogram and performing a little math, and voilà—no more color cast **(FIGURE 8.10)**.

To remove a color cast:

1. If you're specifically adjusting for an image's color cast, another option to try is to choose Enhance > Adjust Color > Remove Color Cast.

2. Using the eyedropper provided, click an area of the image that should be white, gray, or black.

3. Click OK to accept the adjustment.

TIP **I'm constantly amazed at how well Auto Color Correction works, and usually give it a try even if I don't perceive a color cast. It almost always offers some degree of improvement to the color.**

To adjust hue and saturation:

1. Do one of the following:

 ▸ In the Layers panel, click the Create New Fill Or Adjustment Layer button and choose Hue/Saturation.

 ▸ Choose Enhance > Adjust Color > Adjust Hue/Saturation, or press Ctrl+U/Command+U to open the Hue/Saturation dialog.

2. Adjust the Saturation slider to increase or decrease the saturation **(FIGURE 8.12)**.

3. If the hue is slightly off, or if you want to pull the colors in one direction (suppose you want more blues, for example), adjust the Hue slider.

4. Use the Lightness slider to increase or decrease the brightness of the effect.

5. The settings apply to all colors in the image; to adjust the hue, saturation, or lightness of a particular range of colors, choose from the Channel menu at the top of the panel **(FIGURE 8.13)**.

To adjust color using color curves:

1. Choose Enhance > Adjust Color > Adjust Color Curves to open the Adjust Color Curves dialog.

2. To go with one of the tool's suggestions, click a style at left **(FIGURE 8.14)**. Or, drag the sliders to manually tweak highlights, midtone brightness and contrast, or shadows. The points on the color curve to the right represent each setting.

3. Click OK to apply the color changes.

VIDEO 8.1
Photomerge Exposure

Saturation: 0 Saturation: +45

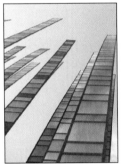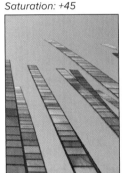

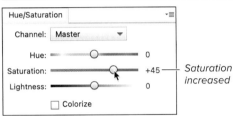

Saturation increased

FIGURE 8.12 Increasing the saturation can punch up the colors in a photo.

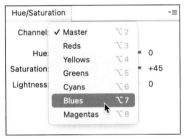

FIGURE 8.13 Adjust color ranges instead of the entire spectrum.

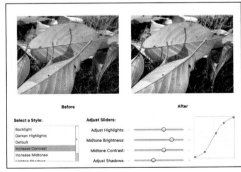

FIGURE 8.14 Adjust Color Curves provides one more way of fine-tuning an image's color.

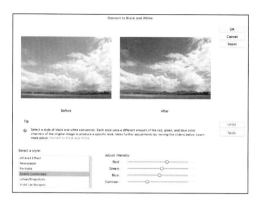

FIGURE 8.15 The Convert To Black And White dialog includes several controls for creating striking black-and-white photos.

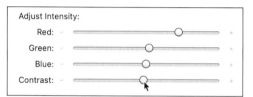

FIGURE 8.16 Experiment with the Adjust Intensity sliders to get the look you want.

FIGURE 8.17 You may not be Ansel, but you're getting there.

Convert to Black and White

If you wanted just a black-and-white photo (*grayscale*, technically), you could set the Saturation slider to –100 in a Hue/Saturation adjustment layer. But black-and-white photography is more than just draining the color. The Convert To Black And White dialog starts with a set of preconfigured styles and then rolls together the ability to set RGB values to highlight different tones with a contrast adjustment.

To convert an image to black and white:

1. Open the image you want to convert.

2. Choose Enhance > Convert To Black And White (or press Ctrl+Alt+B/ Command+Option+B) to open the similarly named dialog **(FIGURE 8.15)**.

3. Optionally, choose a preset from the Select A Style list that matches the type of image you're editing.

4. If you want to change the black-and-white photo's appearance, use the Adjust Intensity sliders **(FIGURE 8.16)**.

5. When you're satisfied with the result in the preview, click OK. The photo is converted to black and white **(FIGURE 8.17)**.

TIP Duplicate the image layer in the Layers panel before you open the Convert To Black And White dialog, and then apply the command to that layer. The feature applies only to the active layer, not the entire image.

TIP Why not simply change the image's color mode to grayscale? That works, but it throws all the color data out of the file. We want to work with as much data as we can when editing.

Remove Color

Unlike converting to black and white (which applies the effect to the entire image), the Remove Color command strips color from just a portion of an image. This feature can be used to great effect for highlighting or dimming specific areas, creating neutral fields in which to place type, or as a first step before applying a colorization or color tint effect.

To apply the Remove Color command:

1. Using any of the selection or marquee tools, select the area of your image from which you want to remove the color (**FIGURE 8.18**).

2. Choose Enhance > Adjust Color > Remove Color, or press Ctrl+Shift+U/ Command+Shift+U.

 All of the color in the selection is replaced by levels of gray (**FIGURE 8.19**).

TIP You can also control how much color to remove from an image or selection by decreasing saturation. In the Layers panel, create a new Hue/Saturation adjustment layer. Then, move the Saturation slider to the left until you achieve the desired effect (**FIGURE 8.20**). The value 0 on the saturation scale represents normal color saturation, whereas –100 (all the way to the left) represents completely desaturated color, or grayscale.

FIGURE 8.18 Select the area you want to convert to grayscale.

FIGURE 8.19 The color in the selection is removed.

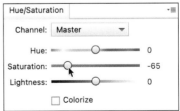

FIGURE 8.20 Control the amount of color you remove using the Saturation slider in the Hue/Saturation panel.

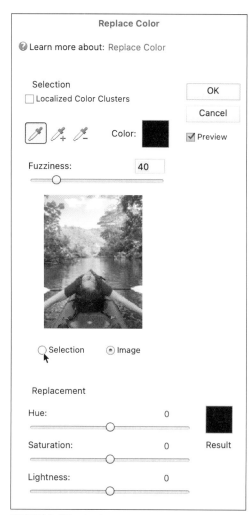

FIGURE 8.21 In the Replace Color dialog, options under the image preview let you choose whether to view your color selections or just the image.

FIGURE 8.22 The color you click in your image is represented in gray in the Selection thumbnail.

Replace Color

The Replace Color command allows you to select a specific color, either across an entire image or in an isolated area of an image, and then change not only the color but its saturation and lightness values as well. Eyedropper tools let you add and subtract colors to be replaced, while a slider control softens the transition between the colors you choose and those around them. I've seen this used to great effect on projects as varied as experimenting with different color schemes before painting a house's trim to changing the color of a favorite uncle's tie so it no longer clashes with his suit.

To replace color across an entire image:

1. Duplicate the image layer you'll be working on. Sometimes the controls can affect colors outside the area you're targeting—such as reds in the background when you intend to change just the reds in the foreground. By working on a duplicate layer, you can later create a mask and let the original background areas show through in those areas if needed.

2. Choose Enhance > Adjust Color > Replace Color.

3. In the Replace Color dialog, click the Selection option under the image preview box (FIGURE 8.21).

 When the Replace Color dialog is open, your pointer will automatically change to an eyedropper when you move it over your image.

4. With this eyedropper, click in the image to select the color you want to change (FIGURE 8.22).

The color selection appears as a white area in the image preview of the Replace Color dialog.

5. To expand the selection and include similar colors, drag the Fuzziness slider to the right **(FIGURE 8.23)**. To contract the selection and exclude similar colors, drag the Fuzziness slider to the left.

 You may want to expand or contract your selection beyond the limits of the Fuzziness slider. If parts of a selection fall too heavily in shadow or highlight, or have very reflective surfaces, you may need to make additional color selections or deletions.

6. To add a color to the selection, Shift-click with the eyedropper in another area of the image. To subtract a color from the selection, press Alt/Option and click.

 The dialog contains separate add and subtract eyedropper tools, but the keyboard shortcuts provide a much more efficient way to modify your color selections.

7. With the Preview checkbox selected, drag the Hue, Saturation, and Lightness sliders until you achieve the desired color effect **(FIGURE 8.24)**.

 These sliders operate just like those in the Hue/Saturation dialog. The Hue slider controls the actual color change; the Saturation slider controls the intensity of the color, from muted to pure; and the Lightness slider controls the color's brightness value, adding either black or white.

8. Click OK to close the Replace Color dialog and view your corrected image **(FIGURE 8.25)**.

FIGURE 8.23 Increasing the Fuzziness value broadens the range of colors affected by the effect.

FIGURE 8.24 Drag the Hue, Saturation, and Lightness sliders until you capture the right color effect. You may have to experiment a little until you get it just right.

FIGURE 8.25 The color of the kayak has been changed without making any selections.

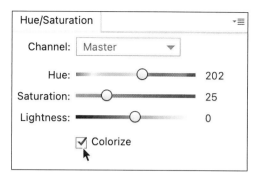

FIGURE 8.26 The position of the Hue slider determines the color your tinted image will be.

Hue/Saturation adjustment layer

FIGURE 8.27 When selectively colorizing your image, you'll get more flexibility by using an adjustment layer.

Add a Color Tint

Using a technique called *colorization*, you can add a single color tint to your images, simulating the look of a hand-applied color wash or the warm, antique glow of an old sepia-toned photograph.

To colorize an area of an image:

1. Using any of the selection or marquee tools, select the area of your image you want to colorize. If you want to colorize an entire image, it's not necessary to make a selection.

2. Do one of the following:
 - ▸ In the Layers panel, click the Create New Fill Or Adjustment Layer button and choose Hue/Saturation.
 - ▸ From the Enhance menu, choose Adjust Color > Adjust Hue/Saturation, or press Ctrl+U/Command+U to open the Hue/Saturation dialog.

3. Select the Colorize option to convert all the color in the image to a single hue **(FIGURE 8.26)**.

4. Drag the Hue slider right or left until you arrive at the color you like.

5. Drag the Saturation slider to adjust its values.

6. Drag the Lightness slider to adjust the color's brightness values.

7. If you opened the Hue/Saturation dialog, click OK to close it.

> **TIP** When you're applying a color tint to just a portion of your image, creating a new Hue/Saturation adjustment layer in the Layers panel is definitely the way to go **(FIGURE 8.27)**.

Managing Color Settings

No matter how your images got into the computer, whether from a digital camera, from a scanner, or downloaded from the Internet, the version of the image stored on your hard disk can only approximate the colors of the original scene. A computer is only capable of dealing with numbers, so it somehow has to come up with numerical equivalents of the colors perceived by our eyes.

Computers use number systems, called *color models*, to display and reproduce color. Almost everything you do in the Editor is in RGB (red, green, and blue; see the sidebar "Your Friend, Roy G. Biv (RGB)" earlier in the chapter). It's also possible to convert images to grayscale, bitmap (black and white only), and indexed color (used for some web images). One color mode not supported is CMYK (cyan, magenta, yellow, and black), which is used in professional publishing. If you need to output images in CMYK, you'll need the full version of Photoshop.

This information is important because cameras, screens, and printers often don't process color information in the same way. However, you can take a couple of steps to help ensure that the color you view on your computer monitor will be close to what Elements outputs for screens or for print.

Calibrating your display

Fortunately, color management in the Editor is simple and doesn't require any labor-intensive chores on your part.

You should first make sure the colors you see on the monitor are reasonably accurate and represent what others will see on their monitors. Calibrating your monitor is a particularly good idea if you

Color Management Is an Imperfect Science

As you start selecting and adjusting colors in the Editor, it's important to understand that the term *color management* can be a little misleading.

Color management operates under the assumption that we're creating artwork at our calibrated monitors under specific, controlled lighting conditions, and that our calibrated printers work at peak performance at all times. In other words, it assumes controlled, uncompromised perfection.

As I write this, the late afternoon sun is casting some lovely warm reflections off the blinds of the window and onto the wall directly behind my computer monitor, and is competing for attention with the glow from the soft-white LED bulb in my desk lamp. Both of those light sources affect how I perceive the pixels on my display.

Therein lies the problem: The vast majority of Photoshop Elements users are working in similarly imperfect conditions.

In addition to trying to make a perfect science out of a host of imperfect variables, color management all but ignores one of the most imperfect sciences of all: our very human, very subjective perception. I may print out an image I find perfectly acceptable, whereas you may look at the same image and decide to push the color one way or another to try to create a different mood or atmosphere. That's what makes everything we create so different. That's what makes it art. And that's (at least in part) what makes color management an imperfect science. So, keep in mind that your images will never look precisely the same when viewed by different users on different monitors. And that's perfectly all right.

FIGURE 8.28 Choose a color management option best suited to the final output of your image.

About Color Profiles

The choices you make in the Color Settings dialog affect only the display of an image onscreen and won't affect how an image is printed. For instance, the Always Optimize For Printing option will simulate the AdobeRGB color spectrum on your monitor but will not assign the AdobeRGB color profile to an image. A *color profile* is information embedded in an image and stored in the background until it's required (usually by a printer). The color profile helps to interpret the RGB color information in an image and convert it to a color language that a printer can understand in order to reproduce the most accurate color possible. You can assign a color profile to an image at any time regardless of the option you've set in the Color Settings dialog. To apply a profile to an open image that's more suitable for printing, choose Image > Convert Color Mode > Convert Color Profile > AdobeRGB.

have an older monitor or have inherited it from a friend or relative (you don't know what they might have done to the monitor settings). If you have a newer monitor, it probably came with an accurate calibration from the factory.

Windows and macOS both include color calibration tools in the Displays preferences. Or, turn to tools such as Datacolor's Spyder (spyder.datacolor.com).

Choose color settings in Elements

If you prefer, you can also choose color settings optimized for either web graphics or color printing.

To choose color settings:

Choose Edit > Color Settings.

The Color Settings dialog appears with three color management options plus the option to choose No Color Management **(FIGURE 8.28)**.

- **Always Optimize Colors For Computer Screens** displays images based on the sRGB (standard RGB) color profile and is the default setting. It's a good all-around solution, particularly if you are creating images to be viewed primarily onscreen.

- **Always Optimize For Printing** displays color based on the AdobeRGB profile. Although the image you see onscreen may display with only subtle color differences (as compared to sRGB), you will generally get truer, more accurate color when you send the image to print.

- **Allow Me To Choose** will default to sRGB, but if the image contains no color profile, you'll have the option of choosing AdobeRGB.

Working with Camera Raw Photos

Most cameras save photos in the JPEG format, which is highly compressed. The processor in the camera analyzes the image, applies automatic corrections, and tosses out pixels to reduce the size of the file. Usually, you won't notice a difference—JPEG is optimized to produce images that are pleasing to the eye.

As good as this process is, it still throws away data. And when you're editing photos, you want to start with as much data as possible.

Many cameras have the capability to save the unedited data captured by the camera's image sensor, which is commonly known as *camera raw*. Each manufacturer uses its own proprietary specifications, so your raw file names will end in .NEF, .CRW, .RAF, or other extensions.

Camera raw gives you more data to work with, which means more flexibility when adjusting white balance or tonal range because the camera hasn't already made choices for sharpening or tonal balance for you. Then, when you're done making raw adjustments, you can continue to edit the image using the other tools in the Editor.

Work in Adobe Camera Raw

When you open one or more raw files, a separate utility called Adobe Camera Raw (often referred to as just ACR) appears in a new window **(FIGURE 9.1)**. This step is required to convert the raw data—literally just ones and zeros—into the colored pixels we see and edit. ACR includes many of the same correction tools found in the Editor, and in some cases many of your adjustments can be done in ACR alone.

FIGURE 9.1 Adobe Camera Raw gives you an opportunity to adjust the raw, unedited image data.

Use camera profiles

Before we jump into manipulating sliders (because you know how much Adobe loves sliders), I want to talk briefly about camera raw profiles.

Camera manufacturers tweak their raw algorithms to fit each camera model, which is why it's often necessary to install updates that provide raw support for the newest cameras on the market. ACR uses that information to determine how to display the image in a few common profiles such as Landscape, Portrait, and Vivid. Although I typically stick with the ACR default (Adobe Color), it's worth checking out the others as a starting point for your adjustments.

To choose a camera profile:

In the Adobe Camera Raw window, choose a camera profile from the Profile menu **(FIGURE 9.2)**.

Adobe Color and Adobe Landscape are good all-around options. Depending on your camera model, you may also see camera-specific profiles **(FIGURE 9.3)**. Click the Browse Profiles button next to the Profile menu and expand the Camera Matching section to reveal them.

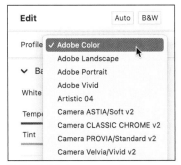

FIGURE 9.2 Camera profiles can interpret the image data differently for common photo situations.

Adobe Color

Camera Velvia/Vivid v2 (a Fujifilm raw profile)

FIGURE 9.3 Two profiles appear different even without making slider adjustments.

Process version warning

FIGURE 9.4 A warning icon appears if an earlier process version is applied.

FIGURE 9.5 Choose a process version in the Calibration pane.

Understand process versions

Not only do camera manufacturers adjust their raw algorithms for each camera model, Adobe is also evolving the way its software handles raw files. Every few years, it incorporates a new *process version* into ACR to better decode the raw data with new or improved features.

Any new raw file you open uses the Version 5 process. If you open a file that was previously processed using an earlier version of ACR, it will open with that older process applied. You can tell right away that an older process version is in use because a warning icon appears **(FIGURE 9.4)**.

You don't need to update to the latest process version—you may have spent considerable time on the image originally, and you don't want to throw away that work. But if you decide to apply the current process, here's how to do it.

To update the process version:

- Click the process version warning icon to update to the current version.

- In the Calibration pane, choose a version from the Process menu **(FIGURE 9.5)**.

> **TIP** The adjustments you make in Adobe Camera Raw apply to the entire image. Any specific areas need to be edited using selections in the Editor after you've exited ACR (see "Save Raw Files," later in this chapter).

Adjust White Balance

Although you can compensate for color casts in the Editor, I prefer the White Balance controls in ACR when editing raw images. It also offers presets that match cameras' white balance modes.

To adjust white balance:

- Choose a preset from the White Balance menu **(FIGURE 9.6)**.

Or

1. Drag the Temperature slider to warm up or cool down the image **(FIGURE 9.7)**.
2. To adjust the color tint—for example, to remove a green color cast—drag the Tint slider.

Or

1. Select the White Balance tool from the toolbar (or press I).
2. Click a white, black, or gray area of your image **(FIGURE 9.8)**. The white balance changes based on where you click.

TIP Adjusting the white balance is a great way to add warmth to an overcast day, or even to add some personalization to a photo without going extreme with filters. In my example photo of a cider press, I deliberately wanted a much warmer image to emphasize the deep color of the cider being produced.

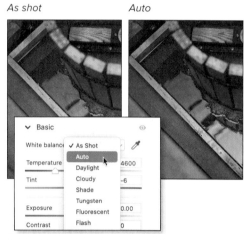

As shot Auto

FIGURE 9.6 White Balance options mirror the settings used by your camera.

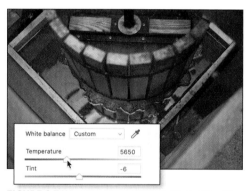

FIGURE 9.7 Warm up or cool down an image using the Temperature slider, or shift color casts using the Tint slider.

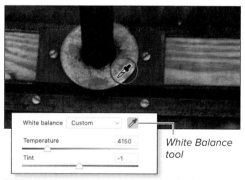

White Balance tool

FIGURE 9.8 Another option is to use the White Balance tool to sample white, black, or gray areas.

Original Auto

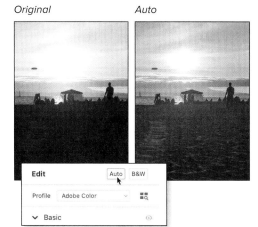

FIGURE 9.9 Clicking Auto is a great first lighting adjustment.

Shadow Highlight
Clipping Warning Clipping Warning

FIGURE 9.10 Display the clipping warnings to identify dark or bright problem areas.

Overexposed areas

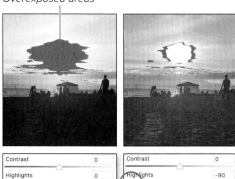

FIGURE 9.11 Decreasing the Highlights value restores visible detail to overexposed areas.

Adjust Lighting

The lighting adjustments in Adobe Camera Raw really demonstrate the advantages of shooting in raw. For example, overexposed areas that in a JPEG would be hopelessly blown out can sometimes be rescued. The lighting controls are similar to many of the features covered in Chapter 8, but are conveniently grouped into one section.

To adjust lighting:

1. As with most adjustments, I recommend clicking the Auto button to see what ACR suggests **(FIGURE 9.9)**. To return to the image's original state, click the Auto button again.

2. To identify areas that are too dark or too light, click the Shadow and Highlight Clipping Warning buttons in the histogram **(FIGURE 9.10)**.

3. Manipulate the individual sliders according to the photo's needs:

 ▸ Exposure brightens or darkens the image.

 ▸ Contrast applies contrast to the image's midtones.

 ▸ Highlights tempers very bright, blown-out areas **(FIGURE 9.11)**.

 ▸ Shadows brightens or darkens midtones.

 ▸ Whites brightens or darkens white values.

 ▸ Blacks pushes darker areas to black or brightens them up a little.

TIP To apply auto adjustments of specific sliders, hold Shift: Most of the lighting controls' names change (for example, Exposure becomes Auto Exposure). Click the name to apply just that adjustment.

Adjust Clarity and Color Saturation

The version of Adobe Camera Raw that ships with Photoshop Elements isn't as robust as what you'll find in the full version of Photoshop. It doesn't include a color mixer for adjusting colors independently, but you can boost or reduce overall color saturation, including the *vibrance* of an image. ACR also lets you modify *clarity*, which can bring out contrasting colors and add drama to a scene.

To adjust clarity:

Drag the Clarity slider to adjust the local contrast between light and dark areas.

To adjust color saturation:

Drag the Vibrance or Saturation sliders:

- ▸ Vibrance applies saturation but doesn't allow colors to become clipped. More importantly, Vibrance keeps skin tones intact (**FIGURE 9.12**).

- ▸ Saturation increases or decreases the color intensity as a whole.

TIP If you're not dealing with skin tones, you can often get more mileage out of the Saturation slider. But be careful: it's easy to overdo it and end up with a photo that looks more like pop art.

Vibrance 0, Saturation 0

Vibrance 0, Saturation +75

Vibrance 0, Saturation +50

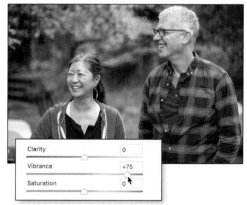

FIGURE 9.12 Applying Saturation (middle) boosts the colors, but adds an unpleasant cast to skin tones—here quite orange. Vibrance (bottom) keeps the skin tones in check while increasing the saturation of the other colors in the image.

Original Sharpening +120

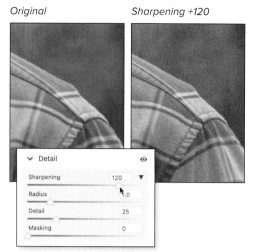

FIGURE 9.13 I set a high Sharpening value on the right (120) to make the effect more visible.

Unaffected area

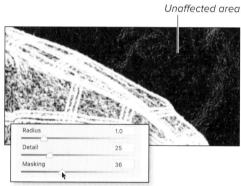

FIGURE 9.14 Hold Alt/Option while dragging to view which masked areas are not sharpened.

TIP Hold the Alt/Option key as you drag a slider to view a version of the image to better see the effect of the adjustment. The Sharpening slider switches to grayscale; Radius and Detail display a flat gray version that shows only the sharpened areas; and the Mask slider identifies sharpened areas in white and masked areas in black (**FIGURE 9.14**).

TIP Camera raw algorithms automatically apply some amount of sharpening, which is why you'll see an Amount value higher than zero even when you've made no adjustments.

Sharpen the Image

Normally, it's a good idea to sharpen an image after most other edits are completed, because making adjustments after can exaggerate the sharpening and cause unwanted halos or artifacts. That said, one advantage of shooting in raw is that the formats include data for handling sharpness at this first raw-decoding stage. Sharpening in ACR often delivers better results, meaning any further sharpening you do in the Editor will be minimal.

To sharpen an image:

1. Expand the Detail pane in the sidebar.

2. Using the Zoom tool, or the Select Zoom Level field in the lower-left corner of the window, increase magnification to 100% or 200% to best view how the effect appears as you edit.

 You can also press Control+Alt+0 (zero)/ Command+Option+0 (zero) to quickly zoom to 100%.

3. Use the Detail sliders as follows:

 ▸ The Sharpening slider controls the amount of the adjustment to apply (**FIGURE 9.13**).

 ▸ Radius sets how many pixels to sample when applying the sharpening.

 ▸ Detail determines how fine the sharpening is to be applied. A lower value sticks to obvious edges, while a higher value emphasizes details such as textures.

 ▸ Masking locates edges and excludes areas that are likely to add noise in broad areas where you don't want it. For example, sharpening a sky can accentuate subtle color variations, but using a high Mask value excludes the sky.

Reduce Noise

When you're shooting in low-light conditions or want to capture objects moving fast, increasing the ISO (light sensitivity) setting on your camera enables you to get shots you might lose. But high ISO comes with a price: more digital noise. The noise reduction sliders can work to remove that digital spottiness in two ways: luminance noise, which manifests as monochromatic spots, and chroma noise, where the dots appear in random colors.

To reduce noise:

1. Expand the Detail pane in the sidebar.

2. Using the Zoom tool, or the Select Zoom Level field in the lower-left corner of the window, increase magnification to 100% or more to see the noise.

3. Drag the Noise Reduction slider to reduce luminance noise **(FIGURE 9.15)**. Or, drag the Color Noise Reduction slider to deal with color noise. (You may need a bit of both.)

4. If necessary, click the expansion triangles for the Noise Reduction and Color Noise Reduction controls to reveal the Detail, Contrast, and Smoothness sliders.

 These controls refine the appearance of the noise reduction.

TIP Noise reduction works by smoothing pixel values, so although you can get rid of unwanted pixelation, you'll also create a softer image overall, especially with the sliders set to high values. Experiment to determine a good balance between noise and softness.

Original

Luminance noise reduction applied

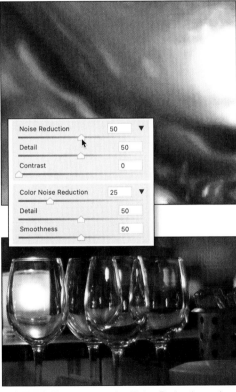

FIGURE 9.15 Increasing the Noise Reduction value smooths the pixels in this low-light photo.

DSCF5871.RAF DSCF5871.xmp

FIGURE 9.16 Raw edits are stored in a separate XMP sidecar file.

FIGURE 9.17 Hold Alt/Option to open the image in the Editor without saving your adjustments first.

Applying Adjustments to Multiple Raw Files

This chapter focuses on editing individual images, but you can also edit several raw files at once (helpful if you're editing photos from the same shoot):

1. Open the raw files you want to edit.

2. Below the main preview area, select the thumbnails of the open images you want to edit simultaneously.

3. Make any adjustments; they're applied to each image as you work. Click an image thumbnail to view it in the editing area.

4. Click the Open button (or Open Copies with Alt/Option held).

Save Raw Files

"Saving" seems a little disingenuous here, because in most cases your adjustments in ACR are just the first step before working with an image in the Editor. But making that step does involve saving, and in the case of raw files it's not straightforward.

ACR treats your raw file as a "digital negative," an untouchable original that you can always go back to if needed. So, any adjustments you make are saved in *sidecar files*—separate XML-formatted text files saved on disk that describe the edits you performed **(FIGURE 9.16)**. Opening the raw file in other editors that support sidecar files gives you the same changes you previously applied. However, if you delete the sidecar file and open the raw file, the image appears as it originally did out of the camera.

When you've finished making adjustments in ACR, a number of actions are available.

To exit ACR:

- Click the Open button to exit ACR and open the image in the Editor. The adjustments you made are saved to the sidecar file.

 At this point you can't change any of the adjustments you made in ACR. Any subsequent edits you make in the Editor are applied on top of what you did in ACR.

- If you want to switch to the Editor but not save the sidecar information, hold the Alt/Option key and click the Open Copy button (which is normally the Open button) **(FIGURE 9.17)**.

continues on next page

- Click Done to save the changes to the sidecar and close the file without opening it in the Editor.

- As you might expect, clicking the Cancel button exits ACR without applying any changes. If you hold Alt/Option, however, the Cancel button becomes the Reset button, which removes any edits you've made so far but keeps the file open.

Limitations of 16-bit Depth

At the bottom of the ACR window is a Depth menu that lets you choose between 16 Bits/Channel and 8 Bits/Channel. Raw images are often captured in 16-bit, which stores much more image data than 8-bit.

However, there's a problem: Although the Editor can open and work with 16-bit files, many features, such as adjustment layers, work on 8-bit images only and aren't accessible. (Also JPEG images are 8-bit, so if you want to save a copy of your photo as a JPEG, you must first switch the depth to 8-bit.)

The solution is to either switch to 8 Bits/Channel in ACR, or choose Image > Mode > 8 Bits/Channel in the Editor.

VIDEO 9.1
Saving Raw Files as DNGs

Fixing and Retouching Photos

How often have you browsed through your photo library and found images you wished were better composed or lit more evenly? Or maybe you've sorted through shoeboxes from the attic, disappointed that time and age have taken their toll on those wonderful old photographs of your dad in his high school band uniform and your grandparents honeymooning at the lake. Until recently, there was no simple way to correct or repair photographs regardless of whether they were out of focus, water damaged, or poorly composed.

Happily, things have changed. In this chapter, you'll learn how to perform a wide variety of photo fixes. I also discuss several clever and time-saving features such as the Photomerge Scene Cleaner (which removes unwanted objects from photos), the Smart Brush tool for quickly painting effects on an image, and much more.

In This Chapter

Repair Flaws and Imperfections

When you're shooting, dust on the lens or the camera sensor can cause unwanted blemishes and flaws. Or, if you're digitizing and restoring old photographs, little maladies such as torn edges, water stains, scratches, and specks of dust on a scanner's glass are all too common. To the rescue come three similar but distinctly different repair and retouch tools.

The Spot Healing Brush tool is the perfect tool for removing small imperfections like dust or tiny scratches. With a single click, it samples (copies) pixels from around the area of a trouble spot and creates a small patch that covers up the flaw and blends in smoothly with its surrounding area.

The Clone Stamp tool is versatile not just for cleaning up and restoring photos, but also for any number of special effects and enhancements. It works on the simple principle of copying and duplicating (cloning) image pixels from one part of an image to another. Although ideal for repairing tears or holes in photographs, it can also be used to add or duplicate objects in a photograph. For example, you can create a hedgerow from one small bush or add more clouds to a nearly cloudless sky.

The Healing Brush tool operates like a combination of the Clone Stamp and Spot Healing Brush tools. As with the Clone Stamp tool, it first samples pixels from one area of your image to another. Then, like the Spot Healing Brush tool, it blends those pixels seamlessly with the area you want to repair (**FIGURE 10.1**).

FIGURE 10.1 Such a lovely image (top), right? That is, until you look closer and realize the lens wasn't clean (middle)! With a little patience and the Spot Healing Brush and Clone Stamp tools, imperfections can be easily removed or repaired (bottom).

FIGURE 10.2 The Spot Healing Brush tool

FIGURE 10.3 With a single click, each dust speck is removed.

FIGURE 10.4 Create a new empty layer and select the Sample All Layers option in the Tool Options bar to work non-destructively.

To clean up small areas with the Spot Healing Brush tool:

1. Select the Spot Healing Brush tool from the toolbox, or press J **(FIGURE 10.2)**.

2. Zoom in to 100% or 200% magnification.

3. In the Tool Options bar, select a healing method.

 ▸ **Proximity Match** samples pixels from around the edge of your brush shape to create the patch over the area you want to repair.

 ▸ **Create Texture** uses the pixels directly beneath the brush shape to create a soft, mottled texture.

 ▸ **Content-Aware** uses advanced algorithms to intelligently fill the affected area (see the sidebar on the next page for more information).

4. Also in the Tool Options bar, select a brush size using the Size slider.

 Try to size the brush to fit snugly around the flaw you're covering.

5. Click to apply the patch **(FIGURE 10.3)**.

TIP To fix a slightly larger area, drag through it with the tool.

TIP To help you see dust spots, create a new Brightness/Contrast adjustment layer and set the Contrast value all the way up to 100. Also, spots are easier to pick out as you scroll across the image. When you're done repairing the image, remove that adjustment layer. And lastly, clean your monitor—there's little more frustrating than using the Spot Healing Brush on an area repeatedly and realizing that the smudge is on the glass in front of you.

TIP Making repairs requires changing the pixels in the image. To work non-destructively, first create a new empty layer above the image layer you're correcting, and select Sample All Layers in the Tool Options bar **(FIGURE 10.4)**. The edits you make apply to the new layer, leaving the underlying image layer intact.

Making Content-Aware Repairs

The Spot Healing Brush tool uses one of the best features in Photoshop Elements: Content-Aware technology. It can not only sample surrounding pixels to make repairs, but can also reconstruct areas based on the image's content.

FIGURE 10.5 I painted over the power line (just once) using the Spot Healing Brush set to Content-Aware.

In most cases, the practical benefit is less time spent making repairs, because the Editor is applying more "thought" to how to fix an area. You don't need to go over it several times with the Clone Stamp tool as you would have in the past.

For example, when removing power lines from a photo, the Spot Healing Brush also intelligently fills in more complicated areas of the landmark as well as the blue sky **(FIGURE 10.5)**.

You can also attempt more dramatic Content-Aware repairs successfully, as seen in **(FIGURE 10.6)** and **(FIGURE 10.7)**. Of course, results will vary depending on the content of the image.

TIP If a repaired area doesn't look right, hit it again with the Spot Healing Brush. In **FIGURE 10.13**, for example, my next step would be to clean up the grass clumps that appeared where the girl's shadow had been.

▶ **VIDEO 10.1**
Recompose a Scene

FIGURE 10.6 Painting over the girl and her shadow...

FIGURE 10.7 ...fills the space with content that wasn't there before.

FIGURE 10.8 The Clone Stamp tool

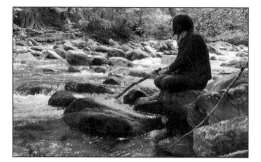

FIGURE 10.9 The fallen stick to the right is distracting (top), but the area is too complicated to get a good result using the Spot Healing Brush tool. Instead, sample the rock texture near the stick by holding Alt/Option; your pointer turns into a bull's-eye target. Click to set it as the origin.

FIGURE 10.10 Drag the Clone Stamp tool over the portion of the image you want to replace. As you drag, a crosshair appears, providing a constant reference point of the cloned pixels as you paint over the image.

To retouch an image with the Clone Stamp tool:

1. Select the Clone Stamp tool from the toolbox, or press S **(FIGURE 10.8)**.

2. In the Tool Options bar, select a brush size using the Size slider.

 The brush size you choose will vary depending on the area you have available to clone from and the area you're trying to repair. Larger brush sizes work well for larger open areas like skies or simple, even-toned backdrops, whereas smaller brushes work well for textured surfaces or areas with a lot of detail.

3. Move the pointer over the area of your image you want to clone (copy), and then hold the Alt/Option key.

 The pointer becomes a target **(FIGURE 10.9)**.

4. Click once to sample that area; it will be the source for stamping (pasting) onto the area you're repairing.

5. Release the Alt/Option key and move the pointer to the area where you want the clone applied.

6. Drag to "paint" the cloned portion over the new area **(FIGURE 10.10)**.

 The original image area is replaced with a clone of the sampled image area.

To remove flaws with the Healing Brush tool:

1. From the toolbox, select the Spot Healing Brush tool. Then, in the Tool Options bar, click the Healing Brush tool.

2. Open the Mode menu in the Tool Options bar and check that Normal is selected **(FIGURE 10.11)**.

 Normal mode blends sampled pixels with the area you're repairing to create a smooth transition with the area surrounding the repair. Replace mode does little more than duplicate the behavior of the Clone Stamp tool. The other modes act like the similarly named layer blending modes.

3. In the Tool Options bar, select a brush size using the Size slider.

 The brush size you choose will vary depending on the area you have available to sample from and the area that you're trying to repair.

4. Move the pointer over the area of your image you want to sample and hold the Alt/Option key. The pointer becomes a target **(FIGURE 10.12)**.

5. Click once to select the area you want to sample.

6. Drag to "paint" the sampled image over the new area **(FIGURE 10.13)**.

 The sampled image blends with the repair area to cover any flaws and imperfections.

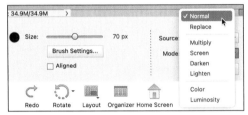

FIGURE 10.11 Although several healing modes are available, most often the Healing Brush tool works best in Normal mode.

FIGURE 10.12 Once you've found an area of your image to use as a patch, hold down the Alt key and click to select it. Your pointer turns into a bull's-eye target.

FIGURE 10.13 As you draw, the Healing Brush picks up the pixels relative to the origin point, just like the Clone Stamp tool. After you release the drag, Elements blends the values in the area.

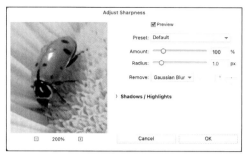

FIGURE 10.14 The Adjust Sharpness dialog's sliders adjust the degree of sharpening you apply.

Original Amount: 125%

Original Amount: 250%

FIGURE 10.15 The Amount slider controls the percentage of sharpness applied to your image. The sharpening appears a little too aggressive in the 250% version when zoomed-in close, but at normal size may look just fine. Feel free to experiment quite a bit to achieve your desired sharpness.

Sharpen Image Detail

Generally speaking, you want most of your photos to be in focus—which can be surprisingly difficult to achieve, depending on surrounding movement, zoom level, or even just plain shaky fingers (maybe cut back on the caffeine). Even then, photos may not quite "pop" the way you'd like them to. In addition, any time you resize an image by resampling, pixels may be lost in the process, and so you also lose some degree of image detail.

The Editor offers an Auto Sharpen command, but you may want more control. Look to the Adjust Sharpness command, which finds pixels with different tonal values and slightly increases the contrast between those adjoining pixels, creating a sharper edge. The resulting correction can help to enhance detail and bring blurred or fuzzy areas throughout an image into clearer focus.

To sharpen an image:

1. Choose Enhance > Adjust Sharpness to open the Adjust Sharpness dialog **(FIGURE 10.14)**.

2. Make sure the Preview box is checked; then adjust the following controls to set the image's sharpness:

 ▸ The **Amount** slider sets the percentage of contrast applied to the pixels, which determines the degree of sharpness you apply. For high-resolution images (those above around 150 pixels per inch), set the Amount slider to between 150% and 200%. For low-resolution images, use settings somewhere around 30% to 80% **(FIGURE 10.15)**.

continues on next page

- The **Radius** slider determines the number of pixels surrounding the contrasting edge pixels that will also be sharpened. Although the radius can be set all the way to 64, you should never have to enter a value much higher than 2, unless you're trying to achieve a strong, high-contrast special effect **(FIGURE 10.16)**.

- The **Remove** menu offers three types of correction: Gaussian Blur applies the effect to the entire image; Lens Blur detects edges in its sharpening; and Motion Blur works to reverse the blur caused by camera movement. If Motion Blur is enabled, adjust the Angle setting to match the angle of the movement **(FIGURE 10.17)**.

- The **Shadows/Highlights** controls work on minimizing the halo artifacts that often crop up. Sharpening emphasizes contrast between light and dark areas; these controls temper the effect. For example, in **FIGURE 10.18** when Remove is set to Motion Blur and the angle is 45 degrees, a light outline appears on the edges of the ladybug's spots. Increasing the Tonal Width removes the artifact.

- Use the preview area to see a detailed view of your image as you apply the changes. You can move to a different area of an image by dragging with the hand pointer in the preview screen. You can also zoom in or out of an area using the minus and plus buttons below the preview.

3. When you're satisfied with the results, click OK to close the dialog and apply the changes.

Original

Amount: 125%
Radius: 10.0 pixels

FIGURE 10.16 The Radius slider controls the number of pixels included in any sharpened edge. Smaller numbers include fewer pixels, and larger numbers include more pixels (exaggerated here for effect).

FIGURE 10.17 If the blur is caused by movement of the camera or subject, Motion Blur can compensate.

Amount: 200%
Shadows Tonal
Width: 0%

Amount: 200%
Shadows Tonal
Width: 100%

FIGURE 10.18 Experiment with the Shadows/Highlights controls to counteract artifacts like this light edge on the ladybug's spots.

FIGURE 10.19 The Blur tool

Original · *After Blur tool applied*

FIGURE 10.20 Drag the brush through the area you want to blur. You can resize the brush as you work on larger and smaller areas.

Selectively Enhance Detail

The Adjust Sharpness command works best on entire images or large portions of images. A couple of other tools are better suited for making sharpening and focus adjustments in smaller, more specific areas of an image. The Blur tool softens the focus in an image by reducing the detail, and the Sharpen tool helps bring areas into focus. For instance, you can create a sense of depth by blurring selected background areas while keeping foreground subjects in focus, or enhance the focus of a specific foreground subject so that it better stands out from others.

To blur a specific area or object:

1. Select the Blur tool from the toolbox, or press R (**FIGURE 10.19**).

2. In the Tool Options bar, select a brush size using the Size slider.

 If you want, you can also select a blending mode and enter a Strength percentage. The higher the percentage, the more the affected area is blurred.

3. Move the brush pointer to the area of your image you want to blur; then drag through the area (**FIGURE 10.20**).

 As you drag, the area is blurred.

TIP Working on a portrait? Another tool to consider is the Surface Blur filter (Filter > Blur > Surface Blur), which smooths surface areas like skin without blurring edges. It's an easy way to minimize wrinkles and other sharp details in faces.

TIP If you're specifically looking for the soft-focus background effect (bokeh), try the Depth Of Field Guided Edit located in the Special Edits tab of Guided mode.

To sharpen a specific area or object:

1. Select the Blur tool from the toolbox, and then click the Sharpen tool in the Tool Options bar. Or, press R to cycle through the Enhance tools to the Sharpen tool.

2. In the Tool Options bar, select a brush size. If you prefer, choose a blending mode and enter a Strength percentage. The higher the percentage, the more the affected area is sharpened.

3. Move the brush pointer to the area of your image you want to sharpen, and then drag through the area **(FIGURE 10.21)**.

 As you drag, the area is sharpened.

To use the Smudge tool:

1. Select the Smudge tool in the Tool Options bar, or press R to toggle through the Enhance tools to the Smudge tool.

2. In the Tool Options bar, select a brush size using the Size slider.

 Just as with the Blur and Sharpen tools, you can select a blending mode and enter a Strength percentage. The higher the percentage, the more the affected area is smudged.

3. Move the brush pointer to the area of your image you want to smudge; then drag through the area **(FIGURE 10.22)**. The pixels are smeared in the direction you drag.

TIP Use the Blur and Sharpen tools together when you want to draw attention to a particular person or object. First, use the Blur tool to soften the focus and detail of the subjects you want to appear to recede into the background. Then use the Sharpen tool to bring the subject of primary interest into sharp focus.

Original *After Sharpen applied*

FIGURE 10.21 I can pull more detail out of the girl's hair and coat by dragging the Sharpen tool over that area.

FIGURE 10.22 The Smudge tool can easily do more harm than good, so use it sparingly.

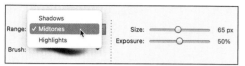

FIGURE 10.23 The Dodge tool in the Tool Options bar

FIGURE 10.24 Select the part of the tonal range you most want to affect with the selected tonal adjustment tool. With both the Dodge and Burn tools, you can choose to limit your changes to just the shadow, midtone, or highlight areas.

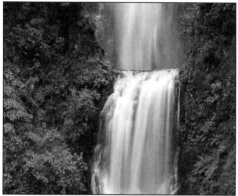

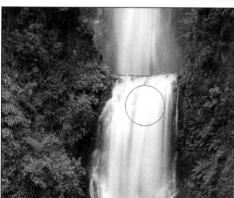

FIGURE 10.25 Drag the Dodge or Burn brush through any area to lighten or darken the pixels while preserving image detail. Here, I want to make the waterfall stand out more, so dodge it with a large brush size to make it lighter.

Selectively Adjust Tone

In film photography, darkroom technicians control darkness and lightness values on specific parts of an image by masking one area of film while exposing another. In the process, selected areas are either burned in (darkened) or dodged (lightened). The Dodge and Burn tools replicate this effect without the bother of creating masks. If one portion of an image is dramatically overexposed or washed out, and another portion is underexposed, the tools can be used to target and correct just those specific problem areas.

The Sponge tool increases or decreases the intensity of the color. Use the Sponge tool to bring colors back to life in badly faded, older photographs; or, work in the opposite direction, pulling the color out of a newer photo to create an antique effect.

These edits change the pixels on an image layer, so it's best to duplicate the layer and work on a copy in order to revert your edits later if necessary.

To lighten a portion of an image with the Dodge tool:

1. Select the Sponge tool from the toolbox, and then select the Dodge tool in the Tool Options bar (FIGURE 10.23). Or, press O to toggle to the Dodge tool.

2. In the Tool Options bar, select a brush size appropriate to your image using the Size slider.

 Using the Range and Exposure settings, you can also select a specific tonal range to lighten (shadows, midtones, or highlights) and control the amount of lightness applied (FIGURE 10.24).

3. Drag the brush pointer through the area you want to lighten (FIGURE 10.25).

To darken a portion of an image with the Burn tool:

1. Select the Burn tool from the toolbox, or press O to toggle through the tonal adjustment tools to the Burn tool (**FIGURE 10.26**).

2. In the Tool Options bar, select a brush size using the Size slider.

 If you like, select a specific tonal range to darken (shadows, midtones, or highlights) and control the amount of darkness applied with the Exposure setting.

3. Drag the brush pointer through the area you want to darken (**FIGURE 10.27**).

To adjust the color saturation with the Sponge tool:

1. Select the Sponge tool from the tool-box, or press O to toggle through the tonal adjustment tools to the Sponge tool.

2. In the Tool Options bar, select a brush size using the Size slider.

3. From the Mode menu, select whether you want to saturate (add) or desaturate (subtract) color (**FIGURE 10.28**).

 You can also adjust the amount of color to be added or subtracted using the Flow percentage slider.

4. Drag the brush pointer through the area where you want to change the color's intensity.

TIP The easiest way to change the size of a brush is to press the bracket keys: [(left bracket) reduces the size, while] (right bracket) increases the size.

FIGURE 10.26 The Burn tool in the Tool Options bar

FIGURE 10.27 I used the Burn tool to darken the foliage next to the waterfall to put more attention on the water.

FIGURE 10.28 In the Tool Options bar, choose whether you want the Sponge tool to subtract color or add it.

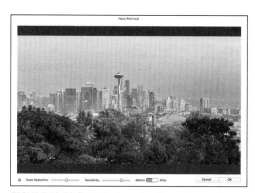
FIGURE 10.29 Preview how the Haze Removal feature's settings will affect the image.

Original

After haze removal

FIGURE 10.30 In addition to reducing the level of haze, the edit has increased saturation throughout the photo.

Remove Haze

I love a dramatic foggy day, when everything in the distance is hidden from view. When visibility is impacted by smog, smoke, or even just a light haze in the air, however, far away objects appear softer than I'd like. In situations like that, the Haze Removal feature can add definition to the scene.

To remove haze:

1. Choose Enhance > Haze Removal.

2. The Haze Removal dialog appears with a moderate amount of removal applied **(FIGURE 10.29)**.

3. Adjust the Haze Reduction slider to increase or decrease the overall amount of the effect.

4. Drag the Sensitivity slider to make small adjustments until the haze in the photo is diminished.

 Click the Before/After toggle to compare the settings with the original image.

5. Click OK to apply the adjustment **(FIGURE 10.30)**.

Erase Backgrounds

The Background Eraser tool is an intelligent (and really quite amazing) feature. Not only does it remove the background from around very complex shapes, but it does so in a way that leaves a natural, softened, anti-aliased edge around the foreground object left behind. Additionally, because the Background Eraser tool always erases to transparency, if you use it to remove the background from even a flattened layer, it automatically converts that layer to a floating, transparent one. This allows you to easily place a new background behind a foreground image, or to move it into a different photo composition altogether.

FIGURE 10.31 The Background Eraser tool in the Tool Options bar

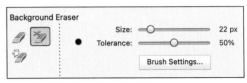

FIGURE 10.32 Use the Tolerance slider to increase or decrease the number of pixels sampled based on their similarity to one another.

To use the Background Eraser tool:

1. Select the Eraser tool from the toolbox and then select the Background Eraser tool in the Tool Options bar **(FIGURE 10.31)**.

 Alternatively, you can press E to select the Eraser tool, and then press E again to toggle to the Background Eraser tool.

2. In the Tool Options bar, select a brush size using the Size slider.

3. Select one of the limit modes:

 ▶ **Contiguous** mode erases any pixels within the brush area that are the same as those currently beneath the crosshairs, as long as they're touching one another.

 ▶ **Discontiguous** mode erases all pixels within the brush area that are the same as those beneath the crosshairs, even if they're not touching one another.

4. Select a Tolerance value using the Tolerance slider **(FIGURE 10.32)**. The value controls which pixels are erased

FIGURE 10.33 Begin by placing the crosshairs of the brush in the background portion of the image (top), then drag the brush along the outside edge of the foreground object to erase the background (bottom). Continue around the edge of the foreground object until it's completely separated from the background.

according to how similar they are to the pixels beneath the eraser crosshairs. Higher Tolerance values increase the range of colors that are erased, and lower values limit the range of colors erased.

5. In the image window, position the eraser pointer on the edge where the background and foreground images meet, and then drag along the edge.

The background portion of the image is erased, leaving behind the foreground image on a transparent background (**FIGURE 10.33**). The brush erases only pixels similar to those directly below the crosshairs, so the entire background can be completely erased while leaving the foreground image intact.

TIP It's okay if the circle (indicating the brush size) overlaps onto the foreground image, but be sure to keep the crosshairs over just the background area. The Background Eraser tool, of course, doesn't really know the difference between background and foreground images, and is simply erasing based on the colors selected, or sampled, beneath the crosshairs. If the crosshairs stray into the foreground image, that part of the image will be erased, too.

TIP This tool works best if the background is fairly uniform (like a sky) and there's plenty of contrast between the background and the object you're keeping visible.

TIP There's a third eraser tool: The Magic Eraser tool operates on the same principle as the Magic Wand tool by deleting like pixels based on color or tonal value. That's all well and good, but you're not given any feedback or opportunity to modify your selection. You just click, and poof—a large area of color is gone. Because the erasure typically is either not quite enough or a little too much, you undo, reset the tolerance, try again, undo—well, you get the idea.

Remove Objects from a Scene

You've probably seen the photo online or forwarded via email from a friend: A couple in full wedding attire are exchanging vows on the beach, the ocean meeting the sky in the background, and...what's that? Yes, a shirtless sunbather is walking into the frame, ruining an otherwise romantic wedding photo. In the Editor, however, that photo would be easily salvageable.

The Photomerge Scene Cleaner lets you take a collection of similar images and selectively "paint out" objects you'd prefer weren't in the photo. Select two or more images that contain an element you want to remove; scenes where people are moving are ideal, because the feature takes areas from the background and superimposes them over the person you wish to hide. (In fact, the early name for Scene Cleaner was "Tourist Remover.")

To remove objects from a scene:

1. Open two or more photos of the scene you want to clean in the Editor **(FIGURE 10.34)**, and select them in the Photo Bin.

2. Switch to Guided mode, and click the Photomerge heading.

3. Click Photomerge Scene Cleaner.

 The first image appears in the Source pane on the left, with an empty Final pane on the right.

4. Choose the image that will be the basis for the finished photo and drag it to the Final pane **(FIGURE 10.35)**.

5. Click a photo in the Photo Bin that contains a clean background in the area where you want to remove an object from the Final image **(FIGURE 10.36)**.

FIGURE 10.34 These shots, taken in quick succession from the same vantage point, allow me to piece portions of each image together.

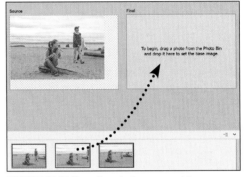

FIGURE 10.35 Drag the photo you want to use as a base into the Final pane.

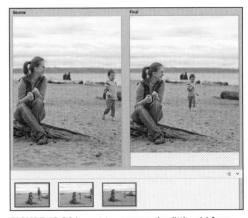

FIGURE 10.36 I want to remove the little girl from the Final image, so I click a photo that has a corresponding empty area—in this case, a shot after she's taken a few steps—to load into the Source pane.

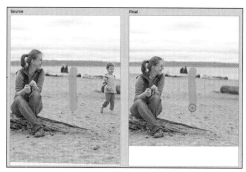

FIGURE 10.37 Drawing over the girl in the Final image at right grabs the corresponding pixels from the Source, removing her.

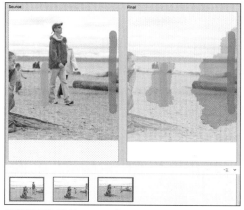

FIGURE 10.38 Two people appeared at the edge of the Final photo, so here I clicked a third photo (with the blue outline) and painted them out in the Source image. With regions visible, you can see which portions are being copied.

FIGURE 10.39 I cropped the final photo to remove artifacts left over from blending the images.

6. Click the Pencil tool in the sidebar, and draw over the object to be removed in the Final image **(FIGURE 10.37)**. The Editor copies that area from the selected Source image into the Final image to make the object vanish.

 Repeat steps 4 and 5 to remove other objects from the scene. (Move the cursor off the Final image to preview it without pencil strokes.) The ink color corresponds to the outline surrounding each source image, so you can easily tell which areas are being used. You can also select Show Regions to view the patchwork that's created **(FIGURE 10.38)**.

7. To fine-tune the effect, you may need to use the Eraser tool to erase some of your pencil marks in the Final image.

8. Click Next. The tool blends the images together. To continue editing click the In Expert button.

9. Click Done to exit the Photomerge Scene Cleaner and return to Guided mode.

TIP You may need to crop the final image to remove blending irregularities **(FIGURE 10.39)**.

TIP Photomerge Scene Cleaner attempts to align the source images based on their contents, but sometimes things end up a little off. If that's the case, click the Advanced Options button to reveal the Alignment tool, which you can use to mark three points the images share. Click the Align Photos button to realign them.

TIP Under Advanced Options, turn on the Pixel Blending option to get a higher-quality, but slower and more processor-intensive, result.

TIP A tool like Photomerge Scene Cleaner is a great reason to take multiple shots of a scene while you're shooting. With digital photography, you can fire off lots of exposures and end up with plenty of choices.

Composite Images

Compositing is the art of combining multiple images to create a single merged image. Combine different digital photos or scanned images to create effects that range from subtle to spectacular to silly. For example, you can replace a landscape's clear blue sky with a dramatic sunset; create complex, multilayered photo collages; or replace the face of the Mona Lisa with that of your Uncle Harold.

To replace part of an image with another image:

1. Open an image that contains an area you want to replace. I'll call this the "target" image.

 In this example, the sky isn't as dynamic as it could be **(FIGURE 10.40)**. Because the edges are well defined, the image is a good candidate for the Background Eraser tool.

2. From the toolbox, select the Background Eraser tool; then adjust its brush size and tolerance values.

3. Position the Background Eraser tool along the outside edge of the foreground shape (the tower). Making sure the brush crosshairs are over the background (sky), drag along the edge to erase the background. Continue to erase the background until the area is completely transparent **(FIGURE 10.41)**.

4. Open the image you want to use to replace the transparent pixels in your original image. I'll call this the "source" image.

FIGURE 10.40 I'll enhance this image by replacing its background with something more dynamic.

FIGURE 10.41 Use the Background Eraser tool to remove the sky and create a transparent background.

FIGURE 10.42 Drag the source image (the sky) into the target image (the tower).

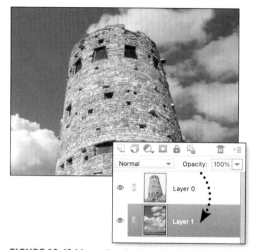

FIGURE 10.43 Move the sky layer below the tower layer on the Layers panel and adjust the position in the image window.

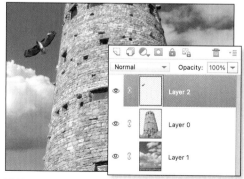

FIGURE 10.44 Add other elements on new layers.

5. Make both images visible by clicking the Layout button on the Task bar and choosing a layout scheme (such as All Column).

6. Select the Move tool and drag the source image into the target image (**FIGURE 10.42**).

 In the example, the sky image is larger than the empty background area, which allows flexibility in positioning the new sky in the composition.

 You can also use the selection tools to select just a portion of the source image, then drag just that selection into the target image.

7. On the Layers panel, drag the source layer below the target layer (**FIGURE 10.43**).

8. In the image window, use the Move tool to adjust the position of the source image until you're satisfied with the composition.

TIP Now that you know how to combine elements into compositions, you can add more objects on their own layers (**FIGURE 10.44**).

TIP It's always good to save a copy of your composition retaining the layers in case you want to make further adjustments. Layered files should be saved as Photoshop Elements (PSD) files.

VIDEO 10.2
Replace a Sky

Merge Portions of Multiple Photos

When you're photographing groups of people (with pets, especially), the burst mode on your camera can be your best friend. Capturing several shots guarantees that everyone is looking good in some of them. The trick is combining those into one perfect portrait.

Photomerge Group Shot lets you combine areas of multiple photos into one nearly seamless composition with just a few swipes of your cursor.

To merge portions of multiple photos:

1. Open two or more similar photos in the Editor.

2. Switch to Guided mode, and click the Photomerge heading.

3. Click Photomerge Group Shot.

 The first image appears in the Source pane on the left, with an empty Final pane on the right.

4. Select the photos you want to use in the Photo Bin.

5. Drag one of the images to the Final pane (**FIGURE 10.45**). This image is the end result, so it should have the fewest imperfections (such as people's heads turned away from the camera, motion blur, or other issues).

6. Click to select a photo in the Photo Bin that contains an element (a better facial expression, for example) you want merged into the Final pane. The photo appears in the Source pane (**FIGURE 10.46**).

FIGURE 10.45 Drag the photo you want to use as a base into the Final pane. In this case, the expressions of the man and the girl look best in the first image, so I'm building on that one.

FIGURE 10.46 The second image includes the woman's best smile, so I clicked it in the Photo Bin to load it into the Source pane at left. Colored borders help you track which photo is which.

VIDEO 10.3
Portrait Retouching

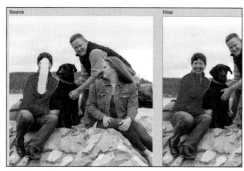

FIGURE 10.47 Photomerge Group Shot calculates the pixels surrounding the areas I've drawn and merges them into the Final image.

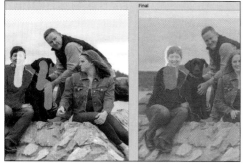

FIGURE 10.48 To include the dog looking at the camera, I painted the portion from the third photo. Notice that I also included part of the man's hand to ensure his hand in the Final image looks normal. I've also selected Show Regions to see how Elements has patched the photo together.

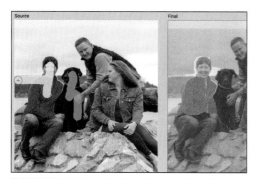

FIGURE 10.49 When I added the dog, the hill behind it was also pasted, which looks weird because of the camera angle in the last photo. Adding a swipe next to the woman grabs more of the area next to her and aligns the background.

7. Click the Pencil tool and, in the Source pane, draw over the area you want to transfer to the Final image **(FIGURE 10.47)**. When you finish drawing, the Photomerge feature incorporates that area into the Final image.

 Repeat Steps 6 and 7 for other areas you want to merge **(FIGURE 10.48)**.

8. Elements does an amazing job of automatically merging images, but it's not perfect. If you need to adjust some areas, use the Eraser tool to edit the drawing lines in the Source pane or draw on other areas that fit well in the overall composition **(FIGURE 10.49)**.

9. Click Next. The tool blends the images together. To continue editing click the In Expert button.

10. Click Done to exit and return to Guided mode.

TIP The tool attempts to align the source images based on their contents, but sometimes things end up a little off—due to different image sizes, slightly different camera angles, and so forth. If that's the case, click the Advanced Options expansion triangle to reveal the Alignment tool, which you can use to mark three points the images share. Click the Align Photos button to realign them.

TIP Select the Pixel Blending option to get a higher-quality, but slower and more processor-intensive, result.

TIP After you exit Photomerge, you may still need to perform some clean-up editing on the image in the Expert mode. The merged image appears on a new layer above the Source image. Use the Clone Stamp tool (or the other tools covered in this chapter) to fine-tune the image.

TIP The Photomerge Faces feature works similarly to Group Shot, but requires you to set alignment points first. It's great rainy-day fun!

Use the Smart Brush

The Smart Brush applies many effects to make common edits as easy as selecting areas of your image. You can also edit the appearance of a Smart Brush effect after you've applied it.

What's behind the magic? Each Smart Brush application is a new adjustment layer; a layer mask defines the area where the effect is applied.

To apply a Smart Brush effect:

1. With an image open in Expert mode, select the Smart Brush tool from the toolbox **(FIGURE 10.50)** or press F.

2. In the Smart Brush Preset Picker in the Tool Options bar, choose an effect **(FIGURE 10.51)**; open the Presets menu at top to list categories of effects, and then click an effect to use it.

3. Adjust the brush size using the Size slider in the Tool Options bar, and then paint over an area of your photo. The tool creates a selection and applies the effect **(FIGURE 10.52)**.

FIGURE 10.50 The Smart Brush tool

FIGURE 10.51 The Smart Brush Preset Picker and Presets menu list the various effects.

FIGURE 10.52 Paint the area to be affected by the effect (Reverse–Black And White shown here).

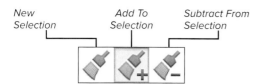

New Selection Add To Selection Subtract From Selection

FIGURE 10.53 The selection tools appear above the Smart Brush area.

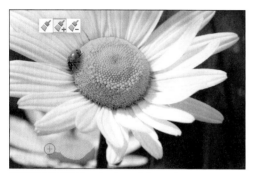

FIGURE 10.54 Use the Detail Smart Brush tool to draw directly on the layer mask.

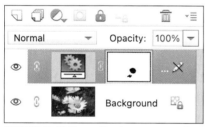

FIGURE 10.55 Smart Brushes are actually just adjustment layers.

FIGURE 10.56 The Blue Skies Smart Brush effect applies a gradient fill to the selected area, which you can edit (but please, not like this, I beg you).

To edit a Smart Brush selection area:

- Once you start painting, the brush is in Add To Selection mode so additional areas you paint are added to the selection.

- To apply the Smart Brush to a different area of the image, click the New Selection button and begin painting.

- To deselect part of the Smart Brush area, click the Subtract From Selection button in the Tool Options bar or in the toolbox that accompanies the selection **(FIGURE 10.53)**.

- Click the Refine Edge button in the Tool Options bar to feather, contract or expand, or smooth the edge. The Inverse checkbox inverts the selection.

- To fine-tune the selection, switch to the Detail Smart Brush tool (press F again). The selection border disappears, letting you add to or subtract from the mask that defines the area **(FIGURE 10.54)**.

To change Smart Brush settings:

In the Layers panel, double-click the adjustment layer that corresponds with the Smart Brush effect **(FIGURE 10.55)**.

The dialog that appears depends on the effect you chose; for example, Blue Skies applies a gradient to the area, so the Gradient Fill dialog appears. You can then edit the gradient **(FIGURE 10.56)**.

TIP Some Smart Brushs, such as the Black And White: Yellow Filter, are not editable. Double-clicking the layer reveals that the effect was created in the full version of Photoshop. That actually means Photoshop Elements has no interface or capability to edit the effect, even though the program is clearly capable of applying it.

Create a Panorama

With Photoshop Elements, you can create wide, panoramic images that would be difficult to capture with a single shot from a standard camera. The Photomerge Panorama feature analyzes your individual photos and assembles them into a single panoramic image **(FIGURE 10.57)**.

Take pictures for panoramas

If you're getting ready to snap some scenic photos and know you want to assemble them into a panorama later, making a few camera adjustments will make it easier to assemble a seamless panorama. When capturing the images:

- Use a consistent zoom level.

- Use a consistent focus. Change your camera's focus mode to manual.

- Use consistent exposure. A panorama with widely varied lighting will be difficult to merge seamlessly. Set your camera's exposure manually or lock the exposure setting if possible. Photomerge Panorama can make slight adjustments for images with different exposures, but it is not as effective when the image exposure varies greatly.

- Use a tripod, if possible. You can take pictures for a panorama with a handheld camera, but you might find it difficult to keep all the images perfectly level.

- Overlap sequential images by about 15% to 40% **(FIGURE 10.58)**. The Photomerge Panorama feature looks for similar detail in the edges of your images to match consecutive pictures. Try to capture as much detail throughout the frame to give the Photomerge Panorama feature more reference points to match up.

FIGURE 10.57 Photomerge Panorama combines separate photos into a single panoramic image.

15% *40%*

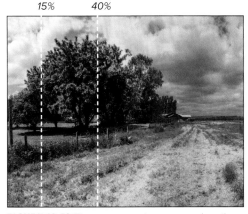

FIGURE 10.58 The more your images overlap, the better your chances of successfully merging them. Try for an overlap of between 15% and 40%.

TIP You're not limited to creating horizontal panoramas. You can also create vertical panoramas of tall subjects, such as skyscrapers or redwood trees.

TIP Some digital cameras include a feature that helps you compose multiple overlapping photos when you shoot.

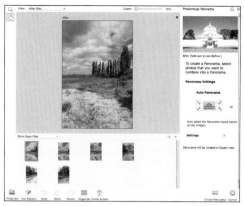

FIGURE 10.59 The Photo Bin is open here to show all the files that will make up this panorama.

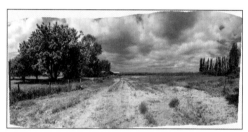

FIGURE 10.60 When you click Create Panorama, the feature blends the images together.

FIGURE 10.61 Choose to fill in the edges using Content-Aware technology.

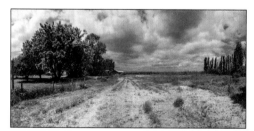

FIGURE 10.62 As part of combining the individual images, the tool fills in transparent edges.

Assemble images into a panorama

To create a panoramic image, select the images you want to merge and then let Photomerge Panorama work its magic.

To create a panorama:

1. Open the images in the Editor.

 If you want to make any adjustments, such as tonal corrections, make your corrections first, before you begin assembling the images.

2. In the Photo Bin, select all of the panorama images.

3. Switch to Guided mode, and click the Photomerge heading.

4. Click Photomerge Panorama to open the feature **(FIGURE 10.59)**.

5. Under Panorama Settings in the sidebar, choose a layout based on your source images. In most cases, leave it set to Auto Panorama. But if you shot a 360-degree revolution around one point, for example, you may get better results by choosing Cylindrical.

6. Click the Create Panorama button.

 The feature automatically merges the images into a single panorama photo **(FIGURE 10.60)**.

7. Elements can attempt to fill in the empty area using its Content-Aware technology. In the dialog that appears, choose whether to apply the fix **(FIGURES 10.61** and **10.62)**. The tool blends the images together.

8. In the next window, click Save or Save As to save the file, or click the In Expert button to continue editing.

 You can also click Done to exit and return to Guided mode.

continues on next page

TIP You may see an alert message telling you that some images can't be assembled. If Photomerge Panorama can't find enough common details in your images, it will ignore those files.

TIP Once you click Create Panorama, there's no returning to the Guided mode interface to make further adjustments. If you're not happy with the way the panorama rendered, you can start over.

TIP If seams are still visible, try touching up the areas with the **Spot Healing Brush** or the **Clone Stamp** tool in Expert mode.

TIP If you choose not to automatically fill in the edges, use the **Crop** tool to remove those rough edges and give your panorama a nice, crisp rectangular border (**FIGURE 10.63**).

TIP Before you print your final panorama, take the time to examine its size in the Image Size dialog (from the File menu, choose **Resize > Image Size**). Depending on the size and resolution of the images you've used, your panoramas can quickly grow to exceed the standard paper stock sizes for your printer (which are usually no larger than 8.5 x 14 or 11 x 17 inches). Once you've determined the final image dimensions, use either the Image Size dialog or the controls in the Print Preview dialog to resize your image so it will fit on whatever paper stock you have available.

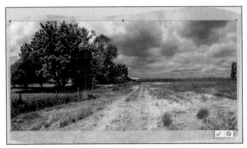

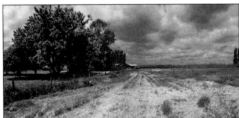

FIGURE 10.63 After creating the panorama, you can use the Crop tool to trim the image.

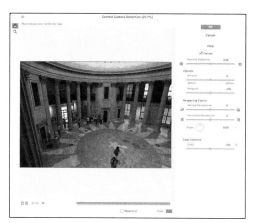

FIGURE 10.64 Correct Camera Distortion fixes many common photographic gaffes.

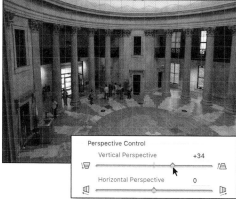

FIGURE 10.65 Although the wide angle captures much of this great hall, the extreme perspective distortion is noticeable (top). Adjusting the Vertical Perspective slider makes the columns look more natural (bottom).

Correct Camera Distortion

Most cameras are digital, but photography is still an optical medium, and every camera has tradeoffs; for example, very wide lenses introduce perspective and distortion issues. The Correct Camera Distortion filter provides tools to compensate.

To correct camera distortion:

1. Select a layer or make a selection to edit.

2. Choose Filter > Correct Camera Distortion **(FIGURE 10.64)**.

3. Apply the following controls based on the distortion found in your image:

 ▸ **Remove Distortion.** Drag the slider to the left to bloat the image or to the right to pinch it.

 ▸ **Vignette.** To add or remove a vignette (such as found in old photographs), drag the Amount slider to change the intensity (lightness or darkness) of the effect. Use the Midpoint slider to adjust the vignette's size.

 ▸ **Perspective Control.** Drag the Vertical and Horizontal Perspective sliders to tilt the image **(FIGURE 10.65)**. The Angle control rotates the image.

 ▸ **Edge Extension.** After using the controls above, you may want to scale the image with Edge Extension to crop unwanted blank areas caused by the adjustments.

4. Click OK to apply the changes.

TIP As with most adjustment dialogs, hold Alt/Option and click the Reset button (which is normally the Cancel button when the key is not pressed) to reset the dialog's settings if needed.

Run Automated Actions

One benefit of sharing the same code base as Photoshop is that Photoshop Elements has more power under the surface than is apparent. For example, it can run Photoshop *actions*, which are scripts that execute commands in succession so you don't have to do them all manually. This way, you can apply a series of levels adjustments and a vignette by clicking a single button. The Actions panel includes a bunch of operations to add borders, resize and crop, and apply special effects to images.

The downside is that you can't create actions in Photoshop Elements—that's a feature Adobe reserves for the elder sibling. However, you can import actions created by Photoshop and run them in the Editor. So, for example, if a friend of yours uses Photoshop extensively and has created an action that resizes an image and adds a border and photo credit, you could run that action in Photoshop Elements instead of performing each step.

FIGURE 10.66 The Actions panel can run automated combinations of adjustments.

To run actions:

1. Choose Window > Actions to bring up the Actions panel **(FIGURE 10.66)**.

2. Select an action to run.

3. Click the Play button.

To load actions:

1. Click the Actions panel menu and choose Load Actions.

2. Locate and select a Photoshop action file—it ends in the extension .atn.

3. Click Open. The actions the file contains appear in the Actions panel.

Filters and Effects

For decades, photographers have used lens filters when shooting to improve and alter the look of their photographs—to change the intensity of color values, or to lighten certain tones and darken others. For more creative effects, they would also rely on darkroom and printing techniques.

Thanks to the advancements of digital technology, though, you don't have to fiddle with chemicals or additional camera equipment to enhance your photographs. The filters and effects included in the Editor go far beyond what's been possible in traditional photography. Many of these filters (such as the Blur filters) allow you to make subtle corrections and improvements to your photos, whereas other filters (such as Artistic, Stylize, and Sketch) can transform an image into a completely new piece of artwork. Photoshop Elements also provides effects you can add to your photos, including striking image effects (lizard skin, anyone?) as well as type effects and unique textures.

Use the Filters and Effects Panels

Most filters include controls in the panel where you can preview any changes and adjust the settings for either a subtle or dramatic effect. And some of the filters (such as the Liquify filter) are so comprehensive, they seem like separate applications.

Effects work a bit differently than filters. When you apply an effect, the Editor runs through a series of automatic actions in which a number of filters and layer styles are applied to your image. If you want to add a drop shadow, picture frame, or brushed-metal type to a photo, browse through the Effects panel to see what's available.

To view filters or effects:

Do one of the following:

- In Expert mode, click the Filters button or the Effects button on the taskbar **(FIGURE 11.1)**. Or, choose Window > Filters or Window > Effects.

- To conserve screen real estate and not engage the Filters panel, use the Filter menu, such as choosing Filter > Blur > Lens Blur.

- Choose Filter > Filter Gallery to work in a separate window that allows you to combine several effects and preview the results before commiting the edit.

To change the number of filters displayed in the panel:

In the Filters panel, choose Show All from the menu at the top to see all filters.

> **TIP** Filter plug-ins created by third-party developers usually appear at the bottom of the Filter menu.

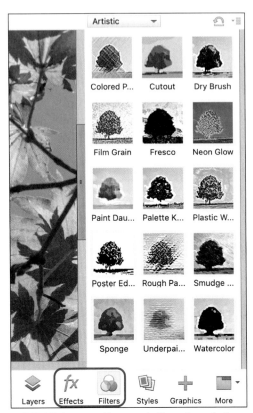

FIGURE 11.1 Access filters and effects from their respective panels in the Editor. If you don't see these buttons, click the menu on the More button and choose Basic Workspace.

Filters and Effects Plug-ins

Plug-ins provide a nifty way to extend your editing experience. If you can't find the effect or filter you want in Photoshop Elements, chances are good that a third-party plug-in might do the trick. Most of the plug-ins designed for Photoshop will work just as well in Photoshop Elements, because both applications use the same file format (PSD). One of the best places to start looking for other filters and effects plug-ins is at the Adobe Exchange (exchange.adobe.com/creativecloud).

FIGURE 11.2 You can apply filters and effects to an entire layer or to a selection.

FIGURE 11.3 Adjust the filter's controls in the options that appear.

FIGURE 11.4 Filter controls can also appear in a Filter Options dialog (top) or a dedicated dialog (bottom).

Apply Filters and Effects

Filters can be applied to an entire image layer or to a selection you make. Effects apply to the entire image, but the Editor can also automatically determine a photo's subject and background and give you the option to affect one or the other.

To apply a filter:

1. To apply a filter to an entire layer, select the layer on the Layers panel to make it active. To apply a filter to just a portion of your image, select an area with one of the selection tools (**FIGURE 11.2**).

2. In the Filters panel, select a category from the Library menu and select the filter you want.

3. Adjust the options that appear below the filter's icon in the panel to control the filter's appearance (**FIGURE 11.3**).

4. Click the Commit button (the check-mark) to apply the filter. If you're not happy with the result, choose Edit > Undo or select the previous state from the History panel.

TIP When choosing filters from the Filter menu, instead of the Filters panel, you'll see either a dedicated dialog or a larger Filter Options dialog (**FIGURE 11.4**). The latter is the same interface as choosing Filter > Filter Gallery.

TIP The list in the lower-right corner of the Filter Options dialog lets you add multiple filters before applying them to your image. Click the New Filter Layer button (the document icon) and choose another filter to see how it affects the image.

VIDEO 11.1
Blur Filters

To apply effects:

1. In the Effects panel, click the Artistic or Classic tab to choose among the options.

2. Click an effect to apply it to the entire image (**FIGURE 11.5**).

3. In the options that appear below, you can:

 ▸ Select Keep Original Photo Colors to maintain the existing color palette.

 ▸ Drag the Intensity slider to adjust the strength of the effect.

 ▸ Choose whether the effect applies to the subject or the background by clicking the appropriate option (**FIGURE 11.6**). The Editor determines which areas are which depending on the content of the photo (so it may choose incorrectly).

When you apply an effect, it creates one or more new layers immediately above the selected layer. If Subject or Background was the only option selected, a mask is also applied. You can edit the mask to refine it, if needed) (**FIGURE 11.7**).

TIP To reduce the visible impact of an effect, change the opacity of the effect layer using the Opacity slider on the Layers panel.

TIP To change the look of an effect, experiment with the various blending modes on the Layers panel.

VIDEO 11.2
Add Lighting Effects

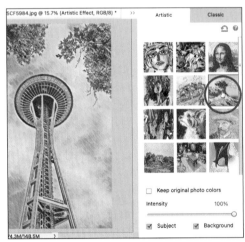

FIGURE 11.5 Click an effect in the Effects panel to apply it to an image or selection.

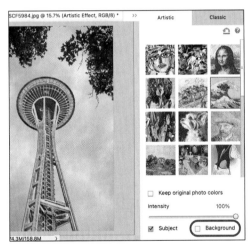

FIGURE 11.6 The Editor determines which area is the subject and which is the background.

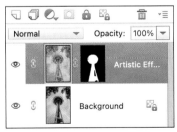

FIGURE 11.7 The effect is applied to a new layer.

The Liquify Tools

Warp lets you push pixels around as you drag.

Twirl Clockwise and **Twirl Counterclockwise** rotate pixels in either direction.

Pucker moves pixels toward the center of the brush area.

Bloat moves pixels away from the brush center and toward the edges of your brush.

Shift Pixels moves pixels perpendicular to the direction of your brush stroke.

Reconstruct restores distorted areas to their original state. As you brush over areas with this tool, your image gradually returns to its original state, undoing each change you've made with the Liquify tools. You can stop the reconstruction at any point and continue from there.

The **Zoom** and **Hand** tools work just like those on the Photoshop Elements toolbox.

Distort Images

The Distort filters include an amazing array of options that let you ripple, pinch, shear, and twist your images. Experiment with all of the Distort filters to get a feel for the different effects you can apply to images. One filter in particular stands above the others in its power and flexibility: Liquify.

The Liquify filter creates amazing effects by letting you warp, twirl, stretch, and twist pixels to make objects appear to not obey the normal laws of physics. You've probably seen plenty of examples of this filter, where someone's face is wildly distorted with bulging eyes and a puckered mouth. However, you can also use the Liquify filter to create more subtle changes and achieve effects that would be difficult with other tools, such as portrait retouching.

The Liquify filter is unique in that it works within a dialog with its own complete set of image manipulation tools. After you've distorted something and closed the dialog, you can't undo those specific changes with the Edit > Undo command or History panel. Before you exit the filter and commit those changes, though, you can use the filter's own Reconstruct tool to restore any area to its original (or less contorted) state. The Reconstruct tool allows you to "paint" over your image and gradually return to the original version, or stop at any state along the way. If you just want to go back and start over, clicking the Revert button is the quickest method.

To distort an image with the Liquify filter:

1. Select an entire layer, or make a selection of the area you want to change.

2. Choose Filter > Distort > Liquify; or, in the Filters panel, choose Distort from the Library menu, and click the Liquify filter.

 If your image includes a type layer, you will be prompted to simplify the type to continue. This means the type layer will be combined with the rest of your image's layers. Be aware that if you click OK, the type will no longer be editable.

 The Liquify dialog appears, including a preview of the layer or selection area. The Warp tool is selected by default **(FIGURE 11.8)**.

3. To change the brush settings, do any of the following:

 ▸ To change the brush size, drag the Size slider, or enter a value in the option box. The brush size ranges from 1 to 15000 (!) pixels.

 ▸ To change the brush pressure, drag the slider or enter a value in the option box. The brush pressure ranges from 1% to 100%.

 ▸ If you're using a connected stylus, select the Stylus Pressure option.

4. Distort your image with any of the Liquify tools located on the left side of the dialog **(FIGURE 11.9)** until you achieve the look you want. To use any tool, simply select it (just as you do tools on the main toolbar) and then paint using the cursor on the image **(FIGURE 11.10)**.

FIGURE 11.8 The Liquify dialog includes its own set of distortion tools as well as options for changing the brush size and pressure.

FIGURE 11.9 The Liquify tool set

Before After

FIGURE 11.10 The best way to become familiar with the Liquify distortion tools is to experiment with them.

To undo changes:

Choose Edit > Undo or Edit > Step Backward.

Or, click the Reconstruct tool. Then drag over your image to gradually return those pixels to their original appearance.

To undo all Liquify changes:

In the Liquify dialog, click the Revert button to return the image to its original state.

TIP Here's another way to undo Liquify changes: In the Liquify dialog, hold down the Alt/Option key. The Cancel button changes to Reset. Click the Reset button to undo any changes you've made with the Liquify tools. The Revert and Reset buttons work the same way, but the Reset button, true to its name, also resets the Liquify tools to their original settings.

VIDEO 11.3
Make Moving Photos and Overlays

Painting and Drawing

A lifetime ago (in computer years, anyway) a little company just south of San Francisco introduced a small beige box with a tiny 9-inch keyhole of a monitor and a mouse resembling a bar of soap. It could display and print only in black and white, was incapable of reproducing even remotely convincing photographic images, and was strictly limited to a resolution of 72 pixels per inch. And yet graphic artists smiled a collective smile, because bundled in its modest software suite, alongside its stunted little word processor, Apple's Macintosh gave the world MacPaint.

Painting and drawing programs have jumped by leaps and bounds since taking those first, early baby steps, but one aspect remains the same: They're still fun to use!

Although Photoshop Elements is mostly used for editing photos, its built-in drawing and painting tools let you create original artwork or enhance your photos—whether you're filling parts of your image with color, adding a decorative stroked border to a logo or design element, or "painting" a photo with textures.

Fill Areas with Color

You have two primary ways of filling areas with a solid color. With the Fill command, you can quickly blanket an entire layer or a selected area of a layer. The Paint Bucket tool operates in a more controlled manner, filling only portions of areas based on properties that you set on the Tool Options bar. Either method works especially well for those times when you want to cover large, expansive areas with a single color.

To fill a selection or layer with color:

1. Using any of the selection tools, select the area of your image you want to fill with color.

 To fill an entire layer, select it in the Layers panel, or create a new layer.

2. Select a fill color by doing one of the following:

 ▸ Click the current foreground color swatch at the bottom of the toolbar **(FIGURE 12.1)** to open the Color Picker, then select a color and click OK **(FIGURE 12.2)**. (You can click the background color instead and use it in the next dialog, but most of the time it's easier to change the foreground color.)

 ▸ Choose Window > Color Swatches and click any color in the panel.

3. Choose > Edit > Fill Selection (if a selection is active) or Edit > Fill Layer to open the Fill Layer dialog.

4. From the Use menu, choose a source for your fill color **(FIGURE 12.3)**.

5. From the Blending area of the dialog, select a blending mode and opacity for your fill. (For more information on blending modes, see "Set Opacity and Blending Modes" in Chapter 7.)

FIGURE 12.1 Click the foreground or background color swatch in the toolbar to open the Color Picker.

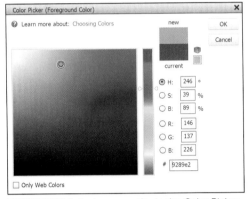

FIGURE 12.2 Select a new color in the Color Picker.

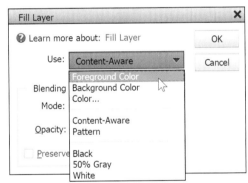

FIGURE 12.3 The Use menu contains various sources from which to choose a fill color. Choose the Foreground Color option to apply a specific color chosen from the Color Picker or Swatches panel.

FIGURE 12.4 In this example, an area of the Background layer is selected (left), then filled with a color using the Fill dialog (right).

6. Select the Preserve Transparency checkbox if you want to maintain a layer's transparency when you apply the fill.

7. Click OK to close the dialog.

The selection or layer is filled with the color and properties you specified **(FIGURE 12.4)**.

TIP To save time, use keyboard shortcuts to fill a selection or layer with either the current foreground or background color. Alt+Backspace/Option+Delete will fill a selection or layer with the current foreground color, and Ctrl+Backspace/Command+Delete applies the current background color.

TIP To swap the foreground and background color swatches in the toolbar, press X.

TIP To switch the foreground and background color to black and white (the defaults), press D.

About Preserving Transparency

The Preserve Transparency checkbox works just like the Lock Transparent Pixels button on the Layers panel. If the checkbox is selected and you fill a layer that has both opaque and transparent pixels, the transparent areas will be locked (or protected), and the Editor will fill only the opaque areas of the layer **(FIGURE 12.5)**. If you select Preserve Transparency and then try to fill an empty layer (one containing only transparent pixels), the layer will remain unfilled. That's because the whole layer, being transparent, is locked. If you fill a flattened layer, like the default Background layer, the checkbox is dimmed and the option isn't available because a Background layer contains no transparency.

FIGURE 12.5 When a layer (left) is filled using the Preserve Transparency option, the transparent areas of the layer remain protected and untouched, and only the layer object accepts the fill color (right).

To apply fill color with the Paint Bucket tool:

1. Select the Paint Bucket tool from the toolbox (or press K) (**FIGURE 12.6**).

2. Select a foreground color from either the Color Picker or the Color Swatches panel.

3. On the Tool Options bar, select a blending mode and opacity setting, if you want.

4. Still on the Tool Options bar, set a Tolerance value (**FIGURE 12.7**); then specify whether you want the colored fill to be anti-aliased, to fill only contiguous pixels, or to affect all layers.

 For more information on these options, see the sidebar "How Does That Paint Bucket Tool Work, Anyway?" on the next page.

5. Click the area of your image where you want to apply the colored fill.

 The tool paints the selected color into your image (**FIGURE 12.8**).

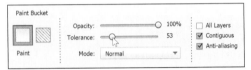

FIGURE 12.6 The Paint Bucket tool

FIGURE 12.7 The Paint Bucket tool takes advantage of all of Photoshop Elements' blending modes and opacity options.

FIGURE 12.8 The Paint Bucket tool fills areas based on their tonal values. Here it automatically selects and fills just the light-colored background area.

How Does That Paint Bucket Tool Work, Anyway?

If you're familiar with other painting and drawing programs, the Editor's Paint Bucket tool may leave you scratching your head. In many apps, the Paint Bucket tool does little more than indiscriminately dump color across large areas of an image. But the Paint Bucket tool in Photoshop Elements is much more intelligent and selective about where it applies color. Depending on the parameters you set in the Tool Options bar, it fills areas based on the tonal values of their pixels.

The Tolerance slider determines the range of pixels the Paint Bucket fills. The greater the value, the larger the range of pixels filled.

Select Anti-aliasing to add a smooth, soft transition to the edges of your color fill.

Select Contiguous to limit the fill to pixels similar in color or tonal value that touch, or are contiguous with, one another. If you're using the Paint Bucket tool to switch your car's color from green to blue, this ensures that only the car's green pixels are turned blue—not all the green pixels within the entire image.

If you select the All Layers option, the Editor recognizes and considers pixel colors and values across all the layers, but applies the fill only to the active layer. This means if you click the Paint Bucket tool in an area of any inactive layer, the fill will be applied to the current active layer **(FIGURE 12.9)**.

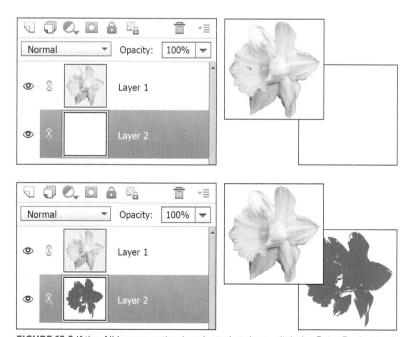

FIGURE 12.9 If the All Layers option is selected and you click the Paint Bucket tool in an inactive layer (top), the fill for that specific area is applied to the active layer (bottom).

Fill Areas with a Gradient

The Gradient tool fills any selection or layer with smooth transitions of color, one blending gradually into the next. It can be rendered as an opaque fill or seamlessly incorporated into a layered project using blending modes and opacity settings. Use a gradient to create an effective background image for a photo, to screen back a portion of an image, or to create an area on which to place type. Or, use a gradient fill within the mask belonging to an adjustment layer to blend the edit smoothly into the image.

To apply a gradient fill:

1. Using any of the selection tools, select the area you want to fill with color.

 To fill an entire layer, select it in the Layers panel, or create a new layer.

2. Select the Gradient tool from the toolbox (or press G) **(FIGURE 12.10)**.

3. On the Tool Options bar, click the menu button to the side of the gradient preview to open the Gradient Picker **(FIGURE 12.11)**.

4. Click a thumbnail to choose a gradient. Or, choose a category from the Gradient menu and then select the thumbnail you want to use.

5. In the Tool Options bar, click to choose a gradient style **(FIGURE 12.12)**. Choose from five gradient styles: Linear, Radial, Angle, Reflected, and Diamond.

6. In the image window, drag in the area where you want to apply the gradient **(FIGURE 12.13)**.

 The tool fills the selection or layer with the gradient.

TIP Hold the Shift key to constrain a gradient horizontally, vertically, or at a 45-degree angle.

FIGURE 12.10 The Gradient tool

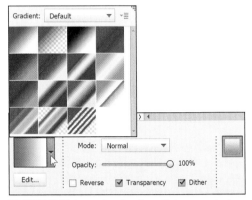

FIGURE 12.11 Open the Gradient Picker to select from sets of gradient thumbnails.

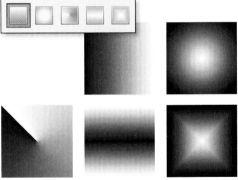

FIGURE 12.12 Click a gradient style button in the Tool Options bar to draw one of five gradient styles.

FIGURE 12.13 Drag from the center to the edge to create a halo effect with the Radial gradient.

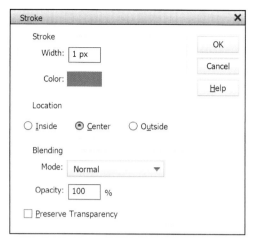

FIGURE 12.14 Draw borders around selections using the Stroke dialog.

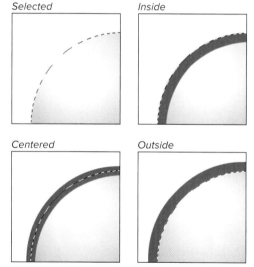

FIGURE 12.15 Once an object is selected, you can stroke it either inside, centered on, or outside of the selection.

Add a Stroke

A *stroke* is a colored rule or border around any selected object or layer. With the Stroke command, you can trace around almost anything, from simple rectangle or ellipse selections to complex typographic characters. Because you can control both the stroke's thickness and where the stroke is drawn in relation to a selection (inside, outside, or centered), you can create everything from delicate, single-ruled outlines to decorative, multiple-stroked borders and frames.

To apply a stroke:

1. Using any of the selection or marquee tools, select the area of your image to which you want to add a stroke.

 If you're adding a stroke to an object on its own transparent layer, there's no need to make a selection. Instead, just check that the layer is active on the Layers panel.

2. Choose Edit > Stroke (Outline) Selection to open the Stroke dialog **(FIGURE 12.14)**.

3. In the Width text field, enter the stroke width in pixels.

 There's no need to enter the pixel abbreviation (px) following the number value.

4. Change the stroke color by clicking the Color box to open the Color Picker, and then click to select a new color. Click OK to exit the dialog.

5. Select the placement of the stroke, which determines where the stroke is drawn: inside, outside, or centered directly on the selection **(FIGURE 12.15)**.

continues on next page

6. Ignore the Blending portion of the dialog for now.

7. Click OK to apply the stroke to your selection or layer **(FIGURE 12.16)**.

TIP The foreground color is used for the stroke color unless you change the color in the Stroke dialog. So if you want to pick a stroke color from the Color Swatches panel, click the Color Swatches panel to assign the foreground color before anything else; then choose Stroke from the Edit menu. The color you choose from the Color Swatches panel will appear as the stroke color in the dialog.

FIGURE 12.16 Select an object (left), and then choose the Stroke command to apply a stroke (right).

Create a Stroke Layer

It's a good habit to create a new layer before applying strokes to an image. That way, you can control attributes such as opacity and blending modes right on the Layers panel. You can even turn strokes off and on by clicking the stroke layer's Visibility icon. If you're adding a stroke to a selection, simply create a new layer and then follow the steps in the task "To apply a stroke." If you're stroking an object on a transparent layer and want its stroke on a separate layer, you need to perform some additional steps:

1. Identify the object to which you want to add a stroke, then press Ctrl/Command and click once on its layer on the Layers panel. The object is automatically selected in the image window **(FIGURE 12.17)**.

2. Create a new layer by clicking the New Layer button at the top of the Layers panel.

3. With the new layer selected on the Layers panel, choose Stroke (Outline) Selection from the Edit menu, and then follow steps 3 through 7 of "To apply a stroke," above.

The Editor creates a stroke for the object, but places it on its own layer.

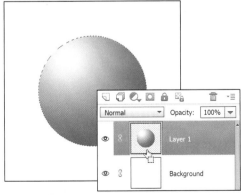

FIGURE 12.17 Ctrl-click/Command-click the Layers panel to create a selection around a layer object.

DRAW

FIGURE 12.18 The Brush tool

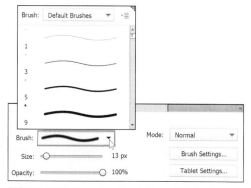

FIGURE 12.19 Open the Brush Preset Picker to select from sets of different brushes.

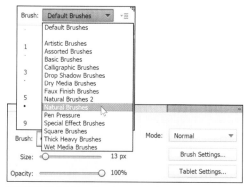

FIGURE 12.20 The Brush menu gives you access to a variety of brush sets.

VIDEO 12.1
▶ Paint with the Impressionist Brush

Use the Brush Tool

The Brush tool offers a near limitless reservoir of hundreds of brushes. You can apply painted brushstrokes directly to the surface of any photograph, or open a new file to serve as a blank canvas to create an original work of fine art. The dozen preset brush libraries offer selections as varied as Calligraphic, Wet Media, and Special Effect, and all brushes can be resized from 1 pixel to 2500 pixels in diameter. You can paint using any of the Editor's blending modes and opacity settings, and you can turn any brush into an airbrush with a single click of a button. So whether you're a budding Van Gogh, would like to add a color-tint effect to an antique black-and-white photograph, or just enjoy doodling while talking on the phone, the brushes can help to bring out your inner artist.

To paint with the Brush tool:

1. To select a paint color, do one of the following:

 ▸ Click the current foreground color swatch at the bottom of the toolbar to open the Color Picker. Choose a color and click OK.

 ▸ Choose a color from the Color Swatches panel.

2. Select the Brush tool in the toolbox (or press B) (FIGURE 12.18).

3. On the Tool Options bar, click to open the Brush Preset Picker (FIGURE 12.19).

4. Click to choose from the list of default brushes, or select a different brush set from the Brush menu (FIGURE 12.20).

continues on next page

5. Drag the Size slider on the Tool Options bar to resize the brush (**FIGURE 12.21**).

6. Select a blend mode and opacity setting, if needed.

7. In the image window, drag to paint a brushstroke (**FIGURE 12.22**).

TIP You can easily resize brushes on the fly using simple keyboard shortcuts. Once a brush of any size is selected, press the] or [key to increase or decrease the current brush size to the nearest unit of 10 pixels. Thus, if you're painting with a brush size of 23 pixels and press the] key, the brush size increases to 30 pixels and then grows in increments of 10 each subsequent time you press]. Conversely, a brush size of 56 pixels is reduced to 50 pixels when you press the [key, and the brush continues to shrink by 10 pixels each time thereafter that you press [.

TIP On macOS, resize a brush by holding the Control and Option keys, and then dragging left (to reduce) or right (to enlarge). Dragging up and down adjusts the Hardness value.

TIP You can make almost any brush behave like an airbrush by clicking the Airbrush button on the Tool Options bar (**FIGURE 12.23**). With the Airbrush activated, paint flows more slowly from the brush and gradually builds denser tones of color. The Airbrush option is most effective when applied to soft, round brushes or to brushes with scatter and spacing properties.

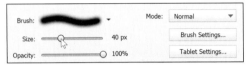

FIGURE 12.21 Use the Size slider to resize your brush.

FIGURE 12.22 Create realistic brush effects simply by dragging through the image window.

FIGURE 12.23 Click the Airbrush button in the Tool Options bar to give a brush the characteristics of an airbrush.

VIDEO 12.2

Create and Save Custom Brushes

FIGURE 12.24 Define a pattern using an interesting texture.

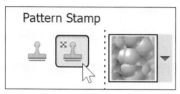

FIGURE 12.25 The Pattern Stamp tool

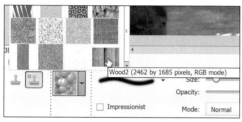

FIGURE 12.26 Choose the pattern you created.

FIGURE 12.27 Paint the pattern onto the photo.

Paint with Texture

Add texture to an image by painting a pattern onto it using the Pattern Stamp tool. The Editor includes some stock patterns, but you can also use your own images.

To define a pattern:

1. Open a photo you want to use as a texture. Also, consider switching the image to grayscale so the photo's colors don't interfere with the texture.

2. Select an area of the photo to define the texture, or select nothing to use the entire image **(FIGURE 12.24)**.

3. Choose Edit > Define Pattern (or Define Pattern from Selection if you selected an area).

4. Give the pattern a name, and click OK.

To paint with texture:

1. In the image on which you want to apply the texture, create a new layer in the Layers panel (so you're not drawing directly on your image).

2. Select the Clone Stamp tool, and then, in the Tool Options bar, select the Pattern Stamp tool (S) **(FIGURE 12.25)**.

3. Click the Pattern Picker and choose a pattern **(FIGURE 12.26)**.

4. Also in the Tool Options bar, choose a brush size, blending mode, and opacity for the Pattern Stamp tool. Those settings apply to the painting you're about to do, not everything you do on the layer, so you'll probably find yourself mixing and matching settings as you paint.

5. Click or drag to paint the pattern in the layer you created in step 1 to create the texture **(FIGURE 12.27)**.

Erase Areas

The images or brushstrokes you choose to remove from a photograph are often as important as those you decide to add or leave behind. The basic Eraser feature is a powerful tool for cleaning up and fine-tuning your images, taking full advantage of every brush style and size that the Editor has to offer. Not only can you perform routine erasing tasks such as rubbing away stray pixels, you can also customize an eraser's brush and opacity settings to create unique texture, color, and pattern effects.

To use the Eraser tool:

1. Select the Eraser tool from the toolbox (or press E) **(FIGURE 12.28)**.

2. In the Tool Options bar, select a brush from the Brush Preset Picker **(FIGURE 12.29)**.

3. Again in the Tool Options bar, select a size using the brush Size slider.

4. Select an eraser type: Pencil, Brush, or Block.

 If you select a soft, anti-aliased brush and then choose the Pencil type, the eraser becomes coarse and aliased **(FIGURE 12.30)**.

5. Select an opacity using the Opacity slider.

6. In the image window, drag the eraser through your image.

 The image is erased according to the attributes you've applied to the eraser.

FIGURE 12.28 The Eraser tool

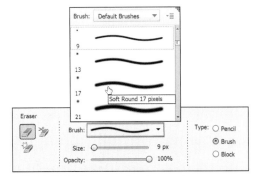

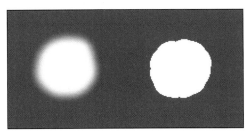

FIGURE 12.29 The same brush presets are available for the Eraser tool as for the Brush tool.

FIGURE 12.30 An eraser in Brush mode (left) and in Pencil mode (right).

FIGURE 12.31 When you draw a shape, you're actually drawing a shape mask.

FIGURE 12.32 Moving a shape really means moving the cutout portion of the mask.

FIGURE 12.33 Adding a shape to a layer masks off another portion of the colored fill below it, in this case giving the illusion that the circle has a square hole in its center.

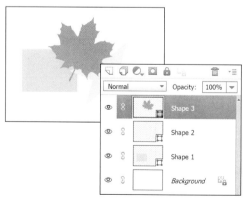

FIGURE 12.34 Shapes appear on their own layers.

Draw Shapes

In the Editor, you create shapes not by rendering them with pixels, but by constructing them from vector paths, which are actually vector masks. I'll use some simple circle and square shapes to illustrate what that means.

Each time you draw a shape with one of the shape tools, the Editor is performing a little behind-the-scenes sleight of hand. Although it may appear that you're drawing a solid, filled circle, for instance, what you're really creating is a new layer containing both a colored fill and a mask with a circle-shaped cutout **(FIGURE 12.31)**. When you move, reshape, or resize a shape, you're actually just moving or reshaping the cutout and revealing a different area of the colored fill below it **(FIGURE 12.32)**. When you add to or subtract from a shape by drawing additional shapes, you're simply revealing or hiding more of the same colored layer **(FIGURE 12.33)**.

Every time you create a new shape, a new shape layer is added to the Layers panel. A shape layer is represented in the panel thumbnails by a gray background (the mask) and a white shape (the mask cutout, or *path*). Since a shape's outline isn't always visible in the image window—if you deselect it, for instance—the Layers panel provides a handy, visual reference for every shape in your image **(FIGURE 12.34)**. And as with any other layered image, you can use the Layers panel to hide a shape's visibility and even change its opacity and its blending mode.

To draw a shape:

1. Select the Shape tool from the toolbox (or press U), and then select a shape in the Tool Options bar (**FIGURE 12.35**).

2. If they're available for the tool you've selected, you can set special properties for your shape before you draw. In the Tool Options bar, enter values specific to the shape you've chosen.

 For example, for the Polygon tool, you can enter the number of sides. For the Line tool, you can enter a pixel weight.

3. In the Tool Options bar, select from the available options for that particular shape or leave the options set to the default of Unconstrained.

4. In the image window, drag to draw the shape (**FIGURE 12.36**).

5. Click the Color Swatches button in the Tool Options bar and click a color to apply it to the shape.

To apply a style to a shape:

1. With a shape selected, in the Tool Options bar, click the icon to open the Style Picker (**FIGURE 12.37**).

2. Choose from the list of available styles, or click the Styles menu to view the available sets.

3. Click a style in the Style Picker to apply it to your shape (**FIGURE 12.38**).

TIP To remove a style from a shape, you have two options. With the shape layer selected in the Layers panel, open the Styles panel menu in the Tool Options bar, click the Panel Options menu, and then choose Remove Style. Or, right-click the Layer Style icon (*fx*) on the desired layer in the Layers panel and choose Clear Layer Style.

TIP To constrain the proportions (to draw a square using the Rectangle shape tool, for example), hold the Shift key as you drag.

FIGURE 12.35 Some shape tools, such as the Polygon tool, have properties you can set in the Tool Options bar.

FIGURE 12.36 Drag to draw the new shape.

FIGURE 12.37 When any shape tool is selected, the shape tool Style Picker appears in the Tool Options bar.

FIGURE 12.38 The shape drawn with the Polygon shape tool (left) is transformed into a glossy button (right) using a style from the Style Picker.

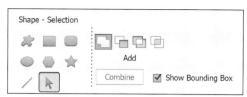

FIGURE 12.39 Access the Shape Selection tool from the Tool Options bar.

FIGURE 12.40 Drag a corner handle to scale.

FIGURE 12.41 Click the Commit button to apply the scale adjustment.

▶ **VIDEO 12.3**
Create Custom Shapes

Transform Shapes

Once a shape is created, you can also scale (resize), rotate, and distort it to your liking. Because shapes exist as their own layers, these controls are similar to the ones used to transform layers described in Chapter 7.

To scale a shape:

1. Choose the Shape Selection tool from beneath the current shape tool in the Tool Options bar **(FIGURE 12.39)**.

2. In the image window, select the shape with the Shape Selection tool.

 You should see handles around the shape. If not, select Show Bounding Box in the Tool Options bar.

3. Drag a corner handle to scale the shape proportionally **(FIGURE 12.40)**. To scale and distort the shape, hold Shift as you drag.

4. Click the Commit button that appears, or press Enter/Return to complete the transformation **(FIGURE 12.41)**.

TIP Another option for scaling a shape is to choose Image > Transform Shape > Free Transform Shape, but as soon as you start dragging one of the bounding box handles, you're effectively in that mode anyway.

TIP After you start dragging a selection handle, the usual complement of Transform controls—choosing an origin point, using precise values to set the scaling percentage, and so forth—become available in the Tool Options bar.

TIP To reposition a shape in the image window, click anywhere inside the shape with the Shape Selection tool and then drag the shape to its new position.

To rotate a shape:

1. Choose the Shape Selection tool from beneath the current shape tool in the toolbar.

2. In the image window, select the shape with the Shape Selection tool.

3. Move the pointer outside the bounding box until it becomes a curved rotation cursor, then drag to rotate the shape **(FIGURE 12.42)**.

4. Click the Commit button that appears or press Enter/Return to complete the transformation.

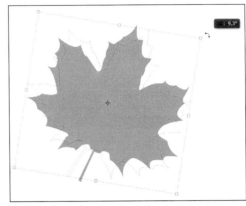

FIGURE 12.42 Rotate a shape by dragging just outside its handles.

To distort a shape:

1. In the image window, select the shape with the Shape Selection tool.

2. Choose Image > Transform Shape > Distort.

3. Drag any of the shape's control handles to distort the shape **(FIGURE 12.43)**.

4. Click the Commit button that appears or press Enter/Return to complete the transformation.

TIP To rotate your shape in 90- or 180-degree increments or to flip it horizontally or vertically, choose Image > Rotate, and then choose from the list of five menu commands below the Free Rotate Layer command.

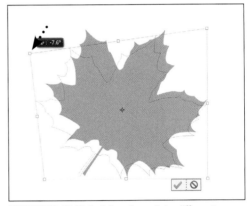

FIGURE 12.43 Distort the shape into different proportions.

 VIDEO 12.4
Use the Cookie Cutter Tool

Distortion Shortcuts

From the Image menu, choose Transform Shape > Free Transform Shape, and then use the following shortcuts while dragging the corner handles in the image window:

To Distort: Ctrl/Command

To Skew: Ctrl+Alt/Command+Option

To create Perspective: Ctrl+Alt+Shift/Command+Option+Shift

13

Working with Text

When you think about all of the sophisticated photo retouching, painting, and drawing you can do in Photoshop Elements, manipulating type may not seem like a priority for your to-do list. However, you can create some amazing projects with the Type tools, including greeting cards, posters, announcements, and invitations—and you don't have to fire up another software application.

This chapter covers the text formatting options and special type effects you can create with Photoshop Elements. If you've had any experience with word processing programs, the basic text formatting options will be familiar to you. But unlike a word processor, Photoshop Elements lets you create myriad special effects, using the type warping and masking tools and layer styles.

We're primarily covering the mechanics of working with text in the Editor. Don't forget there are several Guided edits, such as Text And Border Overlay, Meme Maker, and Photo Text, as well as projects such as Quote Graphic and Greeting Card.

In This Chapter

Create and Edit Text

When you use the Type tools, your text automatically appears on a new text layer. You can modify it every way layers allow, including moving, applying blending modes, and changing the opacity. Also, having text on its own layer allows you to go back and edit it whenever you want.

If you want to paint on your text or apply filters or effects to it, you'll need to simplify the layer by converting it to a standard bitmap. But remember: After a text layer has been simplified, it becomes part of the image, which means you can no longer edit the text. Fortunately, as long as you don't close the file, the Undo History panel will let you go back to the state your type was in before it was simplified. And you can (and should) make a duplicate of the text layer and hide it prior to simplifying the text.

To add text to an image:

1. Select the Type tool from the toolbox (or press T) **(FIGURE 13.1)**. By default, the Horizontal Type tool is selected **(FIGURE 13.2)**.

 Your pointer changes to an I-beam, as in many other text-editing programs.

2. In the image window, move the pointer to the area where you want to insert text, and then do one of the following:

 ▸ Click to create a text insertion point **(FIGURE 13.3)**. This method is perfect if you're placing just a single line of text, or a simple two- or three-line title or heading.

 ▸ If you want to place a long text paragraph that automatically wraps at the edges, drag to create a paragraph text box **(FIGURE 13.4)**.

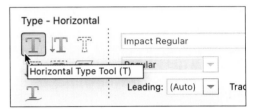
FIGURE 13.1 The Type tool

FIGURE 13.2 Choose one of the Type tools from the Tool Options bar.

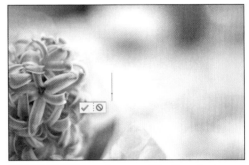
FIGURE 13.3 When using one of the Type tools, your pointer changes appearance to look like an I-beam. The text entry point is indicated by a vertical line whose height is based on the type size.

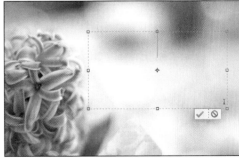
FIGURE 13.4 Alternatively, drag the I-beam to create a paragraph text box.

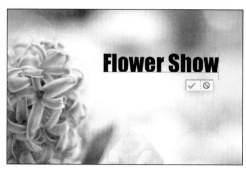

FIGURE 13.5 After you click once to establish the insertion point of your text, start typing.

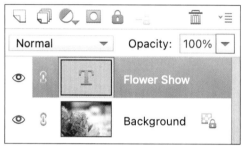

FIGURE 13.6 To make changes to existing text, click the appropriate layer on the Layers panel.

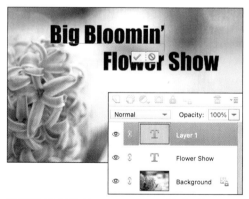

FIGURE 13.7 Clicking a new area with the Type tool creates a new text layer.

3. Type your text (**FIGURE 13.5**). If you want to start a new line, press Enter/Return.

If you've created a paragraph text box, the text automatically flows to a new line when it bumps up against the border of the text box.

4. To confirm the text you've entered, do one of the following:

 ▸ Click the Commit button that appears.

 ▸ Click anywhere in your image, click a panel, or click a tool on the toolbox.

 A new text layer is created and is visible on the Layers panel. The layer name is the text you entered.

To edit text:

1. Select a text layer on the Layers panel to make it active (**FIGURE 13.6**).

2. Select the Type tool from the toolbox.

3. In the image window, click in the text and edit as you would in any basic word processor.

4. Confirm your edits by clicking the Commit button or by clicking elsewhere in your image.

TIP We're covering creating horizontal text, but the Vertical Type tool can make text that reads from top to bottom.

TIP Consider changing the font size before you begin typing (which I describe shortly); 12-point text is easily lost in a high-resolution photo.

TIP If you want to add more text to a different part of your image, click elsewhere in the image and start typing. The new text appears on its own separate layer (**FIGURE 13.7**).

TIP Your image must be in RGB or Grayscale mode if you want to add type to it. The Editor's two other image modes, Bitmap and Indexed, don't support text layers.

To move text:

1. On the Layers panel, select the text layer you want to move.
2. From the toolbox, select the Move tool.

 When you select the Move tool, the type is surrounded by a (nearly invisible) selection bounding box, allowing you to move the type as a single object anywhere on the image.
3. In the image window, drag the text to a new location (**FIGURE 13.8**).

To simplify a text layer:

1. Choose a text layer on the Layers panel by clicking on it.
2. Choose Layer > Simplify Layer.

 The layer ceases to be a text layer, and the text is treated as pixels instead (**FIGURE 13.9**).

TIP You can also move a text layer while the Type tool is selected: Hold Ctrl/Command and click the layer, then drag it into position.

TIP When you simplify a text layer, does its icon in the Layers panel look empty? The tiny thumbnail may not appear to display your text if the type is small in relation to the full image size. Try this: Click the More menu at the right of the Task bar and choose Panel Options. In the dialog that appears, click Layer Bounds in the Thumbnail Contents section, and then click OK. The layer's thumbnail icon displays only the text, not the entire image.

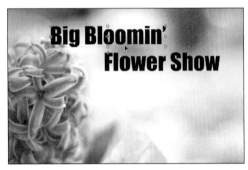

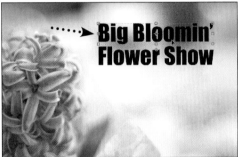

FIGURE 13.8 Because text exists on its own separate layer, you can move it to different areas in the image with the Move tool.

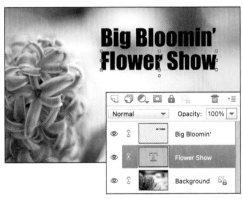

FIGURE 13.9 The Big Bloomin' layer is simplified, so it's now an image layer instead of a text layer.

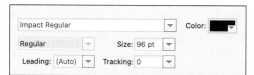

FIGURE 13.10 The type formatting tools are all available on the text Tool Options bar.

FIGURE 13.11 Drag across text with the type pointer.

FIGURE 13.12 Double-click in a word to select it.

FIGURE 13.13 Triple-click anywhere in a line of type to select the entire line.

FIGURE 13.14 Quadruple-click anywhere in a paragraph to select the entire paragraph.

Change the Appearance of Text

You should be comfortable using the type formatting tools—font family, font style, and font size—because they're very similar to those found in most word processing programs. You can also change the text alignment and text color. All of these options are available on the Tool Options bar **(FIGURE 13.10)**.

To change any of these attributes, you first need to select the text characters you want to change. Most of the time, you'll want to select and apply changes to an entire line of text, but you can also select individual words or even individual characters.

To select text:

1. Select the text layer you want to edit on the Layers panel, or click in the type itself with the Move tool.

2. Select the Type tool.

3. To select the text, drag across the characters to highlight them **(FIGURE 13.11)**, or do one of the following:

 ▶ Double-click within a word to select the whole word **(FIGURE 13.12)**.

 ▶ Triple-click to select an entire line of text **(FIGURE 13.13)**.

 ▶ Quadruple-click to select an entire paragraph of text **(FIGURE 13.14)**.

TIP You can select all the text on a layer without even touching the text with your pointer. Just select the text layer on the Layers panel and double-click the T icon.

To choose the font family and style:

1. Select the text you want to change.

2. From the Tool Options bar, choose a font from the Font Family menu (**FIGURE 13.15**).

3. Still in the Tool Options bar, choose a style from the Font Style menu (**FIGURE 13.16**).

 If the font family you selected doesn't include a particular style, you can click the Faux Bold or Faux Italic button to change the look of your text (**FIGURE 13.17**).

 (Yes, Faux Bold and Faux Italic are the real names of those buttons. They're *faux*, or fake, because the effect is created without using a bold or italic variant in the selected font family.)

4. Click the Commit button to apply the change.

TIP Instead of scrolling through the entire Font Family menu, if you know which font you want, start typing its name in the field. You can also type a common name, such as *medium*, to show only fonts with medium-weight variations.

TIP If you haven't memorized the look of each and every font on your computer (and who has?), the Font Family menu displays an example of each font next to its font name. You can change the size of font samples or turn the display of the samples off by choosing Edit > Preferences > Type (Windows) or Adobe Photoshop Elements 2022 Editor > Preferences > Type (macOS) and then using the menu in the Type Options section of the Type Preferences dialog (**FIGURE 13.18**).

FIGURE 13.15 All available fonts are listed on the Font Family menu.

FIGURE 13.16 With a family selected, choose an alternate font style.

FIGURE 13.17 If a font doesn't include style options, you can apply a bold or italic format with the icons in the Tool Options bar.

FIGURE 13.18 Options in the Type Preferences let you control the display of font previews in the Font Family menu.

FIGURE 13.19 Hold the Shift key and press the Up Arrow key to quickly increase your type size in 10-point increments.

▶ **VIDEO 13.1**
Create Text Effects Using Type Masks

To change the font size:

1. Select the text you want to change.

2. Choose a size from the Size menu in the Tool Options bar.

 To change to a type size not listed on the menu, enter a new value in the Size field, and press Enter/Return.

TIP Quickly adjust the type size up and down using keyboard shortcuts. Select your text and then press Ctrl+Shift+. (period)/Command+Shift+. (period) to increase the size in 1-point increments. To reduce the size of the text, press Ctrl+Shift+, (comma)/Command+Shift+, (comma).

TIP You can also adjust the type size up and down in 1- or 10-point increments. Select your text and then select the type size in the Size menu in the Tool Options bar. Next, use the Up and Down Arrow Keys to size the type up and down in 1-point increments. If you hold the Shift key while pressing the Up or Down Arrow keys, the type will adjust in 10-point increments (**FIGURE 13.19**).

TIP To change the default measurement unit for type, go to the Editor's preference: in Windows choose Edit > Preferences > Units & Rulers; in macOS choose Adobe Photoshop Elements 2022 Editor > Preferences > Units & Rulers. Here you can select among pixels, points, and millimeters (mm).

To change the leading (line spacing):

1. Select the lines of text you want to change.

2. Choose a value from the Leading menu in the Tool Options bar **(FIGURE 13.20)**.

 To change to a line spacing value not listed on the menu, enter a new value in the Leading field.

To apply underline or strikethrough:

1. Select the text you want to change.

2. Click either the Underline or Strike-through icon in the Tool Options bar to apply that style to your text **(FIGURE 13.21)**.

TIP The default Leading (line spacing) value for any type size (Auto) serves as a good starting point, but it's surprising that something as simple as increasing or decreasing line spacing can have a dramatic visual impact.

TIP If a text layer is set to a vertical orientation, the underline appears on the left side of the type.

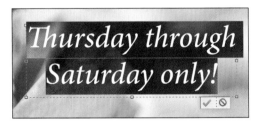

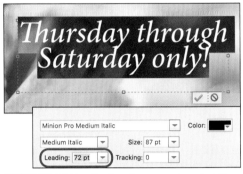

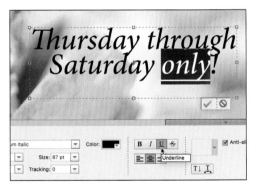

FIGURE 13.20 Use the Leading menu to select line spacing for your type, or enter a specific value in the field.

FIGURE 13.21 Apply underline or strikethrough.

VIDEO 13.2
Apply Layer Styles to Text

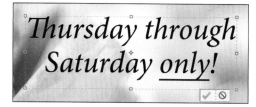

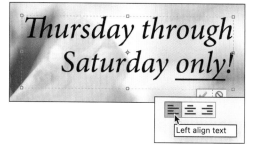

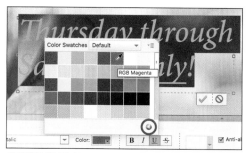

FIGURE 13.22 Aligning text within a paragraph box: Left Align (top), Center (middle), Right Align (bottom).

FIGURE 13.23 Change the text color by clicking the Color menu in the Tool Options bar. Access more colors using the Color Picker button (highlighted).

FIGURE 13.24 Use the eyedropper to copy a color value from the image instead of using a swatch.

To change the text alignment:

1. Select the text you want to change.

2. From the Tool Options bar, choose an alignment option (**FIGURE 13.22**).

 The type shifts in relation to the origin of the line of text, or in the case of paragraph text, in relation to one side of the text box or the other. For point-and-click type, the origin is the place in your image where you first clicked before entering the type.

 ▶ **Left Align** positions the left edge of each line of type at the origin or on the left edge of the paragraph text box.

 ▶ **Center** positions the center of each line of type at the origin or in the center of the paragraph text box.

 ▶ **Right Align** positions the right edge of each line of type at the origin or on the right edge of the paragraph text box.

To change the text color:

1. Select the text you want to change.

2. Click the Color menu in the Tool Options bar and select a swatch from the palette that appears (**FIGURE 13.23**). Or, click the Color Picker button at the lower-right corner to view more color options.

3. Click OK to apply the color to your text.

TIP When you click the Color Picker button in the Color menu, you can use the pointer as an eyedropper to sample colors from the image (**FIGURE 13.24**).

TIP You can also change the color of all text on a text layer without selecting the text itself. With the Type tool active, click to select a text layer in the Layers panel to make it the active layer, then follow the procedure to change the text color.

Create Text on a Path

Text can be much more dynamic when it interacts with the imagery it's built upon. Add text that follows the edge of a selection, a shape, or a custom path. Once the text is created, you can resize, reposition, and restyle it as you wish.

To create text on a selection:

1. From the toolbox, select the Text On Selection tool (**FIGURE 13.25**).

2. Define the selected area (**FIGURE 13.26**). The tool acts like the Quick Selection tool, grabbing areas based on color and contrast as you drag along the object you want to run text around.

 To change the size of the selection brush, use the bracket keys: [and].

3. Optionally drag the Offset slider in the Tool Options bar to enlarge or retract the selection (to make the text appear above or inside the selection).

4. Click the Commit button to complete the selection; the edge becomes a path.

5. Position the pointer over part of the path where you want to start typing and click; the pointer changes to an I-beam (**FIGURE 13.27**).

6. Type the text, which follows the path (**FIGURE 13.28**).

7. Click the Commit button or press Enter/Return to apply the text.

To create text on a shape:

1. Select the Text On Shape tool.

2. In the Tool Options bar, select the shape you want to use.

 To change the appearance of a shape, you need to specify the settings using

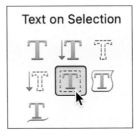

FIGURE 13.25 The text on path tools appear in the Tool Options bar.

Selection

FIGURE 13.26 Although it's a text tool, the first step in using the Text On Selection tool is to create the selected object.

Cursor *Path made from selection*

FIGURE 13.27 Click where you want the text to begin.

FIGURE 13.28 Type the text.

FIGURE 13.29 Text flows around a circle.

FIGURE 13.30 Draw a freehand path.

FIGURE 13.31 Text on a custom path can be less than smooth.

FIGURE 13.32 Use the Modify tool to adjust the control points.

VIDEO 13.3

▶ **Make a Quote Graphic Project**

the corresponding shape's tool. For example, to change the number of sides of a polygon, select the Polygon tool (the tool itself, not the option in the Text On Shape tool) and change the value in the Sides field.

3. Draw the shape on your image and commit it.

4. Click the path and type your text **(FIGURE 13.29)**.

5. Click the Commit button or press Enter/Return to apply the text.

To create text on a custom path:

1. Select the Text On Custom Path tool.

2. Drag to draw a line **(FIGURE 13.30)**, and commit it when you're done.

3. Click the path and type your text **(FIGURE 13.31)**.

 Don't be concerned if the text appears as if it went through an earthquake; Elements is placing the letters over a bumpy path. You can modify the path as described below.

4. Click the Commit button.

5. In the Tool Options bar, click the Modify button. The path's control points appear.

6. Drag the control points to alter the shape of the path **(FIGURE 13.32)**.

7. Click the Draw button to stop editing the path.

TIP I won't sugarcoat it. Editing control points on custom paths can be fiddly, time consuming, and frustrating. Depending on the shape you need, you may be better off creating text on a shape or selection instead.

To edit the text formatting:

1. In the Layers panel, select the text layer you want to edit.

2. With any of the text on path tools active, click the type to insert the cursor, and then select the text.

3. Use the formatting controls in the Tool Options bar to choose typeface, size, and other formatting (**FIGURE 13.33**).

4. Click the Commit button.

To reposition the text:

1. With any of the text on a path tools active, click the text to insert a cursor.

2. Locate the origin point, a small circle where you started typing your text (**FIGURE 13.34**).

3. Hold Ctrl/Command and drag to slide the text away from the origin point; the cursor appears with an arrow icon.

 The behavior of the text as you drag depends on a couple factors:

 ▸ If you drag above the text baseline, the letters remain on top of the line (**FIGURE 13.35**). Pulling the pointer below the baseline causes the text to flow along the inside of the shape.

 ▸ Dragging behind the origin point makes the text disappear. To position the first letters further left, Ctrl/Command-drag the origin point and move it before you slide the letters.

TIP With no text selected, hold Ctrl/Command and click to move the entire path.

TIP Apply modifications such as drop shadows using the options in the Effects panel (**FIGURE 13.36**).

FIGURE 13.33 The formatting settings appear in the Tool Options bar when text is selected.

Origin point

FIGURE 13.34 The origin point can be hard to spot at first.

Origin point Pointer

FIGURE 13.35 Drag to reposition the text on the path.

FIGURE 13.36 You can apply effects to layers that contain text on a path.

FIGURE 13.37 Click the Create Warped Text icon in the Tool Options bar to experiment with distortions.

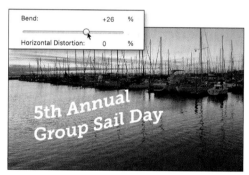

FIGURE 13.38 The Horizontal and Vertical orientation options create radically different results.

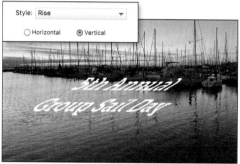

FIGURE 13.39 In this example, the Bend slider has been reduced from +50 to +26 to make the Rise effect less pronounced.

Warp Text

You can select several different options to distort text using the Warp tool. For example, you can adjust the amount of the bend in the type, as well as the horizontal and vertical distortion.

Even after you've warped your text, it's still completely editable, and you can make additional formatting changes to it at any time. But because the Warp effect is applied to the entire text layer, you can't warp individual characters—it's all or nothing.

To warp text:

1. Select a text layer on the Layers panel.

2. From the toolbox, select the Horizontal Type tool (so that the type options appear in the Tool Options bar), and click the Create Warped Text button **(FIGURE 13.37)**.

 The Warp Text dialog appears.

3. Choose a warp style from the Style menu.

4. Select either Horizontal or Vertical orientation for the effect **(FIGURE 13.38)**.

5. Modify the amount of Bend and Horizontal or Vertical distortion using the sliders **(FIGURE 13.39)**.

6. Click OK to apply the effect.

To remove text warp:

1. On the Layers panel, select a text layer that's been warped.

2. Select a Type tool, and click the Create Warped Text icon in the Tool Options bar.

3. Choose None from the Style menu **(FIGURE 13.40)**.

4. Click OK to remove the effect.

TIP As you experiment with the various warping options, your text can undergo some pretty dramatic changes. For this reason, you might want to move the text around to see how it looks in different parts of the image. Luckily, you can do this without closing the Warp Text dialog. If you move the pointer into the image area, you'll see that it automatically changes to the Move tool so you can move the text around while adjusting the warping effect.

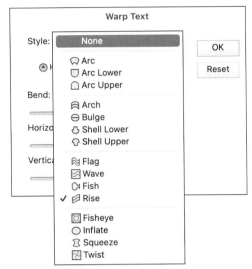

FIGURE 13.40 To remove text warp, select None from the Style menu.

Saving and Printing Images

For most of the book so far, we've stuck to working with photos in the Editor and the Organizer. But there are times when you want to save images in other file formats or prepare them for printing.

In this chapter, I'll begin with a discussion of formatting options and then move on to other considerations for saving your image files and outputting them to paper.

In This Chapter

Understand File Formats

Photoshop Elements lets you save an image in many different file formats, from the native, information-rich Photoshop format to optimized formats for the web, such as JPEG and GIF. Among these is a collection of formats (BMP, Pixar, PNG) that you'll rarely need to use and won't be discussed here. What follows are descriptions of the most common file formats.

Photoshop

Photoshop (PSD) is the native file format of Photoshop Elements, meaning that the saved file will include information for any and all of the features in Photoshop Elements, including layers, styles, effects, typography, and filters. As its name implies, any file saved in the PSD format can be opened not only in Photoshop Elements, but also in Adobe Photoshop. Conversely, any Photoshop file saved in its native format can be opened in Photoshop Elements. However, Photoshop Elements doesn't support all the features available in Photoshop, so although you can open any file saved in the PSD format, some of Photoshop's more advanced features won't be accessible to you within Photoshop Elements.

A good approach is to save every photo you're working on in the native Photoshop format and then, when you've finished editing, save a copy in whatever format is appropriate for that image's intended use or destination. That way, you always have the original, full-featured image file to return to if you want to make changes or just save it in a different format.

Choosing Compression Options

As you save images in the various formats available, you're presented with a variety of format-specific dialogs, each containing its own set of options. One of those options is a choice of compression settings. Compression (or optimization) makes an image's file size smaller, meaning the file downloads faster when you post it to a web page, for example. Following is a brief rundown of the compression schemes:

JPEG: JPEG works best with images like photographs. It compresses by throwing away image information and slightly degrading the image, and is therefore a *lossy* compression format.

LZW: This is the standard compression format for most TIFF images. Although it works best on images with large areas of a single color, LZW helps reduce file sizes at least a little for nearly any image to which it's applied. Because it works behind the scenes, throwing out code rather than image information (meaning it doesn't degrade the image), LZW is a *lossless* compression format.

RLE: This is a lossless compression similar to LZW, but it's specific (in Elements) to BMP-compressed files. It's particularly effective at compressing images containing transparency.

ZIP: This compression scheme is also similar to LZW, but it has the advantage of adding a layer of protection to files that makes them less susceptible to corruption if they're copied between systems or sent via email.

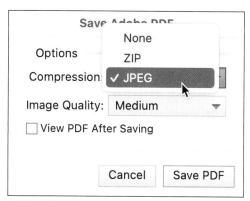
FIGURE 14.1 When you save your work as a PDF file, you can apply JPEG or ZIP compression.

JPEG

JPEG is the most common file format for photos, because it delivers great image quality while also keeping file sizes small. It's also almost universally recognized by apps, web browsers, and operating systems. When saving edited photos from the Editor, you'll usually save them as JPEG images.

GIF

GIF started as a way to save images in as compact a file as possible to help reduce web page loading times. The format accomplishes its compression by reducing its color palette to a limited number of hues (as few as four), and it works well for images with wide swathes of solid colors.

GIF files can also include mutiple images that animate when viewed on web pages or in text messages—and it's become the default format for memes. Some features, such as the Meme Maker and Moving Overlays, can save their results as GIFs.

Photoshop PDF

Portable Document Format (PDF) is the perfect vehicle for sharing images across platforms or for importing them into a variety of graphics and page layout pro-grams. PDF is also one of only three file formats (native Photoshop and TIFF are the other two) that support an image file's layers; layer qualities (like transparency) are preserved when you place a PDF into another application like Adobe Illustra-tor or InDesign. The real beauty of this format is that a PDF file can be opened and viewed by anyone using Adobe's free Acrobat Reader software. PDF offers two compression schemes for controlling file size: ZIP and JPEG **(FIGURE 14.1)**.

TIFF

Tagged Image File Format (TIFF) is a workhorse among the file formats. The format was designed to be platform independent, so TIFF files display and print equally well from both Windows and macOS systems. Additionally, any TIFF file created on one platform can be transferred to the other and placed in almost any graphics or page layout program.

You can optimize TIFF files to save room on your hard drive using one of three compression schemes, or you can save them with no compression at all **(FIGURE 14.2)**. Of the three compression options, LZW is the one supported by the largest number of applications and uses.

The Pixel Order option should be left at the default of Interleaved. The Byte Order option encodes information in the file to determine whether it will be used on a Windows or Macintosh (macOS) platform. On rare occasions, TIFF files saved with the Macintosh option don't transfer cleanly to Windows systems. But since the Mac has no problem with files saved with the IBM PC byte order, I recommend you stick with this option.

Selecting Save Image Pyramid saves your image in multiple tiers of resolution, but since not many applications support the Image Pyramid format, leave this box deselected.

Selecting Save Transparency ensures transparency will be maintained if you place your image into another application, such as Illustrator or InDesign.

If your image contains layers, select a Layer Compression scheme (RLE or ZIP), or choose to discard the layers altogether and save a flattened copy of the image file.

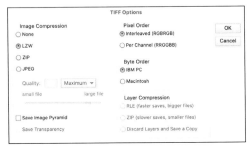

FIGURE 14.2 Although the TIFF format offers several compression schemes, LZW is usually the most reliable.

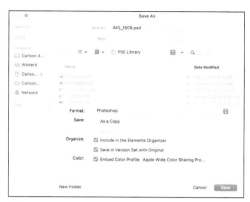

FIGURE 14.3 The Save As dialog includes several options beyond just naming the new file.

Working with Version Sets

In the digital photography realm, the "negative" is the original image file captured by your camera. On the computer, you're working with those original files. So, for example, if you change a photo from color to grayscale and save it, then you lose the color version forever.

To guard against that, Elements offers the ability to save the file in a *version set* when you perform a Save As operation. You're saving a new copy, but it's linked to the original image in the Organizer as a revision **(FIGURE 14.4)**; otherwise, the edited version would appear as a completely separate image. Click the expansion arrow icon to the right of the image to view or hide the version set.

FIGURE 14.4 A version set tracks image edits.

Save Files

As you work on an image in the Editor, it's good practice to save the file regularly. When you save a file, you can choose from a number of file formats.

If you're interested in posting images to the web, you can choose the Save For Web command, which involves its own set of unique operations.

To save a file:

Choose File > Save, or press Ctrl+S/Command+S. If you've added layers during editing, you'll be asked to save the image in a new format.

To save a file in a new format or to a specific location:

1. Choose File > Save As, or press Ctrl+Shift+S/Command+Shift+S. The Save As dialog appears **(FIGURE 14.3)**.

2. Choose a destination for the file by browsing to a location.

3. In the Save As field, type a name for the file.

4. Select Include In The Elements Organizer to make sure the version shows up in your library.

5. If you want to save the file in a different format, choose one from the Format menu.

 If you're not sure which format to use, choose either the native Photoshop format (PSD), which is the best all-purpose format, or JPEG format, which works especially well with digital photos. When saving an image as a JPEG file, choose the highest quality setting possible.

continues on next page

6. If you want to be sure not to alter your original file, select the As A Copy option to save a duplicate. This selection protects your original file from changes as you edit the duplicate.

7. To include color profile information, make sure the Embed Color Profile option is selected. For more information on managing color in your images, see Chapter 8.

8. When you've finished entering your settings, click Save.

 Depending on the format you chose, you may be prompted to set other options, such as with JPEG files **(FIGURE 14.5)**.

TIP Saving using the **As A Copy** option is a good idea if you're experimenting with various changes and want to ensure that you keep your original version intact. It's also handy if you want to save an image in more than one file format, which is useful if you want to save a high-quality copy for printing and keep a smaller-sized file to email to friends.

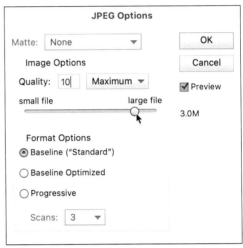

FIGURE 14.5 Each image format has its own specific settings, such as those shown in this dialog for saving a JPEG file.

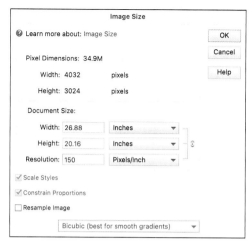

FIGURE 14.6 Enter new Width and Height values to change an image's print size.

Recommended Resolutions

There are no absolute rules for the best resolution to use when working with images for printing. The best approach is to try a few settings and see what works well for your specific situation. Here are a couple of typical situations:

- For color images printed on color inkjet printers, a range of up to 150 ppi is often ideal. The exact resolution will depend on your printer and the type of paper on which you are printing.

- For color or high-resolution black-and-white images printed on photo printers, you'll want a resolution between 150 and 300 ppi.

If you want to create higher-quality professional projects, such as magazine or print design work, be aware that Photoshop Elements is not capable of producing CMYK files (the color-separated files used for high-end printing). If you need to handle these kinds of jobs, consider subscribing to the standard Adobe Photoshop.

Resize an Image

When it comes to printing and resolution, it helps to keep a few basic details in mind to avoid confusion.

You know that image resolution is described in *pixels per inch*, or *ppi*. Print resolution, however, is usually described by the number of *dots per inch*, or *dpi,* a printer is capable of printing. If you want to print a high-quality flyer or photo, you may want to use an image resolution as high as 300 pixels per inch, so that a maximum amount of image information is sent to the printer.

To resize an image for printing:

1. Choose Image > Resize > Image Size.

2. To maintain the current width-to-height ratio, check that the Constrain Proportions option is selected.

3. Deselect the Resample Image box.

4. Choose a unit of measurement (or Percent), and then enter new values in the Width or Height fields in the Document Size area of the dialog **(FIGURE 14.6)**.

 In the Document Size area, the Resolution value changes accordingly. For instance, if you enter values that are half the width and height of the original image, the Resolution value will double. Because you're now compressing the same number of pixels into a smaller space, the image will print clearer and sharper. So, when scaled at 50%, an image 4 inches wide with a resolution of 150 pixels per inch (ppi) will print at 2 inches wide and at a resolution of 300 ppi.

 continues on next page

5. Click OK to complete the change.

The image's print size will be changed, but because it still contains the same number of pixels, it will appear to be unchanged on your screen. You can, however, view a preview of the final print size onscreen:

- Choose View > Print Size. The image is resized on your screen to approximate its final, printed size **(FIGURE 14.7)**.

- Choose View > Actual Pixels, or press Ctrl+1/Command+1 to return the display size to 100 percent.

TIP To return the dialog to its original settings, press Alt/Option to change the Cancel button to Reset, then click Reset.

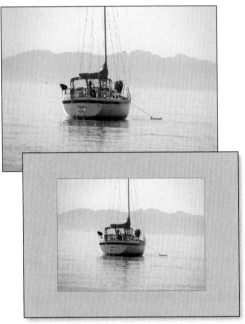

FIGURE 14.7 An image can be viewed at an approximation of its final print size, even when its resolution differs from the computer's display.

VIDEO 14.1

Batch Process Multiple Images

Downsampling vs. Upsampling

Downsampling, which is the term for decreasing resolution by *removing* pixels from a photo, is one of the easiest and most common ways to make your files smaller. If you shrink an 8 x 10 photograph of your grandmother to a 4 x 5 image by reducing its pixel count, you've just downsampled it. The Editor "throws away" unneeded pixels intelligently, with little visible impact on the quality of your image.

But *upsampling*, which is the term for increasing resolution by *adding* new pixels to your photo, should be avoided if possible. If you start with a 4 x 5 photograph and try to enlarge it to 8 x 10, the Editor must manufacture those pixels out of thin air. They tend to add a ghosted, fuzzy appearance to any hard edge. The overall effect is that your image can look out of focus.

Because downsampling rarely detracts from the quality of your images, you should capture all of your original files at the highest resolution possible.

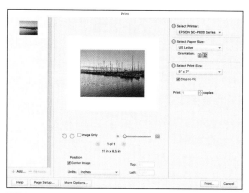

FIGURE 14.8 The Print dialog

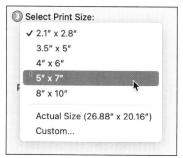

FIGURE 14.9 Choose the size you want the photo to be on the printed page.

Cropping in the Print Dialog

One frustration with printing photos is that the standard aspect ratios of photo prints are different than the ratio used by most cameras. You can pre-crop the image in Elements, but that involves creating a duplicate and cropping the duplicate. Blech.

Instead, after selecting a print size, apply the cropping in the Print dialog. Click the Crop To Fit checkbox to let Elements frame the new size. If that's not quite what you're looking for, drag the image in the preview to move it within the frame (indicated by a blue box). You can also drag the Size slider below the preview to further adjust how the image is framed.

Print an Image

Whether you're printing final photos for clients or just some snapshots for family, you can print to a local printer from within Photoshop Elements.

To print an image:

1. Do one of the following:
 - ▸ In the Organizer, select the photos you would like to print.
 - ▸ In the Editor, open the files you want, or select them in the Photo Bin.

2. Click the Create menu in the upper-right corner of the window and choose Photo Prints.

3. From the options that appear, click the Local Printer button.

 If you're printing from the Organizer, the task must be handed off to the Editor. Click Yes when asked to continue.

 The Print dialog opens (**FIGURE 14.8**).

4. Choose a printer and optionally adjust settings specific to it from the Select Printer and Select Paper Size menus.

5. Click the Select Print Size menu and choose the size at which the image will print (**FIGURE 14.9**). The page preview reflects the page size in proportion to the image you want to print.

 Choosing Custom opens the More Options dialog (see the next page).

6. Specify the number of copies of each page to print.

7. Click the Print button to send the job to the printer.

Set more printing options

Elements offers optional print settings for adding more information to your prints. They can be helpful when printing drafts or outputting images for other projects.

To set more printing options:

1. Before you print, click the More Options button and, in the dialog that appears (**FIGURE 14.10**), do one of the following:

 ▶ Make sure Printing Choices is selected in the sidebar. In the Photo Details area, click the checkboxes to display an image's date, caption, or filename.

 ▶ In the Border area, click the Thickness checkbox and specify a width for a line if you want one (**FIGURE 14.11**). Click the small color swatch to the right to select the border's color. You can also set a background color for the page.

 ▶ If you're making transfers for T-shirts, select the Flip Image option under Iron-On Transfer to invert the image horizontally. (If your printer's driver has an invert image option, make sure that's not selected—otherwise, the image will flip back to its original orientation when printed.)

 ▶ Under Trim Guidelines, click the Print Crop Marks button if you want to include crop marks (**FIGURE 14.12**).

2. Click the Apply button to view the changes in the preview without leaving the More Options dialog. Or, click OK to return to the Print dialog.

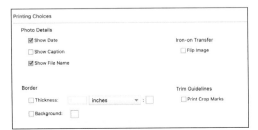

FIGURE 14.10 The Printing Choices of the More Options print dialog

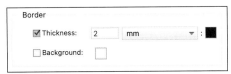

FIGURE 14.11 Select a measurement unit and size for your border.

FIGURE 14.12 Crop marks are positioned at the corners in this preview of how the page will look.

VIDEO 14.2

Create Contact Sheets and Picture Packages

Sharing Your Images

If you're shooting photos and making compositions in Photoshop Elements, it's a safe bet that you want to share them with others. In the past, you'd make prints and either carry them everywhere or send them through the mail. Now, you can upload photos to social media sites, email photos directly, make your own slideshow, and more.

Of course, you can also save an image to disk (as described in the previous chapter) and share it from there. But some services are integrated into Photoshop Elements, streamlining the process.

In This Chapter

Upload to an Online Service

Uploading photos to a social networking service such as Flickr or Twitter is often an easy way to share your photos to a wide audience. (You'll need an existing account with any of the services you want to use.) I'll use Flickr in my example here.

To upload to a photo sharing service:

1. In the Organizer, select one or more photos you want to upload.

2. Click the Share menu in the upper-right corner of the window and choose Flickr (**FIGURE 15.1**).

 The first time you do so, you'll need to authorize Elements as a legitimate sharing service within Flickr. Click the Authorize button in the Share To Flickr dialog, which takes you to Flickr's website. Return to the Share To Flickr dialog, and click the Complete Authorization button. The Upload To Flickr interface appears (**FIGURE 15.2**).

3. The photos you selected appear in the Items field. Click the Add (+) or Remove (–) buttons if you want to change which images are uploaded.

4. If you want to include the photos in an album, select the Upload As An Album option and specify one you've previously set up at Flickr. You can create a new one by typing its title in the Album Name field.

5. Specify the photos' privacy settings under the heading Who Can See These Photos?

6. Optionally, type keyword tags in the Tags field, separated by spaces.

7. Click the Upload button to publish the photos.

FIGURE 15.1 Share to many popular social media sites and galleries.

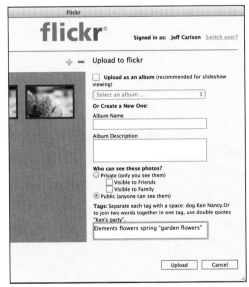

FIGURE 15.2 Upload directly to Flickr from the Organizer.

TIP You can also share directly to Flickr or Twitter in the Editor.

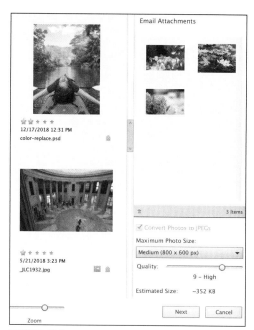

FIGURE 15.3 The Email Attachments sidebar includes the selected photos.

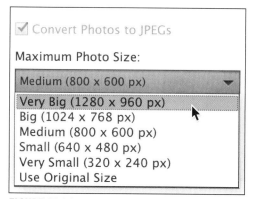

FIGURE 15.4 Choose a maximum size for the attached images.

TIP Be aware that sending photos via email these days can be a hit-or-miss endeavor. Many email gateways look at multiple attachments as suspicious security risks, so your message may not get through to the recipient.

Send Images by Email

Elements can streamline the process of sending digital photos to family and friends. If your photo is too large or is in the wrong file format, Elements can automatically resize and convert your image, if you prefer.

To attach photos to email:

1. In the Organizer, select one or more photos you want to send.

2. Click the Share menu and choose Email.

 The Email Attachments sidebar appears (**FIGURE 15.3**).

3. From the Maximum Photo Size menu, choose the size of your attachment.

 If you choose an option other than Use Original Size, use the Quality slider to control the size and download speed of your attachment (**FIGURE 15.4**).

 If the source image is not a JPEG file, you also have the option of converting the outgoing file by selecting the Convert Photos To JPEGs checkbox.

4. Click Next.

5. At this point you can select recipients, write a subject line, and compose your message, but my advice is to ignore this step. While it's possible to set up a list of contacts within the Organizer (by clicking the Edit Recipients In Contact Book button), you no doubt already have that information in the email app you already use.

 Instead, click Next again.

 The Organizer converts the images and attaches them to an outgoing message in your default email app, where you can add a sender and write your text.

Create a Slideshow

Recently I had to explain the concept of a slideshow to someone (younger) who didn't know what a "slide" was. Although we no longer use slivers of transparent plastic in rotating projectors, we often want a succession of photos that can play on a TV or attached to a digital projector. The Slideshow feature in Photoshop Elements sets a series of images to music, with several themes to choose from and options to customize the show.

A slideshow can start with photos you choose, or you can use Auto Curate and let the Organizer choose the images.

To create a slideshow using Auto Curate:

1. In the Organizer, make sure no photos are selected. Or, select Auto Curate and specify the number of photos to include.

2. Click the Slideshow button on the taskbar, or click the Create menu and choose Slideshow (**FIGURE 15.5**).

3. In the dialog that appears, click Pick The Best to let the software choose the photos (**FIGURE 15.6**). Or, click Use All Media to build a slideshow with everything in your library.

 The Organizer builds a slideshow using the photos and a default theme. It also starts playing automatically (**FIGURE 15.7**). (Click anywhere in the show to pause playback.)

To create a slideshow of selected photos:

1. In the Organizer, select one or more photos that will appear in the slideshow. (You can also start with open images in the Editor, but they will then be handed off to the Organizer.)

FIGURE 15.5 Create a new slideshow in the Organizer.

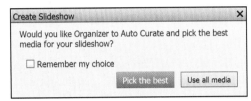

FIGURE 15.6 The Organizer can build a curated slideshow based on what it thinks are your best images.

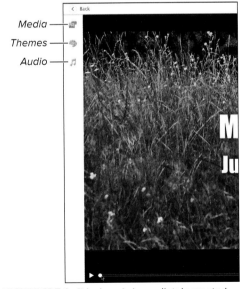

Media

Themes

Audio

FIGURE 15.7 A slideshow is immediately created, which you can then customize.

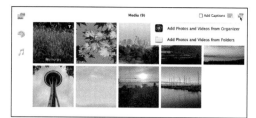

FIGURE 15.8 Add photos or videos to a slideshow from the Organizer or from a folder.

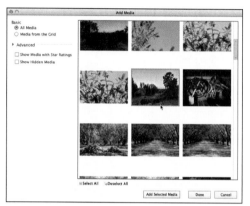

FIGURE 15.9 Add more media to the slideshow from the Organizer.

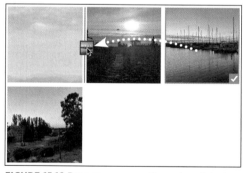

FIGURE 15.10 Drag to rearrange the order of photos.

TIP Did an image get added with the wrong orientation? Right-click it and choose Rotate Clockwise or Rotate Anti-Clockwise.

2. Click the Create menu and choose Slideshow.

The Organizer builds a slideshow using the photos and a default theme.

To add photos to the slideshow:

1. Click the Media button at the top of the sidebar.

Note that you can also add video and audio files to a slideshow.

2. Click the Add Photos And Videos button, and choose either Add Photos And Videos From Organizer or Add Photos And Videos From Folders **(FIGURE 15.8)**.

3. Do the following, depending on your choice:

 ▸ If you're grabbing items from the Organizer, in the Add Media dialog that appears select the photos you want to include in your slideshow. Click Add Selected Media, or click Done to add the items and close the window **(FIGURE 15.9)**.

 ▸ If your source was a folder, select files in the Open window and then click Open.

4. Click the Media button again to close the Media panel and incorporate the new images into the slideshow.

To reorder slides:

1. Click the Media button to view the Media panel.

2. Select an image.

3. Drag the image to a new spot in the grid; a blue vertical line indicates where you're dropping it **(FIGURE 15.10)**.

TIP In the Media panel, select the Add Captions option to reveal text fields for each image. Anything you type there appears on that photo's slide.

To add a text slide:

1. In the Media panel, click the Add Text Slide button **(FIGURE 15.11)**.

 The slide appears in the Slide Preview.

2. Click the left or right buttons to choose the text slide's background **(FIGURE 15.12)**. (These are custom to each theme. You can't use one of your own images, unfortunately.)

3. Enter a title and subtitle.

4. Click Add to create the slide, which by default appears at the beginning of the slideshow.

5. Drag the text slide to your desired location in the Media panel.

To edit an existing text slide:

1. In the Media panel, double-click a text slide, or right-click it and choose Edit.

2. Make the changes you want.

3. Click Save.

To remove a slide from the slideshow:

1. In the Media panel, select the slide that no longer belongs.

2. Press the Backspace/Delete key, or right-click and choose Remove.

To choose a new theme:

1. Click the Themes button in the Slideshow window's toolbar.

2. Select one of the themes in the list **(FIGURE 15.13)**.

3. Click Apply.

 The preview begins playing with the new theme applied.

FIGURE 15.11 Create a new text slide in the Media panel.

FIGURE 15.12 Choose a background for the text slide and enter the text.

FIGURE 15.13 Pick one of the provided themes.

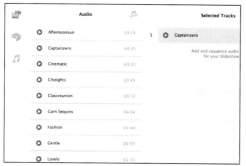

FIGURE 15.14 Choose from the songs used in each of the built-in themes.

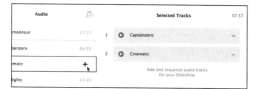

FIGURE 15.15 Add audio tracks to the slideshow.

To change the audio:

1. Click the Audio button to reveal the clips used by each theme **(FIGURE 15.14)**.

2. Preview any track by clicking the play icon to the left of the title.

3. To add one of the tracks to the slideshow, select it and then click the + button **(FIGURE 15.15)**.

 The track appears at the bottom of the Selected Tracks list, but you can drag it to any spot.

4. To use an audio track from outside the Organizer, click the Add Audio button above the track list and choose a file from your disk. Then click the + button to add it to the Selected Tracks list.

5. To remove a track from the slideshow, click the minus (–) sign to the right of the title in the Selected Tracks list. You can also remove all the tracks from the list to create a slideshow without background music.

6. Click the Audio button to close the panel.

To save a slideshow:

1. Click the Save button at the top of the window (or choose Save As from the button's menu).

2. In the dialog, type a name and click Save.

 The slideshow is saved to the Organizer's Photo Browser.

TIP An audio clip will repeat if the slideshow is longer than the clip's duration. If the clip is longer than the show, the time in the top-right corner of the Selected Tracks list appears red.

To export a slideshow:

1. From the Export menu at the top of the Slideshow window, choose YouTube or Vimeo to export and upload the slideshow video to one of those services. Or, choose Export Video To Local Disk.

2. In the case of YouTube or Vimeo, follow the instructions specific to them, which includes authorizing Photoshop Elements to upload directly.

 In the case of saving to your disk, in the Export dialog that appears enter a filename and location for the movie that's created (**FIGURE 15.16**).

3. Choose a Quality size: 720p HD or 1080p HD.

4. Click OK to save the file.

5. Choose whether to add the video to the Organizer when asked.

To exit the Slideshow window:

Click the Back button. If you didn't save the slideshow, you're prompted to do so.

To view a movie slideshow:

To view a movie slideshow, double-click it in the Organizer (if you opted to import it there) or open the file in File Explorer (Windows) or the Finder (macOS) (**FIGURE 15.17**).

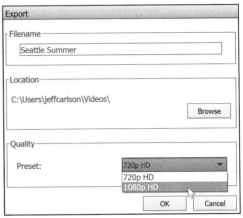

FIGURE 15.16 Export the slideshow at either 720p or 1080p quality.

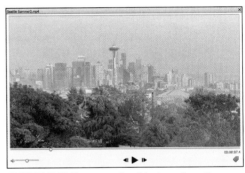

FIGURE 15.17 Play a movie slideshow from the Organizer.

Troubleshoot at Startup

It takes a lot of code to run an application capable of complex image manipulation, so there are bound to be some rough areas. If Photoshop Elements seems just a little off to you, you can try several key combinations to press while starting the program to weed out data corruption or possible troublesome plug-ins.

From the Photoshop Elements Home screen, do any of the following:

- Hold the Shift key and click the Photo Editor button. A dialog appears asking if you'd like to skip loading optional and third-party plug-ins. Click Yes to start the Editor with just the default plug-ins enabled. This technique can help you determine if a third-party plug-in might be interfering with the Editor.

- Hold Shift and click the Organizer button to bring up the Catalog Manager dialog for managing catalogs (see Chapter 3 for more on working with catalogs).

- Hold Ctrl+Shift/Command+Shift and click the Photo Editor button to specify a folder to load new third-party plug-ins.

- Hold Ctrl+Alt+Shift/Command+Option+ Shift and click either the Organizer or the Photo Editor button to be asked if you want to delete the program's settings file. If a preference becomes corrupted, this combination starts the application from a blank slate.

- Hold Ctrl+Alt/Command+Option and click the Photo Editor button to specify which drives to use for scratch disks (temporary storage for data that Elements uses while processing images).

Editor Keyboard Shortcuts (Windows)

TO CHOOSE A TOOL

Tools

Move	V
Zoom	Z
Hand	H
Color Picker	I
Marquee	M
Lasso	L
Recompose	W
Selection Brush	A
Type	T
Crop	C
Content-Aware Move	Q
Straighten	P
Red Eye Removal	Y
Spot Healing Brush	J
Clone Stamp	S
Eraser	E
Brush	B
Smart Brush	F
Pencil	N

TO CHOOSE A TOOL

Tools *(continued)*

Paint Bucket	K
Gradient	G
Shape	U
Blur	R
Sponge	O

TO CYCLE THROUGH TOOLS

Marquee tools	M
Lasso tools	L
Type tools	T
Healing Brush tools	J
Clone Stamp tools	S
Eraser tools	E
Brush tools	B
Smart Brush tools	F
Shape tools	U
Blur and Sharpen tools	R
Crop, Cookie Cutter, and Perspective Crop	C
Sponge, Dodge, and Burn	O

WORKING WITH TOOLS

Marquee Tool

Draw marquee from center	Alt-drag
Constrain to square or circle	Shift-drag
Draw from center and constrain to...	Alt+Shift-drag

Move Tool

Constrain move to 45°	Shift-drag
Copy selection or layer	Alt-drag
Nudge selection or layer 1 pixel	Arrow key
Nudge selection or layer 10 pixels	Shift+Arrow key

Lasso Tool

Add to selection	Shift-drag
Delete from selection	Alt-drag
Intersect with selection	Alt+Shift-drag
Change to Polygonal Lasso	Click, then Alt-drag

Polygonal Lasso Tool

Add to selection	Shift-click, then draw
Delete from selection	Alt-click, then draw
Intersect with selection	Alt+Shift-click, then draw
Draw using Lasso	Alt-drag
Constrain to 45° while drawing	Shift-drag

Magnetic Lasso Tool

Add to selection	Shift-click, then draw
Delete from selection	Alt-click, then draw
Intersect with selection	Alt+Shift-click, then draw
Add point	Single click
Remove last point	Backspace
Close path	Double-click or Enter

WORKING WITH TOOLS

Magnetic Lasso Tool *(continued)*

Close path over start point	Click on start point
Close path using straight line segment	Alt-double-click
Switch to Lasso	Alt-drag
Switch to Polygonal Lasso	Alt-click

Crop Tool

Rotate crop marquee	Drag outside crop marquee
Move crop marquee	Drag inside crop marquee
Resize crop marquee	Drag crop handles
Resize crop box while maintaining its aspect ratio	Shift-drag corner handles

Shape Tools

Constrain to square or circle	Shift-drag
Constrain Line tool to 45°	Shift-drag
Transform shape	Ctrl+T
Distort	Ctrl-drag
Skew	Ctrl+Alt-drag
Create Perspective	Ctrl+Alt+Shift-drag

Type Tool

Select a word	Double-click in text
Select a line	Triple-click in text
Select a paragraph	Quadruple-click in text
Select all characters	Ctrl+A
Left align text	Ctrl+Shift+L
Center text	Ctrl+Shift+C
Right align text	Ctrl+Shift+R
Increase by 1 point	Ctrl+Shift+. (period)
Decrease by 1 point	Ctrl+Shift+, (comma)
Scroll through fonts	Select font in menu+Up/Down Arrow

WORKING WITH TOOLS

Paint Bucket Tool

Change color of area	Shift-click outside canvas

Brush and Pencil Tools

Decrease or increase size	[or] (bracket keys)

Smudge Tool

Smudge using Foreground color	Alt-drag

Color Picker Tool

Choose Background color	Alt-click

DISPLAY SHORTCUTS

Change View

Zoom in	Ctrl+Spacebar-click/ drag or Ctrl++ (plus)
Zoom out	Alt+Spacebar-click/ drag or Ctrl+− (minus)
Zoom to 100% / Actual pixels	Double-click Zoom tool or Ctrl+Alt+0 (zero)
Zoom to fit window / Fit on screen	Double-click Hand tool or Ctrl+0 (zero)
Show/hide edges of selection	Ctrl+H
Show/hide ruler	Ctrl+Shift+R

Hand Tool

Toggle to zoom in	Ctrl
Toggle to zoom out	Alt
Fit image on screen	Double-click tool

DISPLAY SHORTCUTS

Zoom Tool

Zoom out	Alt-click
Actual size	Double-click tool

Move Image in Window

Scroll up one screen	Page Up
Scroll down one screen	Page Down
Scroll left one screen	Ctrl+Page Up
Scroll right one screen	Ctrl+Page Down
Scroll up 10 pixels	Shift+Page Up
Scroll down 10 pixels	Shift+Page Down
Scroll left 10 pixels	Ctrl+Shift+Page Up
Scroll right 10 pixels	Ctrl+Shift+Page Down
Move view to upper left	Home key
Move view to lower right	End key

MENU SHORTCUTS

File Menu

New > Blank File	Ctrl+N
Open	Ctrl+O
Open In Camera Raw	Ctrl+Alt+O
Close	Ctrl+W
Close All	Ctrl+Alt+W
Save	Ctrl+S
Save As	Ctrl+Shift+S
Save For Web	Ctrl+Alt+Shift+S
Print	Ctrl+P
Exit	Ctrl+Q

Edit Menu

Undo	Ctrl+Z
Redo	Ctrl+Y
Cut	Ctrl+X
Copy	Ctrl+C
Copy Merged	Ctrl+Shift+C
Paste	Ctrl+V
Paste Into Selection	Ctrl+Shift+V
Color Settings	Ctrl+Shift+K
Preferences > General	Ctrl+K

Image Menu

Free Transform	Ctrl+T
Image Size	Ctrl+Alt+I
Canvas Size	Ctrl+Alt+C

Enhance Menu

Auto Smart Fix	Ctrl+Alt+M
Auto Smart Tone	Ctrl+Alt+T
Auto Levels	Ctrl+Shift+L
Auto Contrast	Ctrl+Alt+Shift+L
Auto Haze Removal	Ctrl+Shift+A
Auto Color Correction	Ctrl+Shift+B
Auto Red Eye Fix	Ctrl+R
Adjust Color > Adjust Hue/ Saturation	Ctrl+U
Adjust Color > Remove Color	Ctrl+Shift+U

MENU SHORTCUTS

Enhance Menu *(continued)*

Adjust Lighting > Levels	Ctrl+L
Adjust Smart Fix	Ctrl+Shift+M
Convert To Black And White	Ctrl+Alt+B
Colorize Photo	Ctrl+Alt+R
Haze Removal	Ctrl+Alt+Z

Layer Menu

New > Layer	Ctrl+Shift+N
New > Layer Via Copy	Ctrl+J
New > Layer Via Cut	Ctrl+Shift+J
Create Clipping Mask	Ctrl+Alt+G
Group Layers	Ctrl+G
Ungroup Layers	Ctrl+Shift+G
Hide Layers	Ctrl+,
Arrange > Bring To Front	Ctrl+Shift+]
Arrange > Bring Forward	Ctrl+]
Arrange > Send Backward	Ctrl+[
Arrange > Send To Back	Ctrl+Shift+[
Merge Down	Ctrl+E
Merge Visible	Ctrl+Shift+E

Select Menu

All	Ctrl+A
Deselect	Ctrl+D
Reselect	Ctrl+Shift+D
Inverse	Ctrl+Shift+I
Feather	Ctrl+Alt+D
Subject	Ctrl+Alt+S
Nudge selection marquee 1 pixel	Arrow key
Nudge selection marquee 10 pixels	Shift+Arrow key

Filter Menu

Last Filter	Ctrl+F
Adjustments > Invert	Ctrl+I

Organizer Keyboard Shortcuts (Windows)

MENU SHORTCUTS

File Menu

Get Photos And Videos > From Files And Folders	Ctrl+Shift+G
Get Photos And Videos > From Camera Or Card Reader	Ctrl+G
Get Photos And Videos > From Scanner	Ctrl+U
Manage Catalogs	Ctrl+Shift+C
Backup Catalog	Ctrl+B
Copy/Move To Removable Drive	Ctrl+Shift+O
Move	Ctrl+Shift+V
Export As New File(s)	Ctrl+E
Rename	Ctrl+Shift+N
Duplicate	Ctrl+Shift+D
Set As Desktop Wallpaper	Ctrl+Shift+W
Save Metadata To Files	Ctrl+W
Print	Ctrl+P
Exit	Ctrl+Q

MENU SHORTCUTS

Edit Menu

Undo	Ctrl+Z
Redo	Ctrl+Y
Copy	Ctrl+C
Select All	Ctrl+A
Deselect	Ctrl+Shift+A
Delete From Catalog	Delete
Rotate 90° Left	Ctrl+Left Arrow
Rotate 90° Right	Ctrl+Right Arrow
Edit With Photoshop Elements Editor	Ctrl+I
Edit With Premiere Elements Editor	Ctrl+M
Adjust Date And Time	Ctrl+J
Add Caption	Ctrl+Shift+T
Update Thumbnail	Ctrl+Shift+U
Visibility > Mark As Hidden	Alt+F2
Stack > Automatically Suggest Photo Stacks	Ctrl+Alt+K
Stack > Stack Selected Photos	Ctrl+Alt+S

MENU SHORTCUTS

Edit Menu *(continued)*

Stack > Expand Photos In Stack	Ctrl+Alt+R
Stack > Collapse Photos In Stack	Ctrl+Alt+Shift+R
Color Settings	Ctrl+Alt+G
Preferences > General	Ctrl+K

Find Menu

By Media Type > Photos	Alt+1
By Media Type > Video	Alt+2
By Media Type > Audio	Alt+3
By Media Type > Projects	Alt+4
By Media Type > Items With Audio Captions	Alt+6
By Caption Or Note	Ctrl+Shift+J
By Filename	Ctrl+Shift+K
All Version Sets	Ctrl+Alt+V
All Stacks	Ctrl+Alt+Shift+S
Items With Unknown Date Or Time	Ctrl+Shift+X
Untagged Items	Ctrl+Shift+Q

View Menu

Refresh	F5
Media Types > Photos	Ctrl+1
Media Types > Video	Ctrl+2
Media Types > Audio	Ctrl+3
Media Types > Projects	Ctrl+4
Details	Ctrl+D
Full Screen	F11
Timeline	Ctrl+L
Set Date Range	Ctrl+Alt+F
Clear Date Range	Ctrl+Shift+F

MENU SHORTCUTS

Help Menu

Photoshop Elements Help	F1

NAVIGATING IN THE PHOTO BROWSER

Move Selection up/down/left/right	Up/Down/Left/Right Arrow
Show full-size thumbnail of selected photo	Enter

VIEWING PHOTOS IN FULL SCREEN MODE

Start slideshow	Spacebar
Show next slide	Right/Down Arrow
Show previous slide	Left/Up Arrow
Pause slideshow	Spacebar
End slideshow	Esc

Editor Keyboard Shortcuts (macOS)

TO CHOOSE A TOOL

Tools

Move	V
Zoom	Z
Hand	H
Color Picker	I
Marquee	M
Lasso	L
Recompose	W
Selection Brush	A
Type	T
Crop	C
Content-Aware Move	Q
Straighten	P
Red Eye Removal	Y
Healing Brush	J
Clone Stamp	S
Eraser	E
Brush	B
Smart Brush	F
Pencil	N

TO CHOOSE A TOOL

Tools *(continued)*

Paint Bucket	K
Gradient	G
Shape	U
Blur	R
Sponge	O

TO CYCLE THROUGH TOOLS

Marquee tools	M
Lasso tools	L
Type tools	T
Healing Brush tools	J
Clone Stamp tools	S
Eraser tools	E
Brush tools	B
Smart Brush tools	F
Shape tools	U
Blur and Sharpen tools	R
Crop, Cookie Cutter, and Perspective Crop	C
Sponge, Dodge, and Burn	O

WORKING WITH TOOLS

Marquee Tool

Draw marquee from center	Option-drag
Constrain to square or circle	Shift-drag
Draw from center and constrain to...	Option+Shift-drag

Move Tool

Constrain move to 45°	Shift-drag
Copy selection or layer	Option-drag
Nudge selection or layer 1 pixel	Arrow key
Nudge selection or layer 10 pixels	Shift+Arrow key

Lasso Tool

Add to selection	Shift-drag
Delete from selection	Option-drag
Intersect with selection	Option+Shift-drag
Change to Polygonal Lasso	Click, then Option-drag

Polygonal Lasso Tool

Add to selection	Shift-click, then draw
Delete from selection	Option-click, then draw
Intersect with selection	Option+Shift-click, then draw
Draw using Lasso	Option-drag
Constrain to 45° while drawing	Shift-drag

Magnetic Lasso Tool

Add to selection	Shift-click, then draw
Delete from selection	Option-click, then draw
Intersect with selection	Option+Shift-click, then draw
Add point	Single click
Remove last point	Delete
Close path	Double-click or Return

WORKING WITH TOOLS

Magnetic Lasso Tool *(continued)*

Close path over start point	Click on start point
Close path using straight line segment	Option-double-click
Switch to Lasso	Option-drag
Switch to Polygonal Lasso	Option-click

Crop Tool

Rotate crop marquee	Drag outside crop marquee
Move crop marquee	Drag inside crop marquee
Resize crop marquee	Drag crop handles
Resize crop box while maintaining its aspect ratio	Shift-drag corner handles

Shape Tools

Constrain to square or circle	Shift-drag
Constrain Line tool to 45°	Shift-drag
Transform shape	Command+T
Distort	Command-drag
Skew	Command+Option-drag
Create Perspective	Command+Option+Shift-drag

Type Tool

Select a word	Double-click in text
Select a line	Triple-click in text
Select a paragraph	Quadruple-click in text
Select all characters	Command+A
Left align text	Command+Shift+L
Center text	Command+Shift+C
Right align text	Command+Shift+R
Increase by 1 point	Command+Shift+. (period)
Decrease by 1 point	Command+Shift+, (comma)
Scroll through fonts	Select font in menu+Up/Down Arrow

WORKING WITH TOOLS

Paint Bucket Tool

Change color of area	Shift-click outside canvas

Brush and Pencil Tools

Decrease or increase size	[or] (bracket keys)

Smudge Tool

Smudge using Foreground color	Option-drag

Color Picker Tool

Choose Background color	Option-click

DISPLAY SHORTCUTS

Change View

Zoom in	Command++ (plus)
Zoom out	Command+ − (minus)
Zoom to 100% / Actual pixels	Double-click Zoom tool or Command+Option+0 (zero)
Zoom to fit window / Fit on screen	Double-click Hand tool or Command+0 (zero)
Show/hide edges of selection	Command+H
Show/hide ruler	Command+Shift+R

Hand Tool

Toggle to zoom in	Command
Toggle to zoom out	Option
Fit image on screen	Double-click tool

Zoom Tool

Zoom out	Option-click
Actual size	Double-click tool

Move Image in Window

Scroll up one screen	Page Up
Scroll down one screen	Page Down
Scroll left one screen	Command+Page Up
Scroll right one screen	Command+Page Down
Scroll up 10 pixels	Shift+Page Up

DISPLAY SHORTCUTS

Move Image in Window (continued)

Scroll down 10 pixels	Shift+Page Down
Scroll left 10 pixels	Command+Shift+Page Up
Scroll right 10 pixels	Command+Shift+Page Down
Move view to upper left	Home key
Move view to lower right	End key

MENU SHORTCUTS

Adobe Photoshop Elements 2022 Editor

Preferences > General	Command+K
Quit Photoshop Elements	Command+Q

File Menu

New > Blank File	Command+N
Open	Command+O
Open In Camera Raw	Command+Option+O
Close	Command+W
Close All	Command+Option+W
Save	Command+S
Save As	Command+Shift+S
Save For Web	Command+Option+Shift+S
Print	Command+P

MENU SHORTCUTS

Edit Menu

Undo	Command+Z
Redo	Command+Y
Cut	Command+X
Copy	Command+C
Copy Merged	Command+Shift+C
Paste	Command+V
Paste Into Selection	Command+Shift+V
Color Settings	Command+Shift+K

Image Menu

Free Transform	Command+T
Image Size	Command+Option+I
Canvas Size	Command+Option+C

Enhance Menu

Auto Smart Fix	Command+Option+M
Auto Smart Tone	Command+Option+T
Auto Levels	Command+Shift+L
Auto Contrast	Command+Option+Shift+L
Auto Haze Removal	Command+Shift+A
Auto Color Correction	Command+Shift+B
Auto Red Eye Fix	Command+R
Adjust Color > Adjust Hue/ Saturation	Command+U
Adjust Color > Remove Color	Command+Shift+U
Adjust Lighting > Levels	Command+L
Adjust Smart Fix	Command+Shift+M
Convert To Black And White	Command+Option+B
Colorize Photo	Command+Option+R
Haze Removal	Command+Option+Z

MENU SHORTCUTS

Layer Menu

New > Layer	Command+Shift+N
New > Layer Via Copy	Command+J
New > Layer Via Cut	Command+Shift+J
Create Clipping Mask	Command+Option+G
Group Layers	Command+G
Ungroup Layers	Command+Shift+G
Hide Layers	Command+,
Arrange > Bring To Front	Command+Shift+]
Arrange > Bring Forward	Command+]
Arrange > Send Backward	Command+[
Arrange > Send To Back	Command+Shift+[
Merge Down	Command+E
Merge Visible	Command+Shift+E

Select Menu

All	Command+A
Deselect	Command+D
Reselect	Command+Shift+D
Inverse	Command+Shift+I
Feather	Command+Option+D
Subject	Command+Option+S
Nudge selection marquee 1 pixel	Arrow key
Nudge selection marquee 10 pixels	Shift+Arrow key

Filter Menu

Last Filter	Command+F
Adjustments > Invert	Command+I

Organizer Keyboard Shortcuts (macOS)

Elements Organizer Menu

Preferences	Command+K
Quit Elements Organizer	Command+Q

File Menu

Get Photos And Videos > From Files And Folders	Command+Option+G
Get Photos And Videos > From Camera Or Card Reader	Command+G
Manage Catalogs	Command+Shift+C
Backup Catalog	Command+B
Copy/Move To Removable Drive	Command+Shift+O
Move	Command+Shift+V
Export As New File(s)	Command+E
Rename	Command+Shift+N
Duplicate	Command+Shift+D
Save Metadata To Files	Command+W
Print	Command+P

Edit Menu

Undo	Command+Z
Redo	Command+Y
Copy	Command+C
Select All	Command+A
Deselect	Command+Shift+A
Delete From Catalog	Command+Delete
Rotate 90° Left	Command+Left Arrow
Rotate 90° Right	Command+Right Arrow
Edit With Photoshop Elements Editor	Command+I
Edit With Premiere Elements Editor	Command+M
Adjust Date And Time	Command+J
Add Caption	Command+Shift+T
Update Thumbnail	Command+Shift+U
Visibility > Mark As Hidden	Option+F2

MENU SHORTCUTS

Edit Menu *(continued)*

Stack > Automatically Suggest Stacks	Command+ Option+K
Stack > Stack Selected Photos	Command+ Option+S
Stack > Expand Photos In Stack	Command+ Option+R
Stack > Collapse Photos In Stack	Command+ Option+Shift+R
Color Settings	Command+ Option+G

Find Menu

By Media Type > Photos	Option+1
By Media Type > Video	Option+2
By Media Type > Audio	Option+3
By Media Type > Projects	Option+4
By Media Type > Items With Audio Captions	Option+6
By Caption Or Note	Command+ Shift+J
By Filename	Command+ Shift+K
All Version Sets	Command+ Option+V
All Stacks	Command+ Option+Shift+S
Items With Unknown Date Or Time	Command+ Shift+X
Untagged Items	Command+ Shift+Q

MENU SHORTCUTS

View Menu

Refresh	F5
Media Types > Photos	Command+1
Media Types > Video	Command+2
Media Types > Audio	Command+3
Media Types > Projects	Command+4
Details	Command+D
Full Screen	Command+F11
Timeline	Command+L
Set Date Range	Command+ Option+F
Clear Date Range	Command+ Shift+F
Enter Full Screen	Fn-F

Help Menu

Photoshop Elements Help	F1

NAVIGATING IN THE PHOTO BROWSER

Move Selection up/down/left/right	Up/Down/ Left/Right Arrow
Show full-size thumbnail of selected photo	Return

VIEWING PHOTOS IN FULL SCREEN MODE

Start slideshow	Spacebar
Show next slide	Right/Down Arrow
Show previous slide	Left/Up Arrow
Pause slideshow	Spacebar
End slideshow	Esc

Index

Content-Aware technology
 extending backgrounds with, 80
 panorama creation with, 187
 repairing images with, 165, 166
 straightening photos with, 81
contrast, Auto, 140
converting
 Background layers, 121
 color to black and white, 145
 selections to layers, 119
 tags to/from sub-categories, 49
Correct Camera Distortion filter, 189
crop marks, printing, 238
cropping images
 Crop tool for, 4, 78–79
 panorama creation and, 188
 Print dialog used for, 237
 Rectangular Marquee tool for, 79
 size options for, 4, 79
 straightening and, 5, 82
curves, color, 144
Custom workspace, 13

D

Darken Highlights slider, 142
darkening images
 options for, 141, 157
 selectively, 174
deleting
 albums, 59
 categories, 51
 History states, 25
 keyword tags, 44
 layer masks, 132
 layers, 114
 selections, 105
 See also removing
Deselect command, 105
Detail sliders, 159
Detail Smart Brush tool, 185
details
 finding photos by, 68
 lightening in shadows, 142
 selectively enhancing, 171–172
 viewing information and, 36

Difference blending mode, 128
digital cameras
 correcting distortion from, 189
 importing images from, 28–31
 raw profiles for, 154
 taking panorama photos with, 186
digital noise, 160
display
 calibrating, 150–151
 keyboard shortcuts, 251, 257
Distort filters, 195
distortion
 adding to layers, 127
 correcting camera, 189
 keyboard shortcuts, 214
 Liquify filter for, 196
 text warp as, 227–228
 transforming shapes with, 214
distributing layer objects, 127
Dodge tool, 173
downsampling images, 236
dpi (dots per inch), 235
dragging
 categorizing tags by, 50
 importing files by, 32
 reordering layers by, 115
 tagging photos by, 45
drawing shapes, 211–212
duplicate images, 70
duplicating layers, 120

E

Edge Extension option, 189
Edit Keyword Tag dialog, 44, 50
Edit Location button, 64
editing
 files from Organizer, 14
 Instant Fix editor for, 84
 keyword tag properties, 44
 non-destructive method for, 165
 Places view information, 64
 Quick mode for, 85–87
 text, 217, 226
 workflow for, 1–9

Learn the quick and easy way
VISUAL QUICKSTART GUIDES

Visual QuickStart Guides provide an easy, visual approach to learning. Your purchase of the book or eBook includes the Web Edition, a free online version of the book containing bonus video lessons that support and expand on topics covered in the book.

Concise steps and explanations let you get up and running in no time. These step-by-step tutorial and quick-reference guides are an established and trusted resource for creative people.

To see a complete list of our Visual QuickStart Guides go to:

peachpit.com/vqs

HTML and CSS
Visual QuickStart Guide, 9th Edition
ISBN: 9780136702566

Adobe Photoshop Elements
Visual QuickStart Guide
ISBN: 9780137637010

Adobe Illustrator Visual QuickStart Guide
ISBN: 9780137597741

Adobe Photoshop Visual QuickStart Guide
ISBN: 9780137640836

Peachpit Press
www.peachpit.com